DETECTIVES IN THE SHADOWS

DETECTIVES IN THE SHADOWS

A HARD-BOILED HISTORY

SUSANNA LEE

JOHNS HOPKINS UNIVERSITY PRESS | BALTIMORE

3 9082 14300 6354

Johns Hopkins University Press
2715 North Charles Street
Baltimore, Maryland 21218 4363
www.press.jhu.edu

Library of Congress Cataloging-in-Publication Data

Names: Lee, Susanna, 1970– author.
Title: Detectives in the shadows : a hard-boiled history / Susanna Lee.
Description: Baltimore : Johns Hopkins University Press, 2020. | Includes
 bibliographical references and index.
Identifiers: LCCN 2019023262 | ISBN 9781421437095 (hardcover) |
 ISBN 9781421437101 (ebook)
Subjects: LCSH: Detective and mystery stories, American—History and
 criticism. | Detective and mystery films—United States—History and
 criticism. | Detectives in literature. | Detectives in motion pictures. |
 Heroes in literature. | Heroes in motion pictures. | Toughness
 (Personality trait) | National characteristics, American, in literature. |
 National characteristics, American, in motion pictures.
Classification: LCC PS374.D4 L427 2020 | DDC 813/.087209—dc23
LC record available at https://lccn.loc.gov/2019023262

A catalog record for this book is available from the British Library.

*Special discounts are available for bulk purchases of this book. For more information, please
contact Special Sales at specialsales@press.jhu.edu.*

Johns Hopkins University Press uses environmentally friendly book materials,
including recycled text paper that is composed of at least 30 percent post-consumer
waste, whenever possible.

CONTENTS

ACKNOWLEDGMENTS

I am grateful to many friends, family members, and colleagues for their support during the writing of this book. Edward Lee, Marianna Lee, Carole Sargent, Kathryn Shevelow, and Andrew Sobanet read all or portions of the manuscript and gave invaluable advice. Many thanks to Matt McAdam of Johns Hopkins University Press, whose vision helped bring this book into being, and to the wonderful Catherine Goldstead, who encouraged the project's expansion and shepherded it to completion.

A Senior Faculty Research Grant from Georgetown University supported the writing of this book. Kelly Coyne and Toby Hickson provided crucial research assistance. Joe Abbott supplied meticulous editing. Special thanks to Masha Belenky, Jeremy Billetdeaux, Peter Brooks, Erin Callahan, Susann Cokal, Laura Denardis, Mia Dentoni, the staff of the Georgetown University Lauinger Library, Angie Graham, Anne O'Neil Henry, Cynthia Hobbs, Jennifer Kaplan, Peter Kok, Sandra Lee, Elizabeth Letcher, Tammy Lowengrub, Katie MacKaye, Joan Matus, Brian Pope, Maggie Prieto, Helen Sale, Eden Segal, Andrew Sobanet, Annie Steiner, Barbara Steiner, Carole Steiner, Michel Steiner, Erik ten Broecke, Maya ten Broecke, Nova ten Broecke, and Paul Young.

My greatest thanks go to Charlotte, Ryan, and Thomas Crean for making everything more meaningful and more fun. This book is dedicated to them.

- - - - - - - - - - - - - - - - - - - -

A Silhouette

For nearly a century, the trench coat–wearing detective smoking a cigarette on a rainy street has been an American icon. Although not always garnering critical recognition or esteem, stories of the hard-boiled detective *sold*. From Prohibition to the stock market crash of 1929, from the Great Depression to the start of the Second World War, from the postwar threat of communism to the explosion of rock and roll, from the fall of Nixon to the consumerism of the 1980s, and from the national security concerns of the early 2000s to the election of 2016, hard-boiled detectives have persisted through some of the United States' most fraught historical moments. For every tough season in American history, there is a detective who emerged to handle it. And while all crime fiction portrays a wealth of heroes for readers and viewers to enjoy, those of the hard-boiled tradition resonate with Americans on a particular level, the iconic image persisting from the pages of books to the screen. The hard-boiled narrative serves as a dark mirror for America's worst impulses, while also offering a nuanced portrait of response and morality that actual history frequently fails to bear out. The hard-boiled detective is a sort of honorary shadow figure in US history. He emerges in the 1920s and 1930s

with Carroll John Daly's Race Williams, Dashiell Hammett's Continental Op, and Raymond Chandler's Philip Marlowe. In the next two decades, he resurfaces as Mickey Spillane's Mike Hammer. By the 1970s, the hard-boiled detective is Robert Parker's Spenser and television's Jim Rockford and Harry O. And in the early 2000s, a contemporary reincarnation of the hard-boiled appears in the form of *The Wire*'s Jimmy McNulty, *True Detective*'s Rustin Cohle, and *Jessica Jones*'s titular character.

But the American hard-boiled hardly invented detective fiction. Edgar Allan Poe's "Murders in the Rue Morgue," published in 1841, is generally recognized as the first modern detective story. For decades after, the term *detective* meant the sort of armchair sleuth embodied by Sir Arthur Conan Doyle's Sherlock Holmes or Agatha Christie's Hercule Poirot and Miss Marple. Still, about the same time that Poe created Auguste Dupin, James Fenimore Cooper and John Pendleton Kennedy conceived their frontier protagonists. Cooper's Leatherstocking (1823–41) and Kennedy's Horse-Shoe Robinson (1835) are models of the modern American hero.[1] Later in the nineteenth century, western sheriffs like Pat Garrett and Wyatt Earp would capture the popular imagination. When Carroll John Daly and Dashiell Hammett wrote for the pulp magazine *Black Mask* in the early 1920s, it was as if Leatherstocking, Dupin, and the lawmen of the Old West had joined forces to create a new, modern species. The hard-boiled breed had the canny sense of observation and quick mind of Dupin and Holmes and the plainspoken toughness of the American frontier hero. The resulting hybrid of those earlier character types was fantastically popular. First appearing in short stories in pulp magazines then in novels, the hard-boiled protagonist expanded into films and television programs. However reincarnated, the hard-boiled stood up for the nation and stood in for its people in a peculiarly American way.

The term *hard-boiled* first described human character in the late nineteenth century. A 1927 issue of *American Speech* recounts

that "the word egg [from 'hard-boiled eggs'] was dropped and men became merely 'hard boiled'—and the term reverted to the old meaning as it was among the yeggs: hard, shrewd, keen men who neither asked nor expected sympathy nor gave any, who could not be imposed upon." Several early uses of the word, however, had an unmistakably negative connotation. In 1897, an item in Salem's *Daily Capital Journal* upbraided a politician: "Senator Mitchell, now honestly, don't you think it takes the barefaced impudence of a hard-boiled criminal to keep up such a proceeding?"[2] Then in 1919, a brutal former army lieutenant in charge of a French detention farm earned the nickname of Lieutenant "Hardboiled" Smith. According to survivors' reports, Smith would ask his prisoners if they were hard-boiled and then torment them no matter what their response. The name derived from what he said to prisoners rather than from what he did, yet when he was tried for his crimes and jailed, "Hardboiled" Smith went down in history as a sadist to be feared.

Thus, *hard-boiled* could mean cruel or even criminal, but it also and more often simply meant resilient and practical. In Charles and Alice Williamson's 1914 *The Shop Girl*, a man notices that his son "hadn't in him the making of a hard-boiled man of business who'll do anything to succeed." Hemingway uses the term in *The Sun Also Rises*: "It is awfully easy to be hard-boiled about everything in the daytime, but at night it is another thing." Sometimes, calling someone hard-boiled—instead of just tough or strong—meant that you were ready to play with words and sound a little tough yourself. A 1921 edition of the *Flagstaff (AZ) Coconino Sun* included this snarky comment on an erroneous Associated Press story: "The Associated Press announced recently that 'J.M. Ege, former territorial governor of Arizona, died in Oklahoma.' Oldtimers over the state are wondering when Ege was governor; some of the more hardboiled of pioneers are constrained to believe that something is wrong with this omelet."[3] Writers who pointed to

hard-boiled characters invariably began to sound like them, using the kind of talk the genre would become known for.

The essential difference between hard-boiled and just tough was that hard-boiled was a persona, an attitude, an entire way of being. Even before the hard-boiled detective became a standard of 1920s pulp magazines, a joke made the rounds of the "Boys and Girls" section of newspapers in 1921:

> HARD-BOILED DETECTIVE. I can find anything if I look hard enough.
> ANOTHER DETECTIVE. You look hard enough.[4]

This joke told you everything you needed to know about the combination of detective expertise and tough exterior that defined the hard-boiled. When Carroll John Daly published his first story in *Black Mask* in December of 1922, a sort of pre-hard-boiled tale entitled "The False Burton Combs," the narrator made sure to seem as tough as possible and to remind the reader of his hardness at every turn:

> That gun is always with me. It ain't like I only carry it when I think there's trouble coming. I always have it. You see, a chap in my line of work makes a lot of bad friends and he can't tell when one of them is going to bob up and demand an explanation. But they all find out that I ain't a bird to fool with and am just as likely to start the fireworks as they are.[5]

That narrator may well have been a bird not to fool with, but he was also nameless and called himself a "gentleman adventurer." He had some of the component parts of what would become the hard-boiled detective, the cockiness and the slang, but he wasn't there yet. In May of 1923, Daly published "Three Gun Terry." That story gave the main character a name, Terry Mack, and it made him a detective. Mack stated that his life was his own and that others' opinions didn't matter to him. His office had a sign

that read "Private Investigator" on the door, which he said "means whatever you wish to think it."[6]

Daly, it would seem, was entirely aware—maybe too much so—of writing a "first" and establishing the principal elements of the hard-boiled detective. Being hard meant being impervious to the opinions—and bullets—of others. It meant claiming autonomy in all circumstances. A few months later, in October of 1923, Dashiell Hammett published his first Continental Op story, "Arson Plus." Also published in *Black Mask*, it opens in the detective's office, in the middle of a conversation with a sheriff: "Jim Tarr picked up the cigar I rolled across his desk, looked at the band, bit off an end, and reached for a match. 'Fifteen cents straight,' he said. 'You must want me to break a *couple* of laws for you this time.'"[7]

Criminals, police, fans—it isn't just the opinions of society that don't matter but their laws. Something about the semi-lawlessness of the hard-boiled detective appealed profoundly to readers. Publishers and reviewers took up the term, which became code for unsentimental, matter-of-fact, practical, hard-to-beat, dangerous, and smart. By the mid-1930s, the *New York Times* described Hammett as a member of the "hard-boiled school."

Even though the 1920s and 1930s saw dozens of hard-boiled detectives, and each of their particular actions and words were distinct, "the hard-boiled detective" is in many ways a single persona. He is a silhouette of a trench-coated form in the evening. He is recognizable by his cigarette, his inscrutable glance, the shadows and rain that surround him. That familiarity has cemented his place in popular culture. In 1945, in a laudatory essay on Dashiell Hammett entitled "The Simple Art of Murder," Raymond Chandler—by then himself a renowned crime writer—wrote what would become an enduring definition of the hard-boiled detective:

> Down these mean streets a man must go who is not himself mean, who is neither tarnished nor afraid. He is the hero; he is everything.

He must be a complete man and a common man and yet an unusual man. He must be, to use a rather weathered phrase, a man of honor—by instinct, by inevitability, without thought of it, and certainly without saying it. He must be the best man in his world and a good enough man for any world.[8]

This format raised the stakes of the hard-boiled persona to even greater heights, delineating what separated the hard-boiled from the conventional tough guy. Hard-boiled is not just toughness that declares itself; it *means* something. It stands for individual impermeability that weathers the storm. It is an attitude, a personality, and a moral attribute all in one. Chandler's rhapsodic passage gets cited constantly in writing about hard-boiled crime fiction because it presents the character as the center of the world, the nucleus of an organism. The idea that an individual could be this pivotal, this important, *and* this reassuringly dedicated to others presented a complimentary image of American individualism and, for decades, masculinity.

More than any other literary genre, the hard-boiled is powerfully driven by character. The hard-boiled protagonist is clever with words, quick with a comeback, and talented with a gun. But emptiness never lurked beneath an alluring personality: the hard-boiled was honorable all the way down.

...

In 1924, a *Black Mask* editorial offered this advertisement for the magazine's fiction: "Fulfill that secret desire for an exciting life! Satisfy your craving for thrills! Let Race Williams and Terry Mack kill your enemies for you!"[9] This advertisement, published in the leading detective-story magazine of the 1920s, sums up the dual promise hard-boiled crime fiction offered its readers. Reading the first two sentences of the ad, one imagines a bored reader looking for entertainment, but the final sentence suggests a reader demanding a hit man or backup muscle, whose life, arguably, must

already be exciting. Hard-boiled detective fiction provides both the excitement of a dangerous, risk-filled story and the certainty of a victorious outcome.

In a sense, the advertisement makes hard-boiled stories a catchall distraction for reader resentment, aggression, and boredom. "Your enemies" might be an annoying neighbor or a demanding boss, and there are many more of those in the world than there are daunting criminals. "Thrills" might mean a life where the enemies are more threatening and compelling, and dispatching them is heroic rather than just inappropriate or crazy. At the same time, having a hard-boiled character as your own personal hit man ensures that the perils of excitement never become too real or life-threatening. Plenty of fiction had brought excitement to its readers; that was, indeed, the goal of westerns and romance novels. But when the hard-boiled detective came on the scene, it was the first time that a character so clearly addressed the reader in person. Hard-boiled detective fiction invited readers to identify with fictional characters but also encouraged them to depend on these heroes. The *Black Mask* advertisement, in which the hard-boiled character provides the drama and then steps in to take care of its rougher aspects, set up the dynamic that the hard-boiled would follow for the rest of the century. The detective was enough of an everyman to look like someone that anyone could be, but he was also unbeatable and unsinkable—a dream of American tenacity.

By turns a character model, a cool older sibling, and the tough guy you see around the neighborhood, the hard-boiled character promises that if the world becomes too daunting, someone close by knows what he is doing. More than this, hard-boiled detectives were models and stand-ins not just for the individual reader but also for the country as a whole. And in one historical period after another, a curious thing happened: actual politicians echoed the attitudes and stances of the hard-boiled detectives of their

eras. Whether coincidence or not, public figures from Hoover to Roosevelt, from Truman to Carter and beyond, replicated their vocabulary and manner. Carroll John Daly's Terry Mack boasted about his life being his own; then Hoover exhorted Americans to rugged individualism and self-reliance. Hammett's Op discovered corruption in Poisonville "from Adam's apple to ankles," while Roosevelt announced Americans were facing "the grim problem of existence."[10]

In Daly's first Race Williams story, "Knights of the Open Palm," published in 1923, the main character announces: "I'm like all Americans—a born joiner." But in the same breath he states, "I don't belong to any order. . . . It would be mighty bad in my line." Because the order in question is the Ku Klux Klan, this assertion is charged with ethical meaning, but the protagonist's statements encompass the paradox of the hard-boiled hero, who is both an individualist and a national icon.[11] He is someone who wouldn't join the club, but if he wanted to, he would be welcome. Nor can you be sure whether he is refusing so that he can remain dedicated to his own self-interest or so he can remain dedicated to the interests of everyone.

When Williams states, "I'm like all Americans," it's a grand statement, one meant to create an American identity. Hard-boiled fiction promotes the illusion that tough white masculinity *is* American and that America *is* tough white masculinity. But even as it does this, it insists that people have always needed a model to imitate, since American individualism is not just a disembodied idea. It comes tethered to a physical image. To be an American is to attach oneself to other Americans, even when the attribute you are imitating is a refusal to imitate. For a long time, the ideal American was a white man. Similarly, to be a man is to attach to and emulate another man, a tough-talking, screen-tested, fictional frontier alter ego who pines for an earlier time, remembers when times were better for him, and lives with complete

autonomy. Crucially, hard-boiled characters never emulate others or look back with yearning. The buck stops with them. They don't look around for examples or accolades, and that enviably solid individuality is the source of their appeal.

In a way, hard-boiled characters parallel the work of super-heroes, giving readers someone to admire and with whom to iden-tify. But unlike superheroes, hard-boiled detectives are entirely

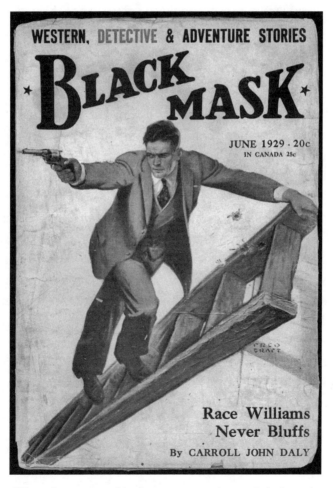

Race Williams first appeared in the June 1, 1923, issue of *Black Mask*. By 1929, he was the magazine's most popular fictional detective.

within the earthly realm of fiction. In this realm, a character's exceptional qualities come not from some outside source but from an ideal mix of action and determination thoroughly bound to human concerns. This is what makes the genre so attractive to American readers, who have long appreciated people who declare themselves competent, independent, and fearless and whose stories then bear that out.

Even in tough times, detectives never fall into maudlin victimhood. Erin Smith, writing about the advertisements in early detective magazines, explains: "Pulp magazines shaped working men into consumers by promising the restoration of historical male prerogatives—patriarchal male supremacy, autonomous work, a family wage."[12] But the hard-boiled character never needed those prerogatives restored. Readers might, and the enemies that haunt them might be the very folks they blame for taking their prerogatives away, but the characters themselves never speak from need. They don't whine. Their problems move them but never change them. If something is difficult, they deal with it and move on. Helplessness and self-doubt are enemies that the hard-boiled detective could kill for you, even though he would hardly ever need to kill them on his own behalf. This evolving detective trope is like the country itself, taking on new identities and morphing to meet modern crises. As the twenty-first century unfolds, the hard-boiled is much less exclusively white and male. Obstacles to individualism, to ethics, and to goodness itself persist. Characters continue to emerge, though, as avatars of American hope and delusion, seeking to reassure humanity that it can survive its own shortcomings.

CHAPTER ONE

Arriving on the Scene

Stories we tell about the Jazz Age perpetuate a lighthearted image of the 1920s. The entire nation breathed a sigh of relief at the end of World War I and then celebrated. Although the war had been horrific, it had taken place overseas—or, as George M. Cohan's famous song had so memorably expressed it, "over there." Cohan penned this song at the start of the war, the very day after President Woodrow Wilson committed the American military to the Allied cause in 1917. Cohan's intent was to rally young men to enlist, and his tactic succeeded brilliantly.

When the war ended, however, it was tempting to think that its major horrors had been left behind, "over there." The reality of trench warfare was barely reported to the American public. Returning veterans—much like those who would return from World War II and Vietnam—were reluctant to talk about their painful experiences. Despite the revelry of popular culture in the 1920s, the reality remained that more than 116,000 American lives were lost in World War I. Many who survived returned with missing limbs, shell shock, and lifelong debilities as a result of the widespread deployment of poison gases.

The literature of the age registers the dubious success of the Jazz Age's carefree air. The classic novel of the time is F. Scott Fitzgerald's *The Great Gatsby*. No close reader of that classic can miss its painful ambivalence: while there is admiration—even envy—for Gatsby's lifestyle, there is also revulsion and moral uneasiness. And although liquor flowed freely at his parties, because Prohibition had been national policy since the passage of the Volstead Act in 1919, all that liquor was assuredly illegal. The mob activities that satiated the national thirst would some-day serve as context for the popular TV series *Boardwalk Empire*, but at the time, the reality was murder and crime. Even though it was the business of the organized police force to combat these criminals, the 1920s saw a radical literary hero emerge to confront social problems—not "over there" but right here at home.

Carroll John Daly created the first hard-boiled detective in 1923. His name was Terry Mack. Mack made his debut in "Three Gun Terry," and he returned in the 1924 "Action! Action!" Both stories were published in *Black Mask* magazine. Mack was a voluble private investigator who claimed to "play the game on the level, in my own way," which meant jumping on moving cars, brandishing his gun, and blowing his own horn. Daly then invented Race Williams—in many ways Terry Mack with another name—in the 1923 *Black Mask* story "Knights of the Open Palm." Though Mack may have been the first hard-boiled detective, Williams became the most durable character of the 1920s. He was a runaway success. He worked alone, he knew the alleys and gutters of New York City, he was an excellent shot, and he never tired of reminding you of his capabilities. Judges were suspicious of him. Criminals feared him. In narrating his own stories, he talked through every step he made and noted every bad guy he took down. Williams appeared in a number of short stories and, in 1927, his own novel, *The Snarl of the Beast*. On the first page Williams announces: "Right and wrong are not written on the statutes for me, nor do I find my code

of morals in the essays of long-winded professors. My ethics are my own. I'm not saying they're good and I'm not admitting they're bad, and what's more I'm not interested in the opinions of others on that subject." This was more or less an echo of the opening line of "Three Gun Terry," where Mack proclaimed, "My life is my own, and the opinions of others don't interest me."[1]

In fact, a lot of what made Race Williams appealing was not what interested him but what didn't. The list was long: it included not only other people's opinions, the laws of the land, social graces, and due process but also elitism, greed, prudishness, and caution. It included grammar and good writing, which is one reason that Daly, crucial as he is to the history of the hard-boiled genre and fun as he was to read, was soon consigned to the dustbin of literary history. A historian of *Black Mask* puts it well: "The writing was impossibly crude, the plotting labored and ridiculous, and Williams emerged as a swaggering illiterate with the emotional instability of a gun-crazed vigilante."[2] Unstable or not, Williams stuck up for the underdog and defended his clients when they were under the gun. From one story to the next he gave readers an ambitious portrait of strength, courage, boundless energy, kindness, and complete irreverence.

. . .

The 1920s were an exciting time for social freedom, music, dancing, and daring financial dealings. Those who speak of the "Roaring Twenties" usually have in mind the bustle of parties, the blare of music on the radio, and raucous laughter as folks danced the Charleston. But the decade also roared with the sounds of police sirens and machine guns and of newsboys announcing that another cabinet member had gone to prison. Crime was rampant in no small part because Prohibition made alcohol illegal. Enacted in 1920, Prohibition blurred the lines between the law-abiding citizen and the criminal. Even those who, unlike Race Williams, saw right and wrong written "on the statutes" were ready to

dismiss that particular statute.[3] Though the violent crime surrounding the production and sale of alcohol made criminals more menacing, the mere existence of Prohibition made breaking the law against imbibing banal. Prohibition criminalized an activity that millions of Americans had enjoyed for centuries with no legal obstacles. Alcoholism has its pernicious consequences, of course, but was hardly nullified by the Eighteenth Amendment. Prohibition drew ethical lines not so much between those who broke the law and those who didn't but between those who were violent and those who weren't. Organized gangs supplied polite society with booze but also fought brutally among one another to do so. It was hard to tell who deserved more blame—the criminals who ran liquor, the politicians whose amendment created an outlaw market, or the everyday Americans who continued to imbibe. When it came to alcohol, organized crime simply responded to an all-American law of supply and demand.

Blurring the boundary between right and wrong still more, scandal tainted the lawmakers themselves. In 1921, President Harding gave supervision of naval oil-reserve lands to the Department of the Interior. Secretary of the Interior Albert Fall granted exclusive leases to private oil companies in return for bribes. Senate committees investigated, the Supreme Court declared the leases fraudulent, and oil executives were charged with bribery and criminal conspiracy. The executives were acquitted, but Fall was convicted of accepting a bribe and was imprisoned. This marked the first time that a cabinet member had gone to prison. Running liquor and selling oil leases were both tied to laissez-faire capitalism, which grew across the decade but would prove in 1929 to be trouble no matter which side of the law you were on.

On top of political scandals, the 1920s saw profound cultural conflicts and a rise in nativist sentiments similar to those of the mid-2010s. Labor activism had made gains during the war but faced powerful resistance in its aftermath as the rise of American

business benefited the few at the expense of the many.[4] Union membership declined throughout the decade, even as income inequality soared. And although credit was more available than before, most Americans did not have access to cars, electricity, or telephones. The question of American identity was a point of contention, with the Emergency Immigration Act of 1921 and the National Origins Act of 1924 restricting European immigration and the Ku Klux Klan experiencing a national resurgence. President Calvin Coolidge announced, when signing the 1924 act, that "America must be kept American," and numerous white Americans lined up to endorse that sentiment.

In this context of political and cultural turmoil, Race Williams came onto the scene and claimed a judicial limbo. As he put it, "The police don't like me. The crooks don't like me. I'm just a halfway house between the law and crime, sort of working both ends against the middle."[5] Because he fought crime night and day and narrated his actions in tireless detail, his "halfway house" became a jumping-off point for real public service. Williams did the work of a multitude of social services that did not yet exist. He fulfilled a major American fantasy that individual autonomy and dedication to the public good were not only compatible but natural partners. He played to fears of criminals and lawmakers alike when their moral separation was blurred. Repeating ad nauseam the improvisational and independent nature of his principles allowed him to separate himself from groups tainted by corruption or specious reasoning—in other words, from just about everybody.

But Williams didn't just hover between crooks and the police. He was an individualist without god or master, without a boss, without a codified frame of reference. On any given evening, he would slip out of the house, slink around the Lower East Side, and foil a murder attempt or disable an assailant, all while commenting casually that the law was starting to look at him with suspicion. When he said, "My ethics are my own," he could have turned

himself into a dangerously loose cannon, but there are several historical events that make this less likely. Self-reliance was one of the main financial and social principles of the decade. During his 1928 campaign, Herbert Hoover described America as "challenged with a peacetime choice between the American system of rugged individualism and a European philosophy of diametrically opposed doctrines—doctrines of paternalism and state socialism."[6] Given a choice between depending on oneself or on the government for support, to choose the former looked patriotic and courageous. Williams falls in line with this belief: he works for himself, earns his own income, takes care of himself, and makes his own rules. Although he frequented the back alleys and tenements of New York, and although he claimed that his bank account was low, he was incongruously at ease financially. He lived in a brownstone with a library and employed a chauffeur, putting him among the social ranks of the well-heeled characters in Agatha Christie's novels, or even with Gatsby, more so than with the grunting hoodlums he claimed to know.

The rugged individualism that Hoover advocated centered on finance, but Williams's brand of self-sufficiency had a mental resonance well-suited to his circumstances. As a character, he is reliable, a friend who confronts bullies and protects the weak, who looks up to no one just as he looks down on no one. His appeal lies in a combination of kindness and fearlessness. Williams doesn't tell the reader much about his past, since he is usually busy reporting each present case in rapid-fire narration. But *The Snarl of the Beast*'s one mention of the narrator's younger days describes "the bleak walls of the orphanage where [he] learned to coldly calculate the frailties of man."[7] As an orphan, his toughness may well be a survival mechanism, just as his decency is something of a miracle. This self-reliance was idealized even before Hoover championed it, precisely because of the traumatic residue of World War I.

After the war, numerous American soldiers returned to the United States devastated by battle. Even when support for the war effort was high, and even though those terrible losses had led to victory, the effects of a prolonged war were brutal and long-lasting. In fact, the psychic residue of death and violence "over there" permeated America in the decade that followed. Race Williams is not a soldier, but the hard-boiled has always measured its detectives in terms of physical and psychic self-sufficiency, casting the urban scene as its own battlefield. At the outset of *Snarl*, Williams tells us that "for an ordinary man, to get a bullet through his hat as he walked home at night would be something to talk about for years. Now, with me; just the price of a new hat—nothing more." It would have been impossible to read this in 1926 without remembering that for countless ordinary men, including many of Daly's readers, the violence observed during the war was very much something to talk about for years, whether they wanted to or not. The image of a man who could take a bullet through the hat and keep on whistling was an almost impossibly optimistic picture of resilience. Early medical documents portrayed shell shock as a curable, short-term problem, but in reality, many returning soldiers needed long-term help. In 1927, the year in which *Snarl* was published, veterans with neuropsychiatric disabilities constituted almost half of all patients receiving hospital treatment as Veterans Bureau beneficiaries.[8]

To a surprising extent, Race Williams describes his nervous, debilitated clients with the same vocabulary that doctors used during the war in treating their shell-shocked patients.[9] Williams, though, despite the bullets that whizzed past him (or through his hat), boasted of his ease in the presence of immediate danger. Yet he never condescended to those weaker than he. He understood pain and kept his clients company through it, but he could also "kill your enemies for you" because he himself was never undone by the brutal dangers that frightened everyone else. Nor would he

suggest you were surrendering to European paternalism if you needed a helping hand, either financially or emotionally. He is almost like a therapist with a gun, which was a fantastic combination in a decade beset by both war neuroses and organized crime.

Williams's orphanhood underscores his emotional self-sufficiency and resonates with the postwar era. While no one has estimated how many American children were orphaned as a result of World War I, the war indisputably altered the family experience. Orphanages, anachronistic and Dickensian as they can seem to contemporary readers, were not unusual at the time. In the early 1920s, the United States had more than four hundred thousand children either in the care of institutions or under the supervision of child-placing agencies.[10] Some of these placements were the result of the 1918 flu pandemic, which killed fifty million people worldwide, including 670,000 Americans, and remains one of the deadliest disease outbreaks in human history. The image of a disrupted family was endemic to the decade, making the man of courage and decency in the face of constant peril a model for his readers.

Daly's understanding of shell shock may have been partially personal. He was a famously nervous man, claiming to be "Carroll John Daly in the daytime and Race Williams at night," although in his actual life he was by most accounts a hesitant bookworm, agoraphobic, and entirely unfamiliar with guns. As one account would have it, the author, having ventured into Manhattan from his house in White Plains, was unable to find his way home again. According to another, Daly once decided to buy a gun just so he could know, as his character did, what it was like to carry one. On the way home from purchasing the gun, though, he was arrested for carrying a concealed weapon. It is not clear what brought about that arrest, though the first anecdote implies that wandering around bewildered in the street may have had something to do with it. Even the facts of Williams's childhood

could be ascribed to autobiographical details of the author's life. Daly's own youth was thrown into turmoil when he was twelve years old. Both of his parents died of heart failure within three hours of one another, a coincidence remarkable enough to be reported in the *New York Times*.[11] But whereas Williams grew up in an orphanage, Daly was raised by a rich uncle. Even if echoes of the author's personal life do appear in the Race Williams stories, the fact remains that the detective's signature characteristics conformed to what was at a premium in the postwar 1920s: peace of mind amid chaos and blasé resilience in the face of violence.

In his 1985 book *Culture as History*, Warren Susman wrote that the early twentieth century saw a growing interest in the idea of personality rather than character. In Susman's view, a person is assured of "being someone" by cultivating a personality, a crucial enterprise in the "mass society" that the world had become. One creates a personality by "being oneself," but Susman points out the difficulty and potential contradiction inherent in that endeavor: "One is to be unique, be distinctive, follow one's own feelings, make oneself stand out from the crowd, and at the same time appeal—by fascination, magnetism, or attractiveness—to it." This was more or less what the hard-boiled detective did, and he became a sort of cultural celebrity. He balanced the contradiction between standing out from the crowd and appealing to it, and he did this by letting readers leave their troubles behind in an escape to safety. Even Williams's endless monologues satisfied the period's interest in personality, for they gave him a distinctive American voice. He was an individualist, said so, and acted the part. As he says early on in *Snarl*, "Race Williams—Private Investigator—tells the whole story. Right! Let's go." Much of what brought the country together in the mid-1920s was a shared image of American life, disseminated through new widespread technology and popular culture. National advertising, the spread of chain stores, and radio all contributed their part. The Ben Bernie show, Will

Rogers, Sam and Henry, and Father Coughlin were played across the nation. The year 1926 saw the creation of NBC, the year after that CBS. Being a recognizable voice in this expanding public imagination became essential to "being someone." Race Williams was someone who talked a lot, and often, about being someone. As Susman wrote, "Every American was to become a performing self. Every work studied stressed the importance of the human voice in describing methods of voice control and proper methods of conversation or public speaking." As personality imperative coincided with the advent of radio, Race Williams, broadcasting his adventures nonstop from the pages of *Black Mask*, became a "someone" on whom his readers could depend.[12]

Hoover presented "rugged individualism" as a classically American mode of living, and Williams made it compatible with empathic kindness. But there is no denying that the pulp magazine had an almost exclusively white, working-class male readership. It is hard to miss that Williams represented American identity in ways less than warm and all-inclusive. It's no accident that Daly's protagonist is named "Race," or that the beleaguered client in *Snarl of the Beast* is a white European aristocrat, or that most of Daly's damsels in distress are girls from "good families." With the first Williams story, "Knights of the Open Palm," and its focus on the Ku Klux Klan, the hard-boiled is associated with the concept of racial identity right out of the gate. Williams infiltrates the Klan and discusses whether or not he wants to join—he decides not to.

The Klan started as a Confederate veterans' club in Tennessee in 1866. It intimidated and violently acted out against African Americans, Union occupiers, and white Republicans. Despite public accusations of vigilante terrorism, by late 1922 the second Ku Klux Klan had become nothing less than a national mass movement. It targeted Jews and immigrants, as well as African Americans. It engaged in voter intimidation, promoted its candidates,

and, at the 1924 Democratic National Convention, succeeded in defeating a resolution that condemned it by name. In 1925, forty thousand Klan members marched in hoods and robes, carrying American flags, in a public demonstration in Washington, DC. In "Knights of the Open Palm," which appeared in an issue of *Black Mask* dedicated to the Klan, with stories both for and against it, Race Williams explains his reluctance to join: "Of course I'm like all Americans—a born joiner. It just comes to us like children playing. But it wouldn't work with me, it would be mighty bad in my line." The Klan's constitution required oaths of secrecy, obedience, fidelity, and "Klannishness." As Williams elaborates, joining would be "mighty bad" simply because if he were about to shoot someone and that someone showed himself to be a member of the Klan, because of the rules, Williams would have to drop his gun.[13]

As Williams sees it, being a Klansman would not be wrong per se, but it would constrain his freedom of movement. In other words, it would stain him with the sort of interdependence Hoover associated with European socialism. Nonetheless, the casual dismissal with which Williams treats the Klan speaks volumes about the aspirational white self-image the hard-boiled provides. If Race Williams, the "born joiner," is like all Americans, it makes sense that all Americans are like Race Williams—having the option of being one of a group but still choosing his own path. The purpose at hand is protecting Race the individual rather than race the category, but the one blending into the other would not be possible if the character were not white. As Williams also comments: "After all that is said against the Klan, I sure got to admit that there are times when it serves its purpose." Because he is white, he can point out what he considers the Klan's advantages even as he casually mocks it. He sees association with that bastion of murderous whiteness as optional rather than unimaginable or criminal. In hard-boiled fiction, as in the nation at large, being white

is coded as neutral but also superior, as natural but exemplary, as both a precondition for membership in a meaningful collective and for individualism. Only those able to fade into the racial majority have the luxury of choosing to follow their own road. In other words, only those belonging to a group both powerful and invisible have the luxury of associating (or not) with that group. Race Williams, however, implies it is the other way around: that individualism is a choice and that that choice grants social power and enviable toughness. The message appealed enormously to readers in the 1920s. The "born joiner" turns away from Klan membership and can claim a decision both courageous (because immune to white insecurity) and moral (because above white cruelty).[14]

Among other developments, this decade witnessed important advances in women's rights. These included women's suffrage (1920), the election of the first female US senator (1922), the passage of the Equal Rights Amendment (1923), and the election of the first female governor (1924). Women began to sport higher hemlines, cut their hair, and wear makeup. Race Williams neither lamented nor praised these developments but rather talked around them as though they had never taken place. There was something Victorian about his relationships with female characters. The way Williams behaves with women is reminiscent of Victor Hugo's Jean Valjean treating Cosette with paternal care. It is miles away from the smooth seductiveness of Philip Marlowe. As Williams sums it up in one of his stories, adopting some of the creative grammar and incongruous prepositions that so irritated critics: "I can't see nothing to any woman. They won't fit in, in my work." *Black Mask* adopted "The He-Man's Magazine" as its subtitle in the mid-1920s, but Williams's version of this persona was entirely un-amorous. Unlike later chivalric or suave hard-boiled characters, Williams preferred a monasticism that was curiously manic in nature. Ultimately, the distance he maintained between

himself and female characters contributed to the limited shelf life of Race Williams as a protagonist. As the 1920s grew more progressive, readers wanted a more pronounced romantic bent and would soon move to Hammett's Continental Op, who was willing to fall in love and say so. Yet Williams's pure distance, his tendency to engage with women in cartoonish ways, projected a hermetically sealed male world—a world exempt from weakness and need.[15]

On the fronts of gender and race, Race Williams seems to have functioned as a stand-in or righthand man for a disparate group of readers: those who saw the law as corrupt or inadequate; those who feared or admired criminals; those who were bored or harbored mundane resentments; those who nursed white male insecurity or wanted to disavow it. But ultimately, as the decade wore on and Hoover's vaunted individualism ran up against an unprecedented economic crash, the time came for someone who was a little less madcap and who felt the weight of the world a bit more than Williams did. By the end of the decade, a character who plays "both ends against the middle" is still appealing, but Williams's brand of charm was on its way out. Even though he ran through back alleys and knew his way around the tenements of New York City, his well-heeled profile made him a little too Gatsby-esque for the hard-boiled world. (The end of *Snarl of the Beast* shows him collecting a check for his services and spending it on an ocean-liner stateroom.) He was cartoonish, a little too like the superheroes of that era's comic books. It was all well and good to be resilient, but Williams treated death and corruption as sources of amusement. A predator stalking him is "playing the lamb to my little Mary," and later he remarks: "I got the idea that someone might be playing Little Bo Peep through the crack."[16] In "Three Gun Terry," he says: "'All right Mr. Wolf,' I chirped cheerfulike. 'But Little Red Riding Hood and me will trot along.'" As the economic situation became dire and unemployment increased, this

mode of expression sounded precious, more fustian than fearless. It was time for a new detective, this time one with no nonsense, and perhaps no name.

...

The stock market crash of 1929 produced the most dramatic change in economic circumstance during the interwar period in the United States. The Great Depression pushed millions of Americans into unemployment and to (or over) the brink of starvation. Given these changes, it seemed natural for the tide of popularity to turn toward a hero a little less indestructible than Williams, less assured of success—and without a valet. His inexhaustible physical power and skill at taking down the enemy found a new home in the world of fantasy across movies and comic strips. It is no coincidence that the Depression era saw the rise of various superheroes: the Shadow and Dick Tracy (1931), Doc Savage (1932), Flash Gordon (1934), and the Green Hornet (1936). The end of the decade produced Superman (1938) and Batman (1939). And although the hard-boiled detective and comic strip hero shared many traits—both playing the part of the social savior—the American public did not want to see a real person glide above the worries of the world. They had that in Herbert Hoover and in an oblivious upper class whose speculations had caused the market to crash. The public needed someone consistently grounded in human reality, and Dashiell Hammett's Continental Op brought the character to a new, Depression-appropriate level.

Born in 1894 in southern Maryland, Dashiell Hammett left school at the age of fourteen and took up a series of jobs. At twenty-one, he joined the Pinkerton Detective Agency, where he worked for seven years, becoming the only hard-boiled writer who had worked as a detective himself. As Nolan recounts in his history of *Black Mask*, Hammett had run up against swindlers, safecrackers, forgers, blackmailers, and even murderers. As a Pinkerton operative, Hammett learned the vocabulary of the trade and wrote in

the language of people with whom he had come in contact. He offered the audience two main characters, the Continental Op and Sam Spade. Sam Spade is the principal detective in Hammett's third and best-known novel, *The Maltese Falcon*. The Continental Op is his most frequently recurring character, appearing in thirty-six stories between 1923 and 1930. Hammett revised four of those stories into his first novel, *Red Harvest* (1929), and four more into his second, *The Dain Curse* (1929). In many ways, Sam Spade is the most iconic of Hammett's characters. Hammett himself felt that *Falcon* was "by far the best thing [he had] done so far," and a 1941 film version featuring Humphrey Bogart as Sam Spade made the novel's fortunes. Hammett himself has been described as tall and elegantly dressed, and Sam Spade as looking "rather pleasantly like a blond Satan." The Continental Op is much less camera-ready. Overweight and weary, he is an overworked, middle-aged detective living on hard liquor and no sleep. Spade's story is narrated in the third person; the Op narrates his own. If Sam Spade is the star of the show, the nameless Op is the camera itself, the steady, disillusioned, but nonetheless reliable narrator of numerous unpleasant walks of life.[17]

In November of 1927, when the first installment of *Red Harvest* was published in *Black Mask*, the stock market crash was still two years away, and the United States was on an economic and technological rise. Charles Lindbergh had made the first nonstop transatlantic flight. Talking pictures emerged with the debut of *The Jazz Singer*. The NBC radio network had twenty-four stations. Far from riding the ascendant wave, the Op acted as a sort of sardonic tour guide, pointing out people and places you would probably never get to meet or see and wouldn't like very much if you did. *Red Harvest* opens with a searing and disheartening account of the detective's assignment to clean up a corrupt city. "I first heard Personville called Poisonville by a red-haired mucker named Hickey Dewey in the Big Ship in Butte. He also called his

shirt a shoit. I didn't think anything of what he had done to the city's name. . . . A few years later I went to Personville and learned better."[18]

Americans were certainly aware of government corruption, but the idea of an entire city of schemers in murderous survival mode was a stretch even by Prohibition-era standards. Hammett had spent time in Butte, Montana, on which Poisonville was based, and had run into some of the unsavory sorts who populated his novel. He even claimed to have been himself hired to murder a union organizer in Butte, and although this account is probably untrue, he did encounter many shady people and circumstances. When he mentions the Big Ship—what Butte miners called the city's largest boardinghouse—he is talking about a place he had seen as a Pinkerton operative.

Still, before 1929, cynicism and despair were the province of marginal characters, not the normal American condition. In the wake of the stock market crash, economic desperation and disillusionment became the broader American experience. During the last week of October 1929, the stock market lost 40 percent of its value. Individuals and businesses lost their investments, and this included account holders not even aware that banks had been investing their money. By 1933, the value of stock on the NYSE was less than one-fifth of what it had been at its peak in 1929. One-quarter of Americans were unemployed. The historically marginal experience of ongoing unemployment—a little more than 3 percent in 1929—ceased to be marginal.[19] What shell shock had been to soldiers returning from World War I, unemployment and economic insecurity were to the Depression-era middle and working classes. Nearly 50 percent of children in the Great Depression were deprived of adequate food, clothing, shelter, education, and medical care. Soup kitchens multiplied. In a time of widespread poverty and unemployment, hardship and improvisation became a way of life.

In his 1944 article "The Simple Art of Murder," Raymond Chandler praises Hammett for creating the realistic detective: "Hammett gave murder back to the kind of people that commit it for reasons, not just to provide a corpse. . . . He put these people down on paper as they are, and he made them talk and think in the language they customarily used for these purposes. He had style, but his audience didn't know it, because it was in a language not supposed to be capable of such refinements." When Chandler writes "these people," he acknowledges the class tensions of the Great Depression. Vigorous speculation and laissez-faire capitalism opened unimagined possibilities for wealth, tilted money into the hands of the rich, and ultimately sharpened income inequality. Indeed, by 1930 the richest 1 percent of Americans owned 40 percent of the nation's wealth. (By comparison, in 2016, it was 35 percent.)[20] So although the Great Depression made unemployment a common experience in the 1930s, the enrichment of the upper classes at the expense of the lower classes was not a new phenomenon. The rich in America lost money in the market crash, of course, but the fact remains that the upper classes suffered much less by comparison. What is more, many wealthy people who had been spared the ravages of the Depression did not hesitate to show it, dressing as ostentatiously in 1931 as they had in 1928. The lower class, understanding that the financial dealings of the rich had caused the crash in the first place, was resentful. And readers of *Red Harvest* and the subsequent *Dain Curse* understood this new, harsh, class-conscious reality. The fact that Hammett had left school at fourteen and moved around the country, and that his Op rode around the country solving cases with varying degrees of success, resonated with the itinerant existence that was commonplace during the Depression. The Op was no rail-riding hobo, but he did wander from one case to another, as weary and cynical as any of his real-life contemporaries.

The Continental Op was not good-looking, nor did he dress well. What he did provide the public was a model of cool survivalism. He meets people and society on their own terms, solves the crime, collects his check, and shows up again the next day. He sets himself apart with words, elevating an entire class of muckers—Big Ship residents, miners, criminals, drunks, and get-over artists—to a sort of lyricism. In a language that was not supposed to "be capable of such refinements," he demonstrates that there are things more important than elegance. Therein lay the stark poetry of the unrefined. Where Williams said "my ethics are my own," the Op could demonstrate without saying it that his point of view was his own. In this sense the Op was in line with an American tradition of frontier narrators that began with James Fenimore Cooper. His particular brand of plain speaking read like a revindication of the poetry of the unsophisticated. As John Dos Passos put it in the prologue to his famous 1930s *U.S.A.* trilogy: "U.S.A. is a set of bigmouthed officials with too many bank accounts. U.S.A. is a lot of men in their uniforms buried in Arlington Cemetery. U.S.A. is the letters at the end of an address when you are away from home. But mostly U.S.A. is the speech of the people."[21] The upper classes may have had their criminals but none with such names as Bluepoint Vance, Spider Girrucci, Donkey Marr, and Happy Jim Hacker. These came directly from Hammett, who described himself as one of the few "moderately literate" people who took the detective story seriously and hoped that someone would make literature of it. This was a new phenomenon in detective fiction: making rough and improvisational existence seem privileged by perceiving and experiencing things other people couldn't. So it is that in the very opening lines of *Red Harvest*, the Op—who claims no formal education—expresses dark amusement at words themselves. His jokes about Poisonville, his comments on the dictionary, and his coining of the term blood-simple (which lived on to become the title of the first Coen

brothers movie in 1984) are as much a part of his legacy as the drink and the cigarette. And they became integral traits of the hard-boiled detective character.

Since the Op claimed no physical or emotional mastery of his environment, he relied on mental acuity and a resilient attitude. In *Red Harvest*, he admits, "This damn burg's getting to me. If I don't get away soon I'll be going blood-simple like the natives." But even if the burg is getting to him, he is always far enough ahead of it to come up with sentences like these. His mind is his own, and he takes the time to show that not only were marginal characters capable of a clever phrase; they were also capable of independent thought. Unlike Race Williams, who narrated without stopping and delivered such sound bites as "the opinions of others don't interest me," the Op paused to think and to say that he was thinking. Those moments were important because they showed that he had an inner life solid enough to withstand the onslaughts of the outside world. If your ethics being your own was not enough to put food on the table, or if your house or pantry could not be your own, at least your mind, your thoughts, your imagination remained your own. The Op defended that independence. In *The Dain Curse*, when the morphine-addled Gabrielle recounts that she has a hard time thinking, that a "fog" gets between her and her thoughts, and that it happens again and again, the Op responds: "It sounds normal as hell to me. Nobody thinks clearly, no matter what they pretend. Thinking's a dizzy business, a matter of catching as many of those foggy glimpses as you can and fitting them together the best you can. That's why people hang on so tight to their beliefs and opinions; because, compared to the haphazard way in which they're arrived at, even the goofiest opinion seems wonderfully clear, sane, and self-evident."[22] This musing lets us know that just making it through the day, with some combination of random invention and denial, was the way of the world, the way of all people. That sentiment was particularly

sustaining during the Depression, when the outside world was beyond one's control. Compared with Race Williams, who leapt from one action scene to another, narrating all the while, the Continental Op stories contain a lot of waiting. He waits in cars for the suspect to appear, in hotel lobbies for a guest to descend, in a bar with no one to talk to. While there, he thinks and observes. At a time in American history when waiting in breadlines and at soup kitchens had become a common experience, the Op's ability to wait and be bored without losing face—and without losing his empathic, no-nonsense understanding of desperation—gained a new and enhanced currency.

During his 1928 campaign, Herbert Hoover had described America as needing to choose between "rugged individualism" and "paternalism and state socialism." Like Warren Harding and Calvin Coolidge before him, Hoover did not believe it was the job of the federal government to support the needy. He asked state governments to embark on public works and large companies to keep worker pay stable, but neither measure required compliance with his requests. He called Wall Street speculation "crazy and dangerous" but stopped short of demanding either the distribution of aid or even accountability. Individual responsibility sounded good in the abstract. It was part of the American fabric and was celebrated in the 1920s hard-boiled fiction much as it had been in the frontier stories of the nineteenth century. But it was impractical in the absence of reliable employment. With no reasonable means of supporting oneself, what good was individualism? Consider Race Williams's statement "My ethics are my own," which meant something in the era of Prohibition, gun-control laws, and police brutality. If Williams had been unemployed and struggling, "My ethics are my own" would amount to little more than an admission of desperation. In October of 1931, Hoover restated his resistance to government aid: "No governmental action, no economic doctrine, no economic plan or project can replace

that God-imposed responsibility of the individual man and woman to their neighbors. That is a vital part of the very soul of a people."[23] This indirect criticism of socialism had subtly but crucially changed since Hoover first delivered a version of this message in 1928. He no longer claimed that individuals had no need of help. That would have been ridiculous in 1931. But he was determined that the government would not be the one to do the job. Rugged individualism was replaced by stoic neighborliness.

The Op was a good neighbor because unlike the wealthy who wore expensive clothes in the midst of others' misfortune, he himself was never exempt from discomfort. The Depression brought with it a great deal of physical hardship, and the Op novels illustrated it. This went over well in the worst economic downturn in American history. The Op's salient quality is not in living the dream or in doing what every reader would love to do but rather in the opposite—retaining his perspective while he does what the public doesn't want to do but is forced to do. In *The Dain Curse*, he lumbers down a ravine in search of a body, "stumbling, sliding, sweating and swearing." "Water squnched [*sic*] in my torn shoes. I hadn't had any breakfast. My cigarettes had got wet." And in "The Tenth Clew" (1924), after being knocked into the San Francisco Bay and almost drowning: "Half an hour later, shivering and shaking in my wet clothes, keeping my mouth clamped tight so that my teeth wouldn't sound like a dice-game, I climbed into a taxi at the Ferry Building and went to my flat. There, I swallowed a half a pint of whiskey, rubbed myself with a coarse towel until my skin was sore, and, except for an enormous weariness and a worse headache, I felt almost human again." The Op's durability is hardly new. In "The Golden Horseshoe," also from 1924, he recounts, "The fifteen years that had slid by since then had dulled my appetite for rough stuff."[24] If Race Williams had been an improbably enthusiastic tough guy, the Op is just tired, poorly dressed, and overweight. Yet there is no trace of self-pity in his

words; he is still on top of his game, such as it is, and continues to solve crime.

What sets the Op apart from most other hard-boiled detectives—like Race Williams, Sam Spade, and Philip Marlowe—is that he is not his own boss. He has a nominal employer, the Continental Detective Agency, and an even more nominal boss, its director, the "Old Man." In *The Big Knockover*, he says of the director, "Fifty years of crook-hunting for the Continental had emptied him of everything except brains and a soft-spoken, gently smiling shell of politeness that was the same whether things went good or bad—and meant as little at one time as another." The company is more or less abstract and invisible. It's not for nothing that the Op and the director remain nameless. Because of this, and because of the company's complete moral neutrality, the entire Continental operation functions as a metaphor for daily life. It's a metaphor, in other words, for doing what one has to do, fatigued and in ill-fitting shoes, once the promise of success through personality had fallen by the wayside. Yet the company does provide a consistent salary, always desirable and something of a dream during the Great Depression. Being part of a company also ensures the neighbors are watching out for you. You're not completely isolated. In *The House in Turk Street*, when some bad actors have the Op tied up and talk about killing him, one man points out, "He is a Continental operative. Is it likely that his organization doesn't know where he is? Don't you think they know he was coming up here? And don't they know as much about us—chances are—as he does? There's no use killing him. That would only make matters worse."[25] The Continental Op was an ideal hard-boiled detective for a historical era that had grown out of the self-sufficiency Hoover's 1928 exhortation demanded. The masses had not yet met the New Deal that would rescue them. It wasn't complete isolation and autonomy that made someone hard-boiled. It was the toughness and willingness to show up no matter how dire the circumstances.

Ultimately, detectives did usually get themselves out of difficult situations, but they didn't need to do it all alone. And on that score the Op managed to hold up a hard-boiled mirror to the entire country.

A middle-aged hero who did society's dirty work on very little sleep, who showed up whether he wanted to or not, who was seemingly indifferent to solitude and the absence of support yet willing to pursue the rich and hold their feet to the fire—this wasn't a person whose daily life Americans envied but someone they wanted on their side. And, as it turned out, it was the sort of person more and more Americans were forced to be. According to Hoover's 1931 address, people should support each other, as well as themselves, even though the government would remain out of the picture. The American people ultimately took a dim view of this exclusion. In 1932, they elected Franklin Roosevelt, who promised to put the government in the role of world neighbor and, more importantly, in the role of shouldering the improvement of the country's economic fortunes. In his inaugural address, Roosevelt was as clear about the glum state of the nation as Hammett had been about the corruption in 1920s Montana: "This is preeminently the time to speak the truth, the whole truth, frankly and boldly. Nor need we shrink from honestly facing conditions in our country today," he declared. He proclaimed that all we have to fear is fear itself but also admitted unequivocally that "a host of unemployed citizens face the grim problem of existence, and an equally great number toil with little return. Only a foolish optimist can deny the dark realities of the moment."[26]

The same dark realities Roosevelt found in the country's economy, the Continental Op found in Personville. But Roosevelt was president, able to be both neighbor and leader, to introduce the New Deal measures that would rescue the country from further prolonged economic disaster. Grouping the entire US population into one unit, he claimed, when accepting the Democratic

nomination, that danger to one is danger to all and that credit groups are interrelated. Unlike Hoover, who had been content to let economic catastrophe trickle down to the lower classes, Roosevelt saw the entire country as implicated in the downturn. So, too, did the Op, who "faced the grim problem of existence" and the "dark realities of the moment" on a daily basis. He believed that prominent families were just as involved—perhaps more so—as street-level grifters. Cultural realities and the involvement of the upper classes became still grimmer and darker in the years just after *Red Harvest* was published as a novel. The Op couldn't do much about the corruption and murders that surrounded him, but he could "speak the truth, frankly and boldly." His reports from Personville were like fireside chats from someone who didn't have a fireplace and wasn't sure he'd ever get the chance to sit by one.

Hammett's writing career was brilliant but short: the author more or less stopped writing in 1934, derailed by alcoholism and depression. The fact that his publications spanned the criminal 1920s and the postcrash years connected him in the American mind with that historical period and thus with American toughness. Straddling the Depression, the Op stories chronicled someone who made his own rules, drank a lot, and established networks around the country, facing enemies with no-nonsense resilience. Eminently practical, he was wittier than those ten times as rich as he. As the Depression lifted, and, more importantly, as America prepared to step onto the world stage, another author took Hammett's place: Raymond Chandler.

...

When Roosevelt became president in 1933, he brought renewed optimism to a beleaguered nation. Although economic conditions in the United States worsened between his election and his inauguration four months later, his initiatives saved millions of Americans from ruin and starvation. After his first fireside chat, in

which he assured Americans that their bank accounts were secure, they returned almost a billion dollars to those accounts. In 1933, Americans saw the creation of the FDIC and the SEC, as well as such public relief programs as the Civilian Conservation Corps and the Federal Emergency Relief Administration. In 1935, Roosevelt introduced new measures intended to provide a basic social safety net for all Americans. The Works Progress Administration employed three million Americans. In the same year, the National Labor Relations Act and the Social Security Act came into being.[27] Ultimately, however, it was World War II that ended the Great Depression. And the war would, in the end, do even more for the nation: it established the US as a global economic and military superpower. This evolution demanded another order of detective, one grounded enough to have come through the Depression and sophisticated enough to represent America on the world stage.

Today, Raymond Chandler is generally considered the most important writer of modern American detective fiction. He published short stories in the early 1930s with principal characters later renamed "Marlowe" when those stories appeared in book form, but the actual Philip Marlowe first appeared in *The Big Sleep* in 1939. Marlowe returned in *Farewell, My Lovely* (1940), *High Window* (1942), *The Lady in the Lake* (1943), *The Little Sister* (1949), and *The Long Goodbye* (1953). Chandler created Marlowe according to the mold he would set down later in "The Simple Art of Murder": "He must be, to use a rather weathered phrase, a man of honor—by instinct, by inevitability, without thought of it, and certainly without saying it. He must be the best man in his world and a good enough man for any world." Philip Marlowe was as sanguine about danger and pain as the Op had been, but he was more suave, sophisticated, and camera-ready. When the gargantuan Moose Malloy takes hold of him at the start of *Farewell, My Lovely*, Marlowe notes, "A hand I could have sat in came out of the dimness and took hold of my shoulder and squashed it to a

pulp. . . . I wasn't wearing a gun. . . . The big man would probably take it away from me and eat it." One element that set Marlowe apart was his dedication to principle and honor. Another was his much-vaunted talent for metaphor. When we read at the start of *Farewell, My Lovely* that Moose Molloy was "about as inconspicuous as a tarantula on a slice of angel food" or that Helen Grayle is a "blonde to make a bishop kick a hole in a stained-glass window" or, in *The Long Goodbye*, that "I belonged in Idle Valley like a pearl onion on a banana split," we know Marlowe is prepared not only to put his hands on criminals but to take American irreverence to new levels. His talent for insult was unsurpassed. In *The High Window*: "From thirty feet away she looked like a lot of class. From ten feet away she looked like something made up to be seen from thirty feet away."[28] Even when he didn't have the last word, he always had the last thought.

America had not yet entered World War II at the time that Chandler published *The Big Sleep*, which begins with the investigation of a blackmailing scheme and proceeds to the murders of various people connected to the wealthy Sternwood family. In the novel, Marlowe is the classic hard-boiled outsider, an honest wisecracker in the midst of the corrupt and cosseted rich. But the tide of American neutrality and isolation was beginning to turn, and successive Chandler publications traced its movement through World War II. Historical placement is important. It wasn't for nothing that the American detective was living by his principles. Doing the right thing would cast America as a superpower on the world stage.

In 1940, when Chandler published *Farewell, My Lovely*, Roosevelt gave another fireside chat, insisting that the hatred invading Europe also threatened the United States. In 1941, before the bombing of Pearl Harbor, Roosevelt emphasized that American duty was to come to the aid of the world's defense of democracy. (It might not be a coincidence that Marlowe is called a "solitary,

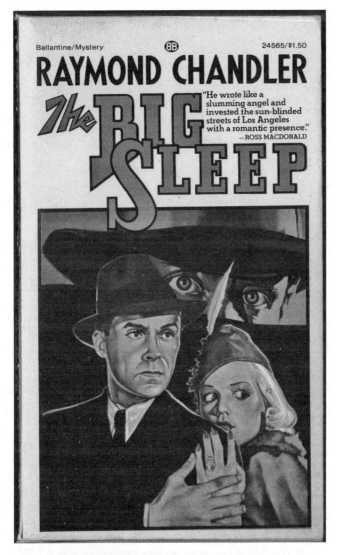

Raymond Chandler published *The Big Sleep* in 1939. It was the first novel to feature detective Philip Marlowe.

questing knight" by more than one critic.) Roosevelt committed "full support of all those resolute peoples, everywhere, who are resisting aggression and are thereby keeping war away from our Hemisphere." He promised "that principles of morality and

considerations for our own security will never permit us to acquiesce in a peace dictated by aggressors and sponsored by appeasers. We know that enduring peace cannot be bought at the cost of other people's freedom." Seven months later, when a German submarine fired on an American destroyer near Greenland, he announced that the time had come for active defense, comparing Nazis to a rattlesnake poised to strike. But it was not until the Japanese attack on Pearl Harbor in December of 1941 that he declared the US "in the midst of a war, not for conquest, not for vengeance, but for a world in which this Nation, and all that this Nation represents, will be safe for our children."[29]

Chandler's Marlowe sees his role much as Roosevelt sees the role of the United States—as a tough and principled entity ready to step into the fray and right moral wrongs. Furthermore, in Chandler's novels and in the global arena, the fray was situated among the vaunted and venerable families connected across Old Europe. Marlowe embodies a tireless and infinitely competent America. Whereas the United States was understandably committed to self-defense, Marlowe never focuses on protecting himself. Even when threatened, he is still more interested in protecting the client than in sheltering himself. He offers General Sternwood his money back when he feels he's done an inadequate job and tells another client that because he's getting "a hundred dollars for doing nothing," he should take the beating that his client fears. Marlowe is like a walking embodiment of Roosevelt's boldest public discourse, both in content and in candor.[30]

In all of the Marlowe novels, a principal plotline follows the honest, no-nonsense detective facing the corruption and guilt of an upper class. But something else is going on in Raymond Chandler's writing, namely the drama of plain-speaking America meeting a time-honored but deteriorating Europe. The message that comes through all the novels is not only that the rich need the working class to keep them honest. It claims that the most

venerable European sophistication can be undone without a strong dose of lowbrow American toughness. In a book about the hard-boiled detective as an embodiment of New Deal liberalism, Sean McCann writes that "everywhere in the worlds of American art and literature, the idea of cultural eminence" was being replaced by the dominance of what was democratic and popular.[31] It had long been the role of the hard-boiled American detective either to achieve what "cultural eminence" could not or to show that such eminence was overrated, maybe even ridiculous. Basically, he created a particularly American humanism, constructed on a foundation of instinct and courage. Consider Race Williams's pride at having an "ethics of his own," without regard for law or education. Consider the Continental Op, hired by Donald Willsson, who "had lived in Europe most of his life," to clean up Poisonville. Willsson is murdered in the first chapter, and the Op takes over as best he can. It's no surprise that American hard-boiled fiction since World War II has been consistently popular in Europe because it stands on the sort of humanism that Europe tends to both admire and condemn. It operates on the principle that the most valuable truth is the truth one *knows* rather than one that must be learned. This contrasts with traditional humanism and corresponds to a storied American frontier tradition of the clever, resourceful anti-intellectual.

The image of the hard-boiled American diplomat poised not just to confront but also to *rescue* a troubled Europe was understandably appealing during the war years. Raymond Chandler was in a particularly good position to create an American champion who would appreciate but not venerate a troubled Old Europe. He combined the intellectual disdain of British detective authors with the street lexicon of Dashiell Hammett, and he understood what American straightforwardness meant to Europe, as well as what European decline could mean to America. The son of an Irish mother and an American father, Chandler was born in

Chicago but moved at the age of seven to Ireland after his alcoholic father abandoned the family. Thanks to a wealthy but arrogant and unpleasant uncle, he entered the Dulwich public school in London at twelve—the same school that had educated the comic writer P. G. Wodehouse and the explorer Ernest Shackleton. At sixteen, Chandler was withdrawn from Dulwich and sent to the Continent, where he spent six months in Paris and six months in Munich and Freiburg. He returned to England trilingual and passed the 1907 civil service exam with great success, obtaining a job at the Admiralty but quitting after just six months. In 1912, at the age of twenty-four, with dual nationality in hand, Chandler returned to America. He made his way across the country and settled in Southern California.

When World War I broke out, Chandler left his home in Los Angeles, went to British Columbia, and enlisted in the Canadian Army. In 1918, he was sent to France. His battalion was in a reserve position but nonetheless saw considerable action. In June of 1918, an onslaught of German shells killed everyone else in his company, leaving Chandler the only survivor. He returned to Vancouver and made his way down the western coast of the United States, returning to Los Angeles in 1919. He never wanted to talk about the war, but various critics have remarked that his writing contains the impact of that experience.[32] He never returned to Europe and spent the rest of his life in Southern California.

Chandler continued to look at the United States with an amused familiarity characteristic of the international traveler. His letters reveal that he devoted a great deal of thought to Americans as a people and to American character. As his biographer, Frank MacShane, put it, Chandler's "American sense of freedom made him ridicule the rigidities of his relatives, but he was by no means free of snobbery himself." He consistently directs a classic dismissiveness toward the American people but admires the boldness of a population unfettered by tradition: "If their education has little

sharp positive value, it has not the stultifying effects of a more rigid training." He described the American people as a group of wild cards, connected by nothing so much as the individualism of their own natures: "Americans have no manners as such; they have the manners that arise from their natures, and so when their natures are sweet they have the best manners in the world." He retained a particular disdain for and curiosity about the Golden State. In a statement whose mention of cars seems to point to California, he wrote: "I like people with manners, grace, some social intuition, an education slightly above the *Reader's Digest* fan, people whose pride of living does not express itself in their kitchen gadgets and their automobiles."[33]

From his vantage point as a British-educated Anglo-American, Chandler trained both acerbic criticism and an admiring glance on the United States. From his vantage point as a resident of Southern California, he pined for the Europe of his youth and realized that it was in trouble. Several months after the publication of *The Big Sleep*, Chandler wrote in a letter to a fellow *Black Mask* writer: "I like a conservative atmosphere, a sense of the past. I like everything that Americans of past generations used to go and look for in Europe, but at the same time I don't want to be bound by the rules."[34] The Europe of 1939, however, was most emphatically not the Europe that past generations had visited seeking something that could not be had in the US. On the contrary, it was a continent succumbing to totalitarian control, a continent on the verge of needing full-blown American intervention. Chandler was aware of this, writing to his publisher in 1939 that his efforts to keep his mind off the war had "reduced him to the mental age of seven,"[35] which as it happens was the age at which Chandler had moved with his mother from Nebraska to England. Marlowe stands for the changes World War II brought to national roles, positioning America as leading the charge against European vulnerability and denial.

Philip Marlowe actually orchestrates a sort of historical sleight of hand wherein America becomes the embodiment of toughness and Europe reclaims the status it had when "past generations used to go and look." But American military dominance—and the fact that it came to be known worldwide—arose in response to the Nazi invasion of Europe—in other words, precisely in response to the destruction of what Americans of past generations had gone there looking for. When Hoover denigrated European socialism in 1928, Europe had stood for a paternalism that was less disastrous and murderous. Chandler's 1943 letter mentioning the "stultifying effects of a more rigid training" similarly recalled the Europe of his youth and education—the one to which he would naturally retreat when "reduced to the mental age of seven." *That* Europe is the one preserved in the Marlowe novels.

One critic wrote that "the name Philip Marlowe . . . from first name to final 'e' connotes Englishness, Elegance, and Establishment." But just like Chandler, the detective holds himself apart from European stultification and self-conscious superiority. Nor does he actually embrace cultural elitism, or "cultural eminence." In *The Long Goodbye*, Marlowe comments: "The French have a phrase for it. The bastards have a phrase for everything and they are always right. To say goodbye is to die a little." As with numerous remarks in the Marlowe corpus, this phrase manages both an urbane affinity with Europe and disdain for its pretentiousness. It announces that Marlowe is worldly enough to be familiar with the French idiom and poetic enough to admire it, irreverent and American enough to call the French "bastards." Chandler mentions Europe often in his novels, always as the sort of place one could go looking for sophistication and high culture. In *Farewell, My Lovely*, comparing the Stillwood chief of police to "Richelieu behind the arras" gives us a France immersed in the pleasantries of Old Regime court life, not one on the verge of occupation. Another character in that novel imagines Marlowe hosting a dinner

party, "with your charming light smile and a phony English accent like Philo Vance." The last novel in which S. S. Van Dine's Philo Vance appeared came out in 1939, which marked the start of the war, as well as publication of *The Big Sleep*. Vance was a foppish dandy, more or less the sort of insubstantial crime fiction personality that Chandler would ridicule in his 1944 essay. Marlowe understands that a dog in *The High Window* named Heathcliff is named for the male lead in Emily Brontë's *Wuthering Heights*, but he also realizes that a rich person gave the dog a highfalutin name. Marlowe can talk a Europhile game and be trusted by clients, but he is fundamentally a no-nonsense cultural ambassador, reminding the world that European sophistication is now in American hands.[36]

Chandler was certainly no socialist. In a 1947 letter to his editor James Sandoe, he describes a screenwriter who was the "last put out by the lefties; they were busted out at the national election. Please don't imagine them are my views." He warns that he and Sandoe "perhaps had better leave politics alone, since I am the reactionary type, who thinks the only reason Uncle Dugashvili has no extermination camps is that he is still trying to find out how to get 50,000 miles out of a truck without greasing it." Socialist collectivism is undesirable and American magnanimity is cast as a positive force. At various points in his novels Marlowe uses the chivalrous vocabulary he introduced on the first page of *The Big Sleep*, when he goes up the stairs of the Sternwood mansion and notices a "broad stained-glass panel showing a knight in dark armor rescuing a lady who was tied to a tree and didn't have any clothes on but some very long and convenient hair." But instead of knocking down sinister Europeans, as Race Williams did, Marlowe is concerned with keeping their paternalism benevolent. At the end of *The Big Sleep*, he points out that Sternwood's innocence is preserved: "I was part of the nastiness now. . . . But the old man didn't have to be. He could lie quiet in his canopied bed, with his

bloodless hands folded on the sheet, waiting."[37] Ultimately, neither America nor Chandler has ceased to be ruggedly individualist, but their individualism serves a global purpose: to usher in the character of a chivalrous America.

As World War II ended the Great Depression, it also introduced a period of dedication to the military cause of rationing and privation. In the early 1940s, American industry was in full war-production mode. In February of 1942, the government ordered that consumer automobile production be stopped so that those factories could devote themselves to military manufacturing. And, indeed, the automobile industry was instrumental in the Allied victory, mass-producing cars, tanks, guns, helmets, helicopters, and bombs. The combination of mass production and the automobile industry created the military industrial complex and came to contribute to American victory. After the war, automobile factories returned to making automobiles for consumer sale and launched what we might call the consumer industrial complex. So when Chandler wrote in 1939 that he liked people whose "pride of living does not express itself in their kitchen gadgets and their automobiles," he was actually speaking in advance of the golden age of cars and gadgets. He mocked American consumerism as it came into being. When in 1940 he described a villain as being about as inconspicuous as a tarantula on a slice of angel food, he could not have known that in 1945, Betty Crocker would be just about the most famous woman in America, second only to Eleanor Roosevelt. When he described cars being driven around the streets of Los Angeles, he anticipated a car culture (and an enthusiasm for car purchasing) that would explode after the war. This was the postwar America that was primed to come into being. Fast food emerged in the 1940s, with McDonald's and Dairy Queen both opening in 1940.[38] The sale of processed food increased: M&Ms, Cheerios, instant coffee, instant mashed potatoes, concentrated juice, and instant cake mix. Nylon was

introduced in 1940 and laid the grounds for an increasing embrace of synthetic materials. As for kitchen gadgets, the 1940s saw the advent of the garbage disposal, the dishwasher, Tupperware, and aluminum foil. Chandler and his fictional Marlowe derided American materialism while it was still on the rise. Yet Marlowe became an American classic because he grasped how much Americans cared about looking good. His ironic awareness (he was a resident of Southern California, after all) set him up—just in time for the 1950s—as a cool commentator on the American obsession with appearances.

Raymond Chandler published at a time in American history defined by the visual. Photojournalism exploded during the mid-1930s and continued during the war, with the Farm Security Administration hiring photographers to chronicle the lives of midwestern farmers and Henry Luce launching *Life* magazine in 1936. Historical memory of the Great Depression and World War II is largely formed by pictures: Dorothea Lange's photos of migrant laborers, Arthur Rothstein's dust bowl pictures, Joe Rosenthal's image of the flag planted at Iwo Jima. The 1940s belonged to the Golden Age of Hollywood, with the production of *Gone with the Wind* (1939), *Citizen Kane* (1941), and *Casablanca* (1942). Not surprisingly, the rise of film noir found its place in the history of the American hard-boiled: John Huston's 1941 *The Maltese Falcon* and Billy Wilder's 1944 *Double Indemnity* (cowritten by Wilder and Chandler) were box office favorites. When Howard Hawks made *The Big Sleep* into a movie in 1946, he cast Humphrey Bogart—who had played Sam Spade in Huston's *Maltese Falcon*—in the role of Marlowe.

As if in anticipation of visual culture, Marlowe showed himself to be image-conscious while giving a sardonic nod to the ultimate emptiness of images. As Hitler invaded Poland in 1939, Marlowe walked up the stairs to meet the wealthy General Sternwood: "I was wearing my powder-blue suit, with dark blue shirt, tie and

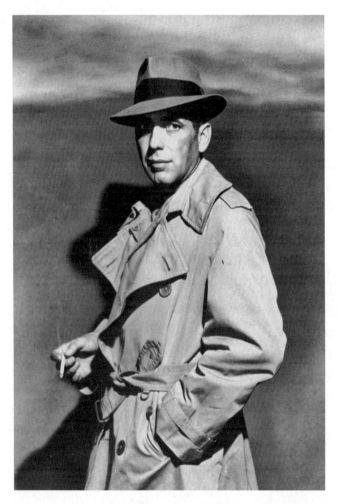

John Huston cast Humphrey Bogart as Sam Spade in his film adaptation of Dashiell Hammett's *The Maltese Falcon* (1941). Bogart also played Philip Marlowe in *The Big Sleep* (1946). These are characters many people picture when calling to mind the iconography of the hard-boiled detective.

display handkerchief, black brogues, black wool socks with dark blue clocks on them. I was neat, clean, shaved and sober, and I didn't care who knew it." Later, when he discovers Carmen Stern-wood's address, he observes that hers was a "nice neighborhood to have bad habits in," pointing out—once again—that visual

images could be manipulated. For Chandler, who had the jaundiced vision and acerbic intelligence of a malcontent alcoholic, fancy closed doors didn't conceal the decay behind them; that decay was right out in front. Some of his best metaphors are about visual disgust, about turning the familiar into the grotesque: "a face like a collapsed lung," "a face like a bucket of mud," "a face long enough to wrap twice around his neck."[39] In Chandler's hands, American life itself turned into a sort of film noir.

As the end of World War II gave way to an increase in consumer spending, the class imbalance of the Great Depression shifted. Postwar America was the era of the middle class: the GI Bill provided returning veterans with funds for homes and education. The 1960s saw an explosion of credit cards. Marlowe's irreverent focus on the well-heeled echoed two important though contradictory trends in American culture: resentment of the rich and an embrace of materialism. One could say that resentment of the rich was a prewar derivative and materialism a postwar consequence. Americans had not forgotten the Great Depression. The wealthy families who committed crimes in hard-boiled novels and paid someone to conceal them are dramatic versions of the wealthy who strolled past breadlines in expensive clothes. For Marlowe, there was something suspect about wealth and something sinister about those who pursued it.[40] Maybe because of this, he is at his most poetic when describing the down-and-out. In *The High Window*, as Marlowe sets out to visit George Anson Phillips (he will find him murdered), he describes the section of town where Phillips lives: "They are all rooming houses now, their parquetry floors are scratched and worn through the once glossy finish and the wide sweeping staircases are dark with time and with cheap varnish laid on over generations of dirt. In the tall rooms haggard landladies bicker with shifty tenants. On the wide cool front porches, reaching their cracked shoes into the sun, and staring at nothing, sit the old men with faces like lost battles."[41]

Although written in 1942, this passage reveals unmistakable reminders of the Great Depression. "Lost battles" evokes the current war in Europe, as well as the poverty-induced world-weariness Steinbeck recounted in *The Grapes of Wrath*. Marlowe puts himself squarely on the side of the working class, telling us that he is trying to get the two nickels in his pocket to mate and describing his office as shabby. This is a clear critique of materialism. Chandler wrote in 1956, "Los Angeles is no longer my city, and La Jolla is nothing but a climate and a lot of meaningless chichi."[42] Southern California might have led the nation in "meaningless chichi," but postwar consumerism set it on its way to being a broad American phenomenon. In *The Long Goodbye*, he gives a multimillionaire a serious monologue about mass production and consumerism:

> In our time we have seen a shocking decline in both public and private morals. You can't expect quality from people whose lives are a subjection to a lack of quality. You can't have quality with mass production. You don't want it because it lasts too long. So you substitute styling, which is a commercial swindle intended to produce artificial obsolescence. Mass production couldn't sell its goods next year unless it made what is sold this year look unfashionable a year from now. We have the whitest kitchens and the most shining bathrooms in the world. But in the lovely white kitchen the average [person] can't produce a meal fit to eat, and the lovely shining bathroom is mostly a receptacle for deodorants, laxatives, sleeping pills, and the products of that confidence racket called the cosmetic industry. We make the finest packages in the world, Mr. Marlowe. The stuff inside is mostly junk.[43]

The middle-class families who would purchase houses in the suburbs and surround themselves with cars and gadgets were not necessarily concealing an inner guilt or rottenness. The desire to acquire, to purchase, to consume, to own—this still meant that you were doing something, walking on some treadmill. Junk

didn't always mean "nastiness" of the amoral kind Marlowe found in the Sternwood family. But the message was clear: some moral exemplarity had been lost in the process of mass production. Concentration on the material might not make you "blood-simple," but it was always going to be a little bit dirty.

...

The classic hard-boiled is now thought of primarily as "Hammett and Chandler," with Daly mostly forgotten. But these three writers combine in a cumulative outline of the American hard-boiled. That outline rests on Daly's declarations of force and independence, Hammett's combination of duty and pessimism, and Chandler's synthesis of European worldliness and tough American practicality. And it does so without addressing or even considering possible contradictions among these characteristics. Race Williams would have mocked someone who called a policeman Richelieu or even knew what an arras is, but for Marlowe erudition is part of his charm. The Continental Op lamented in *Red Harvest*, "It's this damn burg. You can't go straight here." Yet when a policeman friend tells Marlowe in *Farewell, My Lovely* that "a guy can't stay honest if he wants to. You gotta play the game dirty or you don't eat," Marlowe is unwilling to concede this point and remarks that if corrupt Bay City is a sample of how things work, he'll take aspirin. The result of the various contradictions might be a salad of incompatible ingredients, but despite their variety, readers could take what they wanted and ignore the rest. The impression of the hard-boiled detective that remained in the American imagination was of a character who responded to both individual and national needs, who combined the talent of the best with the humility of the good-enough, who rose above the problems of the modern world and killed your enemies for you. Enemies varied, of course, over time, and the hard-boiled did not pursue all of them at once. Political corruption associated with the 1920s wasn't simultaneous with the Great Depression,

and the gang violence of Prohibition didn't overlap with World War II. The enemy could be a vague foreign threat or the greedy rich, a cruel family member, a criminal mastermind, or just a run of bad luck. But as a variety of detectives succeeded one another in taking on a variety of enemies, what remained was an impression of broad competence and strength. More important, what remains is the sense that there is, or can be, an incontrovertibly best man who understands the needs of his world. That sense, that promise, never lost its popularity. The promise *Black Mask* made to "satisfy your craving for thrills" and "kill your enemies" spoke to a dual impulse: to be as independent as the hard-boiled and to believe that someone out there could do it for you.

- - - - - - - - - - - - - - - - - - - -

A Moral Compass

In his 1946 State of the Union address, President Harry Truman remembered 1945 as the "greatest year of achievement in human history." He called the United States "strong and deservedly confident. We have a record of enormous achievements as a democratic society in solving problems and meeting opportunities as they developed." Four years later, he saw the threat of totalitarian dominance of Europe and the Mediterranean area receding and pointed out that America had beat back the greatest economic downturn since the war. In 1948, however, the Communists took power in China. A year later, the Soviet Union ran a successful test of its own atomic device. And in June of 1950, North Korea invaded South Korea. One month later, the United States entered the war (which Truman called "an evil war by proxy") on South Korea's behalf. With the Korean War under way, the 1951 State of the Union Address revealed that the country was in a renewed ideological battle. "The threat of world conquest by Soviet Russia endangers our liberty and endangers the kind of world in which the free spirit of man can survive," Truman said, continuing: "Indeed, the state of our Nation is in great part the state of our friends and allies throughout the world. The

gun that points at them points at us, also."[1] Much of the country heard this menacing announcement, but no one seems to have taken it quite as much to heart as Mickey Spillane's fictitious detective, Mike Hammer.

In 1947, Truman had yet to speak in deeply ominous tones about foreign communist enemies, but Mike Hammer was already primed to come at them with red-blooded American fury. He embodied the nation's pride in its military and in its own role as global savior. World War II had shown that the world needed the intervention of tough American forces, and Hammer ran with the pride of that military success. Driven by a personal sense of justice and revenge, he ended up being one of the longest-running private eyes in history.

Mike Hammer first came into being as a comic book character. Spillane had written stories featuring Batman, Captain America, and Superman, among others. He created the comic book character Mike Danger at the end of World War II (Spillane joined the Air Force after the bombing of Pearl Harbor and served stateside as a flight instructor). Danger did not attract the interest Spillane had hoped for, but in 1947 he published a novel—*I, the Jury*—featuring essentially the same character newly named Mike Hammer. Spillane reportedly wrote the book in nineteen days, and it transformed the tough, chiseled, speech-bubbled personage of the comic book to the character-driven world of the novel. A newspaper blurb warned that it "isn't good fare for the squeamish, but the writer has certainly produced a dramatic climax guaranteed to chill your blood."[2]

When *I, the Jury* came out in paperback, it sold more than eight million copies. Spillane then published *My Gun Is Quick* (1950), *Vengeance Is Mine* (1950), *One Lonely Night* (1951), *The Big Kill* (1951), and *Kiss Me, Deadly* (1952). Despite announcing later in 1952 in an interview with *Life* magazine that he had changed his work to "be in harmony with Jehovah's Kingdom,"[3] he returned

with *The Girl Hunters* (1962), *The Snake* (1964), and *The Twisted Thing* (1966). His devotion to Jehovah's Kingdom did not last long, for these later novels were as packed with sex and violence as those that preceded them. Spillane rounded out the Hammer collection with *The Body Lovers* (1967), *Survival . . . Zero* (1970), *The Killing Man* (1989), and *Black Alley* (1996). He also created the detective Tiger Mann, to whom he devoted twelve books. After the author's death in 2006, his friend and literary executor Max Allan Collins completed ten more Mike Hammer books. Several Hammer novels were adapted to film, including *I, the Jury* (1953), *Kiss Me Deadly* (1955), and *My Gun Is Quick* (1957). Mike Hammer also gave rise to numerous television series, each featuring the personality (and the wardrobe) appropriate to its decade. Two series came out in the 1950s, another in the 1980s (with the improbably natty-looking Stacy Keach), and the most recent one in the 1990s. Spillane himself played the role of Hammer in the movie *The Girl Hunters* (1963). He also appeared in an episode of *Columbo* in 1974 and became a television regular in a series of commercials for Miller Lite beer.

By 1980, seven of the fifteen all-time best-selling fiction books in America were Hammer novels.[4] Spillane jump-started the paperback industry, selling more than 220 million books by the early twenty-first century. There is nothing monolithic about the period from 1947 (*I, the Jury*) to 1996 (*Black Alley*); Mike Hammer was like one of those Russian nesting dolls, revealing many chambers and speaking to various elements of the American psyche over time. He combined elements of the postwar politician, the alienated soldier, the comic book tough guy, the anticommunist, the protector of the social fabric, and the self-sufficient American. He was somehow both a ladies' man *and* a champion of female virtue. For Cold War readers, he evoked a series of peculiarly American fantasies, fears, and contradictions. He is improbably dedicated, indestructible, desirable, and tireless. Like his hard-boiled

Mickey Spillane reportedly wrote *I, the Jury* in nineteen days. By 1953, when the book was adapted into a movie, it had sold 3.5 million copies.

predecessors, he gives his readers a versatile model for dealing with the "gun that points at us."

The World War II memorial in Washington, DC, describes "the moral strength and the awesome power that can flow when a free people are at once united and bonded together in a common and just cause." The United States emerged from World War II with considerable assurance, its force and power in an enviable moral position. In the battle between good and evil, America was indisputably on the side of good. Historians have pointed out that the

most popular American military endeavors were directed toward problems at once absolute and moral in nature, and the destruction of the Axis powers constituted just such a circumstance. And much as America came out of the war as a military force for whose assistance Europe was grateful, Hammer emerges in his novels as a tough friend and advocate. He carries within him the soul of a war hero and treats each case as a personal life-and-death mission. In *I, the Jury*, he is driven by the vision of his army buddy and best friend perishing from a gunshot wound while his killer taunts him. Spillane made sure that other Hammer books followed this pattern. In *My Gun Is Quick*, one victim is Hammer's acquaintance and the next his lover. In *Vengeance Is Mine*, the victim is Hammer's friend, who seems to have committed suicide with Hammer's gun after they had spent the night drinking. In *The Big Kill*, Hammer witnesses the murder of a man he had just seen with his baby son in a bar, and he spends the novel railing against the "orphan-makers" he despises. In every case, Hammer feels the same sort of moral imperative that drove the United States into the Second World War in the first place. This momentum is important to Hammer's success, since America was not just riding the tide of an Allied triumph in World War II but was also in the process of developing serious mutual hostilities with the Soviet Union. In essence, Hammer works as a stand-in for America, proud of its recent victories and prepared for a looming confrontation.[5]

In *The Twisted Thing*, which Spillane wrote in 1950 (but did not publish until 1966), a client asks Hammer if he is a good detective. Hammer's answer shows that he is a product of his time, not nervous for the future of the country, not cowering in the face of communism, but rather personally offended that the world's bad actors would make trouble for him and people around him: "I hate the bastards that make society a thing to be laughed at and preyed upon. I hate them so much I can kill without the

slightest compunction. . . . I think fast, I shoot fast, I've been shot at plenty. And I'm still alive. That's how good a detective I am."[6]

Such a response would have been incomprehensible to Sherlock Holmes and Miss Marple, and probably even to the Continental Op and Philip Marlowe ten years earlier. When we compare this answer to the meaning of *detective* in the early hard-boiled novel, we can see that the word has changed to the point where it has nothing to do with "detection" as such. It does, however, make sense in the context of the Second World War and the subsequent Cold War. Rather than crime solving, being a detective in the Spillane world means hating one's enemies enough to rush into hand-to-hand combat. Hammer embodied the most aggressive elements of the nation's self-image, and his crime-fighting expeditions through the streets of New York City celebrated America's ascension to economic and military dominance. What the Allied forces brought to World War II, Mike Hammer instinctively brings to the streets of New York.

Part of what hard-boiled characters do is act the way Americans would *like* to act—or would like to have acted—in a given set of historical circumstances. Another part of what they do is act out the dark underside of American identity: its moral ambiguities. During the years that came after the war, Hammer was as close as popular culture came to any sort of postatomic remorse. Although the nation was proud of its actions in World War II, there was some amount of soul-searching to be done in the aftermath of Hiroshima and Nagasaki. Mike Hammer, who had come in with guns blazing when someone close to him was threatened, pauses— albeit briefly—to do this work of self-assessment.

The entire United States was understandably relieved at the end of a war that had cost more than 405,000 American lives. The dropping of the atomic bombs on Hiroshima and Nagasaki had seemed to some necessary to produce that end, as well as to avenge the attack on Pearl Harbor. The moral absolutism that encouraged

the fight against Hitler was only reinforced by the December 1941 attack, which killed 2,403 people and wounded more than 1,100 others. At the same time, American attitudes toward the bombings were soon tempered with ambivalence. In August 1946, John Hersey published in the *New Yorker* an account of the bombing as experienced by six survivors.[7] That account did not condemn outright the use of the atom bomb, but it told the stories of individual victims and survivors in such a way as to evoke considerable sympathy for the Japanese. A spectral sense of contrition has continued in the American imagination, even in spite of broad consensus that the bombing was a justified act of war. In 2002, Studs Terkel interviewed Paul Tibbets, pilot of the bomber *Enola Gay*, and asked him about feelings of remorse:

> Second thoughts? No. Studs, look. Number one, I got into the air corps to defend the United States to the best of my ability. That's what I believe in and that's what I work for. . . . On the way to the target I was thinking: I can't think of any mistakes I've made. Maybe I did make a mistake: maybe I was too damned assured. At 29 years of age I was so shot in the ass with confidence I didn't think there was anything I couldn't do. Of course, that applied to airplanes and people. So, no, I had no problem with it. I knew we did the right thing because when I knew we'd be doing that I thought, yes, we're going to kill a lot of people, but by God we're going to save a lot of lives. We won't have to invade [Japan].[8]

The United States continues to reckon with its actions. In 2016, President Obama's visit to Hiroshima—the first visit by a sitting president since the war—raised once more the question of whether the US should apologize for the bombing. To this day, the United States has not apologized; nor have Americans ceased wondering whether it should.

In the fourth Mike Hammer novel, *One Lonely Night* (1951), the detective acts as a proxy for the nation, reckoning with a remorse

very much like the sort that some citizens sensed after the strikes on Japan. Hammer leaves a courtroom where a judge has reluctantly acquitted him of murder. During the trial, the judge had accused him—in pretty apocalyptic terms—of having developed a taste for blood during war, and he "prophesied a rain of purity that was going to wash me into the sewer with the other scum." Hammer—not usually one for self-doubt—takes this damning opinion to heart and replays the lecture in his mind, reflecting that he had gotten a taste of death and "found it palatable to the extent that I could never again eat the fruits of a normal civilization." *One Lonely Night* is the most explicitly anticommunist of all the Mike Hammer novels, and it ends with an unabashed murder of a number of Communists. But some of the detective's most intense problems are not with his enemies but with himself and his memories of wartime. All in all, focusing on actions in the line of duty, Hammer's remembrances read as evaluations of American identity and morality. He ponders "the power of the gun and the obscene pleasure that was brutality and force," which reads as a meditation on what it means to come to power in the context of war.[9] Success in war was, of course, fundamentally oppositional: on the macropolitical level, it depended on the defeat of another nation, and on the individual level, it often depended on the death of another human being.

On the page, Hammer represented America as a former soldier. In American culture, he represented the country as an iconic fictional character. In both roles, Hammer's reflections implied that the nation itself was capable of remorse. It could revise itself—it could move forward on a more stable moral footing. In other words, remorse did not undercut American morality but instead strengthened it and added texture to its foundation. Chandler's Philip Marlowe had sensed in 1939 that moral self-deprecation would have cultural value and appeal. When Marlowe mused at the end of *The Big Sleep* that "I was part of the nastiness now," he

was in fact showing a more solid moral sense than those who never paused to wonder whether they should bear any blame.[10] Just like Race Williams, who said, "My ethics are my own," but nonetheless acted in an ethical manner, the hard-boiled detective is a compass that can be relied on to right itself. The ability to ask the questions, to look at one's own part in world events, and to experience self-doubt stands as an admirable quality. This is true even when the self-doubt is but a gesture and when one quickly resumes the exercise of bold authority. Such authority was the ultimate desirable quality for an American icon, since the nation wanted for decades to see itself as a moral beacon for the rest of the world.

Ultimately, despite Hammer's moments—even his tormenting moments—of self-doubt, the reader is urged to come down on his side. We see that the judge doesn't understand him or doesn't understand the work he does on behalf of the American people. Whereas the United States had considerable moral credit at the end of the war, so in the eyes of the reader does Hammer, and he continues to amass it. The moral status of the nation shores up the moral status of the detective. Consider this conversation between Hammer and his date Marsha, in the 1951 novel *The Big Kill*: "'There are a lot of things you don't know about me.' She uncurled from the chair and picked up the glasses from the table. 'Should I?' 'Uh-uh. They're all bad.'"[11] It is true that Hammer is irritable, dangerous, and quick-tempered. It is also true that he has killed people—but only people who have hurt others. The reader is led to grasp that he is not *really* bad and that he is coming from a favored moral position. The reader understands that he is in America, where statements like these are comparatively benign. In Europe, this admission could well mean that the person had been a Nazi collaborator. In the United States, it is more likely to be a winking confession that Hammer was a little too tough on criminals. Being too ruthless with an evil villain is the sort of "badness" for which the nation has never been entirely apologetic.

It is not a coincidence that Hammer talks a tough game, so much so that it became his signature, even though he never remains completely at peace with violence. After the revenge killing of Charlotte Manning in *I, the Jury*, Hammer says, "It was easy." That closing line of the novel is Mickey Spillane's most quoted, but Hammer returns in later novels to the memory of the murder. In fact, at various points, he reveals that the memory of killing Charlotte haunts him. In *Vengeance Is Mine*, he revisits the scene: "The voice I tried to scream with was only a hoarse, muted whisper saying 'Charlotte, Charlotte . . . I'll kill you again if I have to! I'll kill you again, Charlotte!'" When he prepares to shoot Juno, the man in drag: "The light was in her hair turning it into a halo of white that brought the dead back to life and I was seeing Charlotte's face instead of hers."[12] He lets us know that while it may be reasonable to punish murderers by death, and it may in fact be the American way, this punishment is not without its price. In this, he seems to be spurring on American forces to face the Russian demons of the present without being mired in trauma, or remorse, from wars past. He is reporting for some of his important and popular public services: the roles of American defender and of American id.

The years leading up to Hammer's appearance on the literary scene witnessed numerous contradictory expressions of American identity, some based on democratic ideology and others on a spirit of vengeance. President Roosevelt's mandating the internment of Japanese Americans in the aftermath of Pearl Harbor evoked the latter. Three years later, in 1945, New York became the first state since Reconstruction to introduce antidiscrimination legislation. In August of that year, President Truman ordered the atomic bombing of Hiroshima and Nagasaki. In November, Nazi criminals were brought before Allied military tribunals, and an American prosecutor delivered the opening statement.

Throughout his history the hard-boiled detective has acted as a sort of moral launderer. On the one hand, he embodied the qualities that America was proud to claim; on the other hand, he claimed ownership of those shadowy parts of America's past that had to be grappled with but that the nation might prefer to disavow. A guilt-ridden detective could serve as a sort of waste bin for doubts and shame that could tarnish national self-image. After the judge lectures Hammer and accuses him of violence and immorality, Hammer wonders: "Maybe I was twisted and rotted inside. Maybe I would be washed down the sewer with the rest of all the rottenness sometime."[13] And that wondering sums up an essential public service: the hard-boiled detective could bear the brunt of what the country did not want to admit. The United States had long alternated between moral exemplarity and moral bankruptcy, and Hammer's talk of his "rottenness" reveals an awareness of that dichotomy. Hammer was a soldier and a reputable detective, but as a character, he was just an individual, so his "rottenness" could act as a repository for a broad history of violence.

From the genocide of Native Americans to centuries of slavery, American history is replete with instances of brutality. Because of this, it seems uncomfortably reminiscent of that culture to have Hammer persist in operating on hate and to experience his brutality as so visceral and instinctual. As Hammer announces to his friend, police captain Pat Chambers: "I hate hard, Pat. When I latch onto the one behind this they're going to wish they hadn't started it. Someday before long I'm going to have my rod in my mitt and the killer in front of me. I'm going to watch the killer's face. I'm going to plunk one right in his gut, and when he's dying on the floor I may kick his teeth out."[14] Hammer's furious impulses are meant to read as reactions to someone else's aggression, but they sometimes seem like excuses, convenient outlets for violent impulses that were already there and would remain there no

matter what. Punishment is one thing, but Hammer is also going for straight-up roughness. Since violent impulses have had their place throughout American history, Hammer's job would henceforth be to reconcile a celebration of violence with the traditional hard-boiled function of moral exemplarity.

Mike Hammer helped the United States to reconcile national ambivalence about violence in time to brandish it with unreserved enthusiasm going forward. This took a bit of doing, since in the years immediately after the war, America was—at least officially—focused on moral order rather than on rage. Three months after the bombing of Hiroshima and Nagasaki, judges from the Allied powers of Great Britain, France, the Soviet Union, and the United States opened the Nuremberg trials in Germany. These were the first war crimes trials that had ever been held. Twenty-four Nazis were accused, and twelve were sentenced to death. The trials were an Allied enterprise, not an American one, but the chief prosecutor was the United States Supreme Court justice Robert H. Jackson. Jackson was responsible for meeting with representatives of the Soviet, French, and UK governments to develop procedures for the trial. He argued in a report to the president in June of 1945 that it was time to act on the "juridical principle that aggressive war-making is illegal and criminal."[15] When the trials started, Jackson issued this opening statement:

> The privilege of opening the first trial in history for crimes against the peace of the world imposes a grave responsibility. The wrongs which we seek to condemn and punish have been so calculated, so malignant and so devastating, that civilization cannot tolerate their being ignored, because it cannot survive their being repeated. That four great nations, flushed with victory and stung with injury stay the hand of vengeance and voluntarily submit their captive enemies to the judgment of the law is one of the most significant tributes that Power has ever paid to Reason.[16]

The insistence that Power be subsumed to Reason, even by the victor, becomes a crucial part of America's moral foundation. Jackson's dedication to moderation was also well timed. With Hitler dead and the Nazis defeated, the Allied forces risked little by submitting power to reason. There was no immediate downside to claiming self-control, which, on the contrary, added ethical finesse to proven military dominance.

Jackson's opening statement acknowledged that aggression was part of human behavior. It also stipulated that the Allied powers presiding over the trials were not immune to violent impulses: "And let me make clear that while the law is first applied against German aggressors, the law includes and if it is to serve a useful purpose, it must condemn aggression by any other nation, including those which sit here now in judgment." This acknowledgment may have come from the recollection of Hiroshima, which remained tinged with an air of gratuitous vengeance. But it also prepared the way for American resentment of Russia, whose very participation in the Nuremberg trials had been a point of serious contention. The memory of the 1936–38 Moscow Trials was present to the minds of many American and British foreign policy leaders. John Troutbeck of the British Foreign Office had railed against the proposed alliance that formed the Nuremberg trials, calling the inclusion of Russia in the proceedings a "high point of international hypocrisy."[17] And to make matters much worse, just after the United States tested its atomic bomb in Alamogordo, New Mexico, in 1945, Russia launched a crash program to build a Soviet bomb. The wartime alliance between Russia and the other Allied powers would unravel, and Russia would become the adversary. This is where Mike Hammer came in.

In a 1945 article titled "You and the Atomic Bomb," George Orwell floated the prospect of "two or three monstrous super-states, each possessed of a weapon by which millions of people can be wiped out in a few seconds." That article coined the term *Cold*

War. In 1947, the year Spillane's *I, the Jury* came out, President Truman's Loyalty Order and the Truman Doctrine were also created. This was also the year that Joseph McCarthy was elected to the Senate in Wisconsin and that Ronald Reagan testified before the House Un-American Activities Committee as a friendly witness, declaring that a small group of Communists had "attempted to be a disruptive influence" within the Screen Actors Guild. In 1948, Congress established the Voice of America to broadcast anticommunist radio programs in countries behind the Iron Curtain. As if in defiance of that dissemination, the Soviet Union detonated its first atomic bomb in July of 1949. Nationalist China fell to the Communists, and at the end of that year, NATO foreign ministers met in Brussels to plan the defense of Western Europe against the Soviet Union. In 1950, the Korean War began amid dire security concerns. The country readied for the battle against communism. Mike Hammer was doing the anticommunist work of the American government, placing it on solid footing and replacing uneasiness with force.[18]

Back in the 1920s, *Black Mask* had advertised Carroll John Daly's stories by inviting readers to "fulfill that secret desire for an exciting life! Satisfy your craving for thrills! Let Race Williams and Terry Mack kill your enemies for you!" That advertisement had outlined the double purpose of the hard-boiled detective: to provide not only a sense of security and protection but also to serve as a vicarious shot at unrestrained aggression. *Black Mask* was not proposing to keep your enemies at a distance or to bring them to a fair trial but to kill them and to let you have a good time in the process. This was not too much of a stretch for the reading public, many of whom already supported summary execution of Hitler, Goering, and other Nazi leaders.[19] Although dedication to due process demanded that the rule of law precede the impulse to vengeance, the desire to kill your enemies—a desire no less part of the American fabric—turned it on its head.

Spillane became a phenomenal success precisely because he understood that brute force and moral authority would not stand side by side without some balancing. Hammer provided that balance again and again. In *One Lonely Night*, Hammer's guilt and remorse performed a kind of contemplative cleansing. That is, it took care of unfinished business so that America could claim to stand with the causes of right and justice. If Hammer were washed down the sewer, what was left aboveground would presumably be a purer and more blameless nation—one that could claim restraint and submission to the rule of law. Yet despite his insistent moral inventory in *One Lonely Night*, Hammer's role in his other novels—and even in the remainder of that novel, which was all about murdering "Commies"—is not to "stay the hand of vengeance" but to wield it with furious determination. Throughout Hammer's tenure as America's hard-boiled hero, the menace of Soviet communism was real and serious, which helps explain why he was as beloved by the public as he was lambasted by his critics.

The emotions and actions of the hard-boiled resonate not only in the historical moment that produces them but in the moments that follow as well. Hammer starts out the tough and victorious voice of immediate postwar America, but the timing of his books soon has him responding to the ongoing menace of the Cold War. Without that menace, without the specter of communism and, more importantly, of atomic destruction, Mike Hammer's need to take revenge might have worn thin. After all, Justice Robert Jackson had argued when opening the Nuremberg trials that American moral superiority rested on the principle of restraint, and Hammer's "I hate hard" ran counter to moderation. There had to be a reason—other than boredom or sadism or even revenge—to put equanimity aside. As it happened, the communist threat gave renewable rationale to the simmering resentment that Hammer kept in his pocket. First of all, he hated Communists themselves. Second, and more generally, he had a talent for

uncovering individuals who weren't what they pretended to be. This quality was worth its weight in gold in the era of the Cold War.

In the late 1940s and early 1950s, fewer than 0.03 percent of the American population were members of the Communist Party. Nevertheless, during those years, which were prime Mickey Spillane years, anticommunist sentiment was on the rise. Public employees were forced to take loyalty oaths. Hundreds of Hollywood actors, writers, and directors lost their jobs, as did many others in the public and private sectors. Government boards scrutinized the reading and churchgoing habits of three million government workers. They were asked if they had African American friends and whether they sympathized with the underprivileged. Anti-Communists called for the removal of books—including Steinbeck's *The Grapes of Wrath*—considered too sympathetic to communism. In 1953, a member of the Indiana Textbook Commission even called for the removal of *Robin Hood*, claiming that "take from the rich and give to the poor" was communist policy.[20] J. Edgar Hoover's FBI and a network of informants contributed to McCarthy's hearings on "subversives." The Smith Act of 1940 had made it a crime to "advocate the violent overthrow of the government or to organize or be a member of any group or society devoted to such advocacy."

A crucial part of that 1950s crusade was the ability to locate evil wherever it hides and to suspect even one's inner circle. When Senator Joseph McCarthy made his famous 1950 speech in Wheeling, West Virginia, he threatened that if a great democracy could be destroyed, "it will not be from enemies from without, but rather because of enemies from within." During that speech, McCarthy announced that more than two hundred Communists had infiltrated the US State Department. Those accusations were unsubstantiated, and it has long been known that McCarthy tended to invent guilt. For instance, in 1949, Cedric Parker, a reporter from the *Madison (WI) Capital Times*, investigated McCarthy's involve-

ment in illegal activities. For his trouble, Parker was labeled a Communist. But the cases of Alger Hiss (1950) and Julius and Ethel Rosenberg (1953) made clear that the threat of communist infiltration was not entirely fabricated. Fear of it was strong enough that McCarthy, though later discredited, had fervent supporters. Idaho senator Herman Welker once said of McCarthy: "That fighting Irish marine . . . would give the shirt off his back to anyone who needs it—except a dirty, lying, stinking Communist. That guy he'd kill." Such praise seems aimed at Mike Hammer, with the important distinction that when Hammer named a villain, he was never wrong.[21]

Senator John Bricker (R-OH) called McCarthy an SOB and added: "Sometimes it's useful to have SOBs around to do the dirty work." Dirty work in the 1950s was not the same as it was in the 1920s and 1930s. It had not always meant sniffing out villains behind every door in the name of national security. And it had not always meant having one's guard up against Communists. But in the 1950s, the culmination of decades of antiradicalism, it did. The comic poster "Is your washroom breeding Bolsheviks?" was an actual advertisement for Scott towels in the 1930s. Dirty work had always been the job of the hard-boiled detective, as it had been of the superhero. And if keeping up a percolating suspicion of possible bad guys was the order of the day, then that was the hard-boiled job of the 1950s. Mike Hammer fell in line with this anticommunist sentiment. John Wayne gave Mickey Spillane a Jaguar XK140 to commend him for it, and the vigorously pro-capitalist Ayn Rand claimed to admire his worldview. But hers was hardly an endorsement to be proud of. Flannery O'Connor echoed prevailing critical opinion when she famously remarked that Ayn Rand was as low as you could get in fiction and that she "makes Mickey Spillane look like Dostoevsky." Even *One Lonely Night*, which in many ways is about Hammer's postwar remorse, ends up focusing on the evil and stupidity of communism. As he

puts it: "I had one, good, efficient, enjoyable way of getting rid of cancerous Commies. I killed them."[22]

Linking Mike Hammer with the threat of communism gets a further boost in the 1955 film version of the 1952 novel *Kiss Me, Deadly*. The novel was about the Mafia and did not even mention communism, but the movie ends with an atomic blast. It was, after all, impossible to forget that the Soviet Union had gotten the bomb in 1949. Even though director Robert Aldrich had intended *Kiss Me Deadly* to be an "Anti-Spillane film" and even though the author himself did not like the movie (in part because it omitted the comma after "Kiss Me," an error that had previously led him to pulp an entire printing of the novel), the specter of atomic destruction is inextricably intertwined with communism. Fighting that menace corresponded with Hammer's image as a super-patriot. But not only was he a vigorous anti-Communist; he also displayed a talent for uncovering traitors of all sorts. One Hammer novel after another puts the bad guy amid good guys. The murderer is almost always intimately involved with the case and with Hammer: he or she turns out to be the woman he loves, or his client, or a friend of the victim who is helping him on the case. *I, the Jury* has Hammer discover that Charlotte Manning, the woman he loves and intends to marry, murdered his best friend. He then shoots her in the stomach, and when she asks, "How could you?" tosses off the famous "It was easy." In *The Big Kill*, his lover Marsha, referred to as "my angel," turns out to be the murderer. In *Vengeance Is Mine*, the beautiful Juno, who "made you want to undress her with your eyes and feel the warm flesh of a goddess," turns out to be not just the murderer but also a man in drag. In *Kiss Me, Deadly*, the blonde Lily Carver clings timidly to Hammer throughout the book, seeming to crave his protection. In the end, of course, she, too, is found to be the murderer, and Hammer calls her *"a horrible caricature of a human!"* The list goes on. In every case, the woman he trusts turns out to

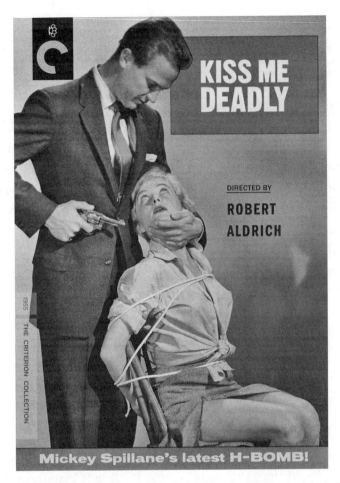

Robert Aldrich turned Spillane's tale of organized crime into a noir thriller for the atomic era. Clever advertising copy called this Hammer story "Spillane's Latest H-Bomb!"

be duplicitous and deadly. Enemies lurk around every corner, even in the most domestic of spaces.[23]

Mike Hammer was in many ways the ideal voice of a period in history marked by both moral certitude and rapidly changeable alliances. In Chandler and Hammett, suspicions of the femme fatale built up gradually. Spillane, however, has his female characters move from innocent and alluring to homicidal and toxic in

the space of a single page. The sheer velocity of these changes echoes a decade ready to detect horror in the familiar. Just as Race Williams said that taking a bullet through his hat was nothing to write home about, Hammer remains remarkably composed when in one novel after another his lovers turn out to be cold-blooded murderers. In *The Girl Hunters*, Hammer kisses Laura Knapp and then, while she is chatting to him from the shower about the case, accuses her of spying for the Russians and murdering her own husband. He booby-traps her gun so that it will kill her when she tries to shoot him. And in case the reader missed the fact that sudden revelations of evil intent were intimately connected to global political instability and concerns for national security, Laura had explained it earlier: "Your friends are only those you have at the moment. Either you outgrow them or something turns friendship into hatred. . . . In 1945 Germany and Japan were our enemies and Russia and the rest our allies. Now our former enemies are our best friends and the former allies the direct enemies."[24] Hammer's ability to root out the murderer in his circle, in his home, or even in his bed testifies—if we read Hammer as a microcosm for the nation—to America's clear-headed and unsentimental concern for national security.

The 1950s were in many ways more politically and financially enlightened than the early 2000s. President Eisenhower expanded public housing and raised the minimum wage. His Federal Highway Act of 1956 was the largest public works program in history. He created the Department of Health, Education, and Welfare and introduced a progressive income tax system. He also proposed that the federal government underwrite risk for private insurance companies, which stands in stark contrast to the current federal position on health insurance sixty years later. All these measures were introduced by a president who derided New Deal initiatives as "creeping socialism" (a phrase he took from Herbert Hoover). The real constraints of the 1950s were based on gender,

race, and sexual orientation. White families (meaning white men and the white women who married them) could find stable employment, purchase homes wherever they wished, access consumer goods, and then retire with the support of pensions and an increased Social Security. Consumer credit was allowed an unprecedented maximum level. Private real estate holdings multiplied. Once one had landed in the security of the middle class, often in a suburban enclave, the limitations that Americans encountered were of another kind—the kind conservatives such as Hammer tended to embrace, even for themselves. This was the famous isolation, often referred to as safety, of the domestic sphere. Focusing on this sort of isolation, a primarily white and suburban experience, historians often describe the 1950s as a decade of paranoia. This meant fear of the atom bomb and fear of Communists but also the sort of anxiety that accompanied a rigorously conformist culture: fear of the neighbors, fear of others' opinions, fear that people and things were not what they seemed to be, and fear of not measuring up. In her chronicle of the 1950s *Homeward Bound*, Elaine Tyler May writes that Americans "wanted secure jobs, secure homes, and secure marriages in a secure country. Security would enable them to take advantage of the fruits of prosperity and peace that were, at long last, available. And so they adhered to an overarching principle that would guide them in their personal and political lives: containment."[25]

As Bono put it in August Wilson's play *Fences*, set in the 1950s: "Some people build fences to keep people out . . . and other people build fences to keep people in." Bono was talking about his father's desire to create a protected zone within a racist culture, but even in the white population, containment meant a combination of limitation and security. In the early 1950s, *The Donna Reed Show*, *Leave It to Beaver*, *I Love Lucy*, and *Father Knows Best* showed a reduced sphere of action from the world at large to the neighborhood and the house. Home was the place where a man had

relative power and freedom.[26] Yet that did not mean that men were entirely autonomous: they could pursue professional ambitions but encountered numerous corporate obstacles to independence. In such novels as Salinger's *The Catcher in the Rye* (1951) and Kerouac's *On the Road* (1951), disaffected young men went out on their own not just to escape the establishment but to escape society as a whole. That isolation indicated some sort of social criticism or existential unease connected with adolescence, with criminal pathology (*Lolita*, *The Killer Inside Me*, *The Talented Mr. Ripley*), or with real social oppression and racism (*Invisible Man*). Allen Ginsberg's *Howl* dreamed of a connection for "angelheaded hipsters." Authors such as James Baldwin, Lorraine Hansberry, and Ralph Ellison wrote about black identity in a culture of oppressive white racism. In film, the 1955 drama *Rebel without a Cause* portrayed rebellious adolescence in the suburban middle class. Ultimately, the downside of containment was much the same as it was in Herbert Hoover's time. The "rugged individualism" of the 1920s at least had had the virtue of being rugged: it sounded like a positive (and, to hear Hoover describe it, patriotic) decision. Containment, however, sounded more timorous than proactive. It implied that connection with the outside world had to be mediated in some way. The very fact of "wanting secure jobs, secure homes, and secure marriages in a secure country" indicated that one felt insecure, and insecurity was an intrinsically un-hard-boiled feeling. The question thus remained of how a man in the 1950s could maintain rugged individualism without becoming—or being seen as—contained.

Repression among 1950s white men—like Mickey Spillane—was primarily social and corporate in nature. As William Whyte put it in *The Organization Man*:

> They are keenly aware of how much more deeply beholden they are to organization than were their elders. They are wry about it, to be

sure; they talk of the 'treadmill,' the 'rat race,' of the inability to control one's direction. But they have no great sense of plight; between themselves and organization they believe they see an ultimate harmony and, more than most elders recognize, they are building an ideology that will vouchsafe this trust.[27]

Narratives about 1950s white America portray the domestic and corporate worlds as repressive for men. Richard Yates's *Revolutionary Road*, Todd Haynes's *Far from Heaven*, and Edward Albee's *Who's Afraid of Virginia Woolf?* exemplify this. Although Hammer had not experienced a repressive domestic sphere, he certainly was not a free spirit à la Kerouac. He was an unmarried urban apartment dweller—who more or less ignored the 1950s expansion of suburbia—as well as a social and political conservative who denigrated "knotheaded liberals and 'better-Red-than-dead' slobs."[28] But his anticommunism took the form of anger instead of fear, so he never comes across as vulnerable even when facing a dangerous public enemy. Thus, a conservative bent that could have set him up for the 1950s snare of rigidity and repression—or of existential crisis—was channeled into rage.

Mike Hammer was nowhere near being an "organization man." He did, however, act out his own cycles of repression and explosion. These made him relatable to readers who *were* such men, or who at least felt pressure to be. Hammer never battled the constraints of cultural norms but rather those of law and basic social acceptability. In *I, the Jury*, when his best friend is murdered, he declares himself in a race against the police. When the homicide captain advises him to "go easy," he resists. "The law is fine. But this time I'm the law and I'm not going to be cold and impartial." When the father of a one-year-old is murdered in *The Big Kill*, he stews. "Goddamn it, this makes me mad! No matter what the hell the guy did it's the kid who has to pay through the nose for it. Of all the lousy, stinking things that happen . . ." By the time he gets

to the last chapter, Hammer has reached a point of total rage: "It gave me a crazy feeling in my head that pushed me faster and faster until the car was a mad dervish screaming around corners in a race with time." It's the same buildup at the end of *My Gun Is Quick*, when Hammer finds his lover, Lola, murdered and pursues the man responsible: "He couldn't lose me now or ever. I was the guy with the cowl and the scythe. I had a hundred and forty black horses under me and an hourglass in my hand, laughing like crazy until the tears rolled down my cheeks."[29]

In all his novels, Mike Hammer more or less disregarded or sidestepped what solitude could mean in the 1950s—loneliness, alienation, unhappiness, or exuberance. He simply acted as though these did not exist. Instead, his displeasure was practical. He couldn't kill his enemies as fast as he wanted to, or at least he said he couldn't; in fact, however, he managed to dispatch them rather effectively. When Hammer is frustrated and wants more freedom of action (something Race Williams in the 1920s never complained about), that frustration is the hard-boiled version of the more abstract 1950s sense of repression. For Hammer it's not about convention; it's about doing what you have to do. Get mad enough, and you'll get what you want. Either you'll get mad enough to run out of the house shouting, or pick up a gun and shoot a man in the face as a burning building collapses around you both. (So ends *My Gun Is Quick*.)

Hammer had another way of holding himself outside the bounds of fear and containment. This was a trick the hard-boiled detective narrator could bring into play precisely because he was himself fictional. He could stand outside the book, reminding you that he was telling a story and had the power to both scare and distract. At the start of *My Gun Is Quick*, Hammer describes books as a diversion from an outside world too alarming for the average citizen:

Oh, it's great to watch, all right. Life through a keyhole. But day after day goes by and nothing like that ever happens to you so you think that it's all in books and not in reality at all and that's that. Still good reading, though. Tomorrow night you'll find another book, forgetting what was in the last and live some more in your imagination. But remember this: there *are* things happening out there. They go on every day and night making Roman holidays look like school picnics.[30]

Hammer's response to public trepidation was intended as a sort of tease for McCarthy-era readers. Writers have often presented fictitious versions of actual disasters.[31] Hammer saw that America was being threatened and understood that the nation wanted security. But his was also the voice of the hard-boiled detective who understood his role was both to protect, as a politician, and to distract, as an entertainer. But first, he had to show himself in no need of protection. He could handle life without boundaries even if no one else could. He didn't need anyone to kill his enemies for him even if those enemies were Russians developing their own bomb. This was more or less the 1950s version of what Race Williams had promised back in the 1920s.What the amorphous Beast was for Williams, the specter of nuclear destruction could be for Hammer.

...

In Irving Berlin's 1946 *Annie Get Your Gun*, Frank Butler outlines for the gunslinging Annie Oakley what he wants in a woman:

> The girl that I marry will have to be
> As soft and as pink as a nursery
> The girl I call my own
> Will wear satins and laces and smell of cologne
> Her nails will be polished and, in her hair,
> She'll wear a gardenia and I'll be there

'Stead of flittin', I'll be sittin'
Next to her and she'll purr like a kitten
A doll I can carry, the girl that I marry must be.

In the musical and subsequent movie of the 1950s, Annie is sad to see that you "can't get a man with a gun" but by the end of the show admits its truth. She intentionally loses the shooting contest, appeasing Frank's pride and getting him to marry her. Frank's ambivalence emerges in the 1950s notion of womanhood. The plucky tomboy may be appealing, but neither she nor the public will be content until she leaves that persona behind and steps into the role of wife. When it came to women, the 1950s significantly limited social possibilities. After World War II, when women went to work in factories and offices, they were encouraged to return to their homes—that is, to the domestic sphere. By the mid-1950s, most women who did go to college (and only a third as many women as men even began college) dropped out, either for marriage or in preparation for it.[32] The 1955 short film *Why Study Home Economics* is a gold mine of cultural information about gender roles in the 1950s. By the end of the decade, the average marriage age of American women was twenty. Betty Friedan's 1963 *The Feminine Mystique* examined the physical, emotional, economic, and, social limitations that a culture of housewifely conformity placed on women. She called it "The Problem That Has No Name," and a glance at the commercials and advertisements of the period shows women basically infantilized. The spirited woman à la Annie Oakley would eventually have to admit, at least in public, that she would rather return to home and family than "do anything better than you." She could not do both.

Even if Hammer sidesteps social conformity to avoid the restrictions of containment, he nonetheless fits in with that conformity just enough to make himself a creature of the time. It is mainly in the realm of gender roles that Hammer shows his 1950s

credentials—progressive enough to be subtly countercultural but conventional enough to seem at times to have stepped out of an advertisement for Van Heusen ties. Of course, this is an easy way to conform, because it demands nothing of him—it just means that his female characters follow the same script that pulp fiction had given them for the decades preceding. It also allows him to seem open-minded when he departs from that script to acknowledge women's independence. Thus, when a former prostitute tells Hammer that she has "a long way to go yet" before deserving his love, he retorts, "I don't give a damn what went on this year or last. Who the hell am I to talk anyway? If there's any shame to attach to the way you run your life, then maybe I ought to be ashamed. I've done the same things you've done, but a man gets away with it."[33] And when his detective license is revoked at the start of *Vengeance Is Mine*, he hands the entire business to his secretary-partner-love interest, Velda. "I won't even tell you how to operate. You can call the signals and carry the ball yourself if you want to." But in a ridiculous twist on the entire Madonna-whore contrast, Velda proclaims herself a virgin and tries to get Mike to sleep with her (and he keeps turning her down). And he talks constantly about women's bodies—if the plural is even appropriate, since every woman in the Hammer novels seems to have exactly the same body. The sex scenes that so shocked 1950s critics also read like ad copy from a McCall's pattern book. The clinging wrap dress was as vital to the scene as the body beneath it, and Spillane's entire oeuvre owes as much to silk crepe de chine as it does to the gun.

Most women in Mike Hammer novels showcase 1950s ideals on steroids. The man-worship apparent in advertisements of the decade is out in full force. For all the grandstanding that Hammer does on his own behalf, and there is plenty of it, over-the-top adorations come from the female characters. In *The Big Kill*: "You're big and not so handsome, but there's a devil inside you that makes

you exciting and tough, yet enough of an angel to make you tender when you have to be." Even better, in *Kiss Me, Deadly*: "You're a killer, Mike. You're dirty, nasty, and you don't care how you do it as long as you do it. You've killed and you'll keep killing until you get killed yourself." Reminiscent of Berlin's "a doll I can carry," virtually every female character is frightened to tears at the idea that Hammer might be hurt. In *The Big Kill*, Marsha exclaims: "'Oh, Mike, I knew something happened to you!' She ran into my arms and the tears welled into her eyes." It is worth mentioning that Marsha is pretending to care and will later try to murder Hammer, but Velda is sincere when she "sobbed and bit her lip. 'Oh, Mike, what happened?'" All the women behave in exactly the same way, whether they are innocents in love with Hammer or villains out to kill him. The American philosopher and gender theorist Judith Butler wrote that gender is a performance, but Mickey Spillane makes it a veritable one-liner. "Oh, Mike!" is probably the most frequent utterance in the entire Spillane corpus. As if in recognition of this fact, a 1980 Broadway musical designed around Spillane's stories (but alas never produced) is entitled "Oh, Mike!"[34]

It has been said that the 1950s lockstep rules around feminine conduct were born of men's anxieties about feminine sexuality. Much as *Black Mask* proposed to "kill your enemies for you," Mike Hammer could handle female unruliness for you. He has no need for the double standards that shame women like Lola, nor is he afraid of women who break out from social bonds. One might wonder why, when the alluring woman with soft lips and silky dress turns out to be the murderer time and again, Hammer does not suspect the next alluring woman he meets. In romantic as in political matters, the hard-boiled detective cannot learn from experience yet is a master of the worst-case scenario. Should the seductive woman turn out to be a murderer, he will turn instantaneously from lover to executioner. In either scenario, as in his

anticommunist machinations, he is fearless but prepared. Even when he discovers that Juno Reeves, the beautiful villain in *Vengeance Is Mine!*, is actually a man, he expresses it with showman's flourish: "Juno was a queen, all right, a real, live queen. You know the kind. *Juno was a man!*" The book ends on this line.

The 1950s was not just the decade of containment and cold war; it was also the decade of television. Television at the time was the fastest-growing cultural medium in history. In 1946, one in every eighteen thousand households had a television. By 1960, nine out of every ten households owned one. It is difficult to overstate the influence television held over the American public, given that its principal purpose was to deliver an audience to advertisers.[35] And for the viewer (that is, for pretty much everyone in America), it delivered a constant stream of images accompanied by voice and entertainment punctuated with commercials. Media instructed and validated. Because television took over at the same time that America came to military and economic dominance, the nation developed its own televised identity and attitude. America as a nation had something of the illustrated comic book hero about it, which is why the superhero has been called the United States' "dominant cultural icon." And, of course, the popular Mike Hammer was born of the comic book character Mike Danger. His anthemic posturing gave readers the sense that frustration and explosion had something patriotic about it. Anger feeds on itself, and on images of itself, as does repression.

Image was vital to the hard-boiled hero, even though to be hard-boiled in the 1950s meant rejecting "image" as such. Hard-boiled detectives rarely look in a mirror, unless it is to notice how badly they have been beaten up or how rumpled their clothing is. In looking down for a moment at his suit and socks, Philip Marlowe remarks that he is "calling on a million dollars," but he seems to notice the disconnect between who he is and who he is dressing to visit. Various historians have discussed the rise of what is

called the "commodity self" in the 1950s.[36] This was a correlate to the explosion of commercial media. It meant that one's own identity—what a person thought of him or herself, not to mention of other people—arose from the commodities that person purchased and used. Whereas Warren Susman had described the rise of "personality" as an American phenomenon in the 1920s, the "commodity self" gave that personality a set of accessories, a foundation, a frame. You were a person who owned this, or wore that, or drove this make of car. Even if there was no actual practical consequence to not possessing status symbols, people wanted them. Mike Hammer, however, seems to own almost nothing and brings no product placement or label when it comes to his residence or his things. His gun is the one exception, but (in part because his name is Hammer) it seems a virtual extension of him. The goods and services he delivers are pure force and volatile emotion. (In a curious twist, Mickey Spillane ended up doing Miller beer commercials in the 1980s.) Hammer seemed too busy knocking out villains to think about domestic concerns, consumer goods, or brand reputation. What is more—and this is important for a hard-boiled character in the advertising era—he was never going for "likable." Race Williams's declarative statements had an often comically preening tone, but when Hammer talked about himself, it was usually to say that he was angry, how much he hated someone, or how other people didn't like him. So in a time of forced commercial cheer, Hammer turned out to be a sort of anti-commodity-self: someone who didn't care what others thought.

In the early 1950s, more Americans were listening to radio than watching television, but by the middle of the decade, several popular radio network shows ended, and comedy and variety shows migrated from radio to television. When this happened, and radio became local, stations saw a drop in income. Live shows and in-house bands were no longer practical. To fill the air-

waves, radio stations turned to recorded music. And as the decade went on, that recorded music was increasingly rock and roll, built on a musical basis of black rhythm and blues. Disc jockeys played rock and roll across America. Adolescents loved it, and postwar prosperity provided an audience. When cross-racial audiences grew, rock music came to define a new youth culture in the mid-twentieth century.

During the 1940s and early 1950s, middle-class adults determined American popular music. When rock and roll became popular, teenagers became the principal record buyers. The reactions of churches, schools, and parents' groups were less enthusiastic. Frank Sinatra summed it up in 1957 when he called rock and roll "the most brutal, ugly, degenerate, vicious form of expression it has been my displeasure to hear." He also called it "sly, lewd, in plain fact dirty" and "a rancid-smelling aphrodisiac." This opinion, which Sinatra wrote for a Parisian magazine called *Western World*, recalls much of what was said about Mickey Spillane. He, too, had been called shabby, nasty, lurid, vicious, degenerative, and perverse. As his collaborator and literary executor, Max Allan Collins, wrote, "It is not hard to imagine the furor Spillane caused in those days of Howdy Doody and Ike. Spillane was to mystery writing what Elvis Presley was to popular music."[37]

When Collins compared Spillane to Elvis, he was probably talking about the strutting, the overt sexual energy, and the adoration of women, not to mention the fact of shaking up a medium that had been almost sedate. It could certainly be said that what rock and roll was to the crooning of earlier decades, Spillane's mean streets were to the parlors of Agatha Christie and even the upper-class sitting rooms of Chandler's Los Angeles. It is no coincidence that there is a lot of noise in the Mike Hammer novels: tires squealing, guns blazing, men bellowing, women screaming, drunks shouting. There is also a lot of movement: running, falling, fighting. Earlier hard-boiled detectives had

sidled and murmured, tossing out one-liners in low tones with a cigarette hanging from the corner of their mouths. Hammer wastes no time in cursing the bastards who make the world a dangerous place, and many of his novels end up in a gruesome roar. Look at the end of *My Gun Is Quick*: "Berin had his mouth open, screaming with all the furies of the gods dethroned, but my laugh was even louder. He was still screaming when I pulled the trigger."[38]

If Spillane had started writing in the 1980s, musical comparisons would have connected him to hard rock and heavy metal. Some of his more apocalyptic scenes even find verbatim echoes in the horror punk genre. But when we remember that Spillane published his six main novels between 1947 and 1953, which was just before the era of rock and roll, another musical counterpart comes to mind. Hammer was certainly a little bit rock and roll, but to paraphrase Donny and Marie, he was also a little bit country. He might have had Elvis's hubris, but he was not much of a dancer. In his words, with his patriotism, his concern for the downtrodden, and his sense that he himself might be rotten inside, he is more "Folsom Prison Blues" than "Jailhouse Rock."

Country musicians sang in the first person but not because they claimed exceptional nature. To quote Hank Williams: "When a hillbilly sings . . . what he is singing is the hopes and prayers and dreams of what some call the common people." In this and other respects, country music had a lot in common with the blues. Many country musicians (including Williams) were raised on the blues. On the other side, B. B. King remembers Williams singing "Cold, Cold Heart" and "Your Cheating Heart," remarking that "many things of this sort are just to me another form of blues sung by other people." Country music also focused on social criticism. When Williams reminds the audience in "Too Many Parties and Too Many Pals" that "For every fallen woman, there's a hundred fallen men," he condemns the double standard of sexual conduct

much as Hammer does when he tells Lola that she needn't be ashamed of her conduct, that he has done the same. Country musicians took heartache and social injustice to heart, much as Spillane does.[39]

In 1951, more than a third of recording sales came from country music. At Columbia Records, 40 percent of singles sales were to the country market. Elvis Presley was signed in Nashville and was initially considered a country musician. Bill Haley, whose "Rock around the Clock" was arguably the first rock and roll hit, had sung with a country band and worked as a country music DJ in Pennsylvania. Country and blues musicians took what had been the domain of poetry, namely sharing desire and pain, put it to music, and let people move to it. Mike Hammer does a lot of lamenting, and in so doing, he echoes both country and the blues. In lines like "I had a hundred and forty black horses under me and an hourglass in my hand, laughing like crazy until the tears rolled down my cheeks," and with a gun in hand, he is miles away from an antiseptic Pat Boone covering Little Richard or Fats Domino.[40] When he laments about being washed down the sewer with the rest of the scum, he recalls the bluesy musings of Hank Williams's "Lost Highway."

Spillane's popularity—like the popularity of country music— was about populism. When Hammer talked about the troubles of orphans, fallen women, and the state of the nation, he was covering the same ground as country music. At the same time, the Hammer novels coincided with the rise of rock and roll, which was connected with television and visual media. Thus the sort of adulation Elvis Presley received on the *Ed Sullivan Show* was about celebrity and spectacle, not about the hopes and dreams of the common people. Presley had begun as a country singer but became a rock and roll phenomenon. So it was with Mike Hammer, whose brand of 1950s hard-boiled combined the popular laments of country music with the celebrity of rock.

There is a lot to be said about the dual histories of crime fiction and popular music. They begin in the rock and roll era, because that is when the element of stardom combined with the element of the countercultural. The end of *Kiss Me, Deadly* could be the voice of horror punk or heavy metal: "The flames were teeth that ate, ripping and tearing, into scars of other flames and her voice the shrill sound of death on the loose."[41] Resentment at the direction the country was going could come from more contemporary country music. Hammer's complaints about people bringing this country down have explicit echoes in Merle Haggard's "The Fighting Side of Me" and Toby Keith's "Beer for My Horses."

As Max Collins also wrote: "Like the early Beatles, Spillane knew that using first-person pronouns in his titles would emphasize the personal nature of his hero's quest."[42] The Beatles were not the first to realize the connection, nor were they the first to use first-person pronouns in their titles. Collins was talking about star power. Although Spillane made himself the voice of the common people, talking about our nation and our society, he also reminded readers that he was stronger than most, more attractive to women, and more relentless in his pursuit of justice.

- - - - - - - - - - - - - - - - - - - -

A Rugged Individual

The decade of the 1960s was not big for the hard-boiled. These were years of dystopian literature, including Ken Kesey's *One Flew over the Cuckoo's Nest* (1962), about patients tormented in a mental hospital; Jacqueline Susann's *Valley of the Dolls* (1966), about drugs and failed ambition; and Kurt Vonnegut's fatalistic science fiction World War II novel, *Slaughterhouse Five* (1969). Some works of literature combined reportage and fiction, focusing often on striking departures from the American mainstream. Truman Capote's nonfiction *In Cold Blood* (1966) recounts the murder of a family in Kansas, and Tom Wolfe's *The Electric Kool-Aid Acid Test* (1968) documented the travels—and trips—of Ken Kesey and the Merry Pranksters. Literature of this decade also turned to social criticism and called out for political change. Rachel Carson's *Silent Spring* (1962) inspired modern environmentalism, Betty Friedan's *The Feminine Mystique* (1964) helped unleash a second wave of feminism, and James Baldwin's *The Fire Next Time* (1963) gave literary voice to the civil rights movement.

When it came to crime fiction, some of the most vibrant writing of the 1960s featured straight-up sociopaths (Jim Thompson's *Pop. 1280* and *The Grifters*) and were not detective novels at all.

Other crime novels were about Cold War intrigue (John le Carré's *The Spy Who Came in from the Cold*) or organized crime (Mario Puzo's *The Godfather* [1969]). Mickey Spillane was still publishing, as was Ross Macdonald, whose Lew Archer unearthed repressed secrets. One critic writes that early Archer "sees the genre into impossibility, moving into fictions of self-deception and self-expenditure."[1] What Philip Marlowe said about being "part of the nastiness" at the end of *The Big Sleep* (1939) is expanded in the 1960s, as the individual turned inward. Individual battles against a hostile outside world—corruption, crime, or social injustice—tended to end in defeat. Sometimes, literature did not even show one person with a dominant and reliable narrative perspective. Joseph Heller's satirical, repetitious, and nonchronological *Catch-22* (1961) is a prime example of this.

If the hard-boiled echoes what the American public wishes their politicians would do, or wishes they themselves could do, then there was reason for the genre to lie low through the 1960s. Social justice movements evolved through the power of collective civil disobedience, much of it nonviolent, with individual leaders connected to rather than separated from the masses. When Marian Anderson followed Martin Luther King's 1963 March on Washington with "He's Got the Whole World in His Hands," it wasn't a paean to King's star power; it was about a common cause and a greater good. In some sense, the civil rights era did not need a hard-boiled detective to be a model of exemplarity, because actual political and civil rights leaders—and masses of activists named and unnamed—did the work of exercising moral authority. And they did it in the name of others, on a public stage, in the streets, in churches, and on television for enormous participant audiences.[2] As the decade progressed, bringing enormous social, political, and aesthetic changes, the Vietnam War also heated up, further widening cultural divisions.

It's not that individual power as such was unwelcome. The problem was that in America, it was patently only available to white men. In the 1920s, when Herbert Hoover praised "rugged individualism," he advocated the "individual initiative and enterprise through which our people have grown to unparalleled greatness."[3] Hoover basically argued that the government should allow individuals to succeed of their own accord. In reality, though, obstacles to such success and to equality of opportunity were legion. The toll of violence and the broad opposition to equal rights showed that for many, individualism was much more beloved as a white male entitlement than as a universal principle.

If an ethical person helped other people, that person deserved respect. Race Williams was clear about that in 1926. But how was that ethos supposed to line up with the understanding—decades later—that respect was systematically denied to minorities and women? If white men were the natural paragons of hard-boiled ethics, what would a detective like Williams have to say about white attacks on civil rights demonstrators? And if men were instinctive champions of individualism, how to reconcile this with vigorous male opposition to women's rights? The hard-boiled genre would have to contend with these inconsistencies going forward.

Numerous moments in the civil rights movement set individual rights against oppressive laws. Rosa Parks, whose refusal to move to the back of a bus set off a widespread boycott, was one example of an individual standing up to laws that stepped on her. So were countless people of color who marched for the right to vote, to go to school, to escape substandard housing, to eat at lunch counters, to be employed where they shopped, to support their families, and to be safe in their homes and on the street. So were women who fought for access to jobs, equal pay, credit cards, contraception, abortion, freedom from violence and harassment, for

the right to serve on juries and to attend elite universities. All stood against laws that limited their individual freedoms. But so, too—in his own mind and in the mind of segregationist whites—did George Wallace, governor of Alabama, who placed himself theatrically at the door of the University of Alabama in 1963 to block the entrance of two black students whom a federal judge had ordered admitted. In declaring his platform of "segregation today, segregation tomorrow, and segregation forever," Wallace claimed to be tossing "the gauntlet before the feet of tyranny." In 1956, North Carolina senator Sam Ervin's "Southern Manifesto" vowed to maintain Jim Crow against the "unwarranted exercise of power by the Court." In the following year, Orval Faubus, the governor of Arkansas, called out the National Guard to prevent integration of a high school in Little Rock. He, too, appropriated the language of brave resistance, declaring that he had not been elected to "surrender all our rights as citizens to an all-powerful federal autocracy."[4]

Opponents of equal rights saw themselves entering into a zero-sum battle, wherein the rights of black individuals threatened to intrude on the rights of white individuals, and the rights of women threatened to intrude on the rights of men. But it was the struggle for voting rights in the 1960s that would expose the greatest hypocrisies of white individualism, much as the struggle for female suffrage had exposed hypocrisies of male individualism leading up to 1920. The vote was a concrete indicator of an adult American's individual existence. Writing for the majority in the 1963 *Gray v. Sanders*, Justice William Douglas stated: "The concept of 'we the people' under the constitution visualizes no preferred class of voters, but equality among those who meet the basic qualifications. . . . The conception of political equality from the Declaration of Independence, to Lincoln's Gettysburg Address, to the Fifteenth, Seventeenth, and Nineteenth Amendments can mean only one thing—one person, one vote." On its face, this expression of an American individual's rights could

hardly be objectionable to those advocating "equality of op-portunity." In practice, though, an arsenal of discriminatory measures—literacy tests, and later, voter ID restrictions, limita-tions on early voting, and closing of polling places—would disen-franchise millions of African Americans and prevent them from participating fully in the nation's democratic process. This dis-enfranchisement continues to the present day and shows no im-mediate signs of abating.[5]

Activists who fought for the voting rights of black Americans never proposed to limit those rights for whites. Those who fought for the rights of black Americans to attend good schools or pur-chase houses in upscale neighborhoods never proposed to limit the rights of whites to do those things. Similarly, women who wanted to pursue the professions of their choice never viewed it in terms of "taking a spot from a qualified man," although many men viewed it this way and sometimes still do.[6] Nonetheless, it was clear that for numerous members of the white male majority, individualism was no universal imperative. Instead, it was a commodity to be rationed. Social and legal mechanisms that maintained white male superiority seemed more important than freedoms for actual individuals. The hard-boiled was too connected with the idea of individual freedom to ignore these blatant instances of hypocrisy. It was heavily invested in Hoover-style individualism, an ideal limited to white men, and was reluctant to face its double standards head-on.

As an early leader of the Black Panther Party put it in a fre-quently quoted phrase, "There is no more neutrality in the world. You either have to be part of the solution, or you're going to be part of the problem."[7] By this measure, Race Williams could well have been part of the problem. In a historical period increasingly con-scious that individual rights and responsibilities were really reserved for certain individuals, Race Williams's grandiose "my ethics are my own" would have been out of step. Even if one were to

set aside the content of the Race Williams stories—the character's casual comments on the advantages of Klan membership come to mind—Williams's nonchalant references to freedom achieved under his own steam were based on the illusion of an egalitarian society. In fact, these references had always been specific to people whose individualism as such encountered no real obstacle. Nobody had told Williams that his ethics shouldn't be his own or that he didn't have the power to choose them. He made enemies, and he boasted about them, but he never lost the power—not to mention the basic legal right—to use his voice and stand up for what he believed. Consider also Philip Marlowe, who murmurs, "I was part of the nastiness now" at the end of *The Big Sleep*. He, too, would be out of tune with the ethos of the civil rights era. It wasn't enough to lament that you were part of the nastiness; in the 1960s, you were supposed to go out there and do something about it.

The women's movement posed a particular challenge to the hard-boiled male. The idea of men as benevolent protectors of women, no matter how fictitious and how disadvantageous to women, was deeply rooted in American tradition. It was the bedrock of American manhood. What is more, many women bought into this notion, which made the road to women's equality complicated. The idea of whites as the benevolent protectors of blacks was believable to no one, but the idea of the protective man proved durable.

The vast majority of African Americans supported the civil rights movement, but the same could not be said about women supporting feminism. As Flora Davis writes in her history of the women's movement, "Social movements aren't formed by isolated individuals who somehow find one another and band together; they almost always develop out of networks already in place."[8] Female networks, though, were usually subordinated to other networks based on race and class. Most feminist activists were white

and middle class, even though black and working-class women had been supporting feminist goals—often with little support from white women—for years. Many black women were reluctant to join a movement that dismissed or actively opposed the concerns of African Americans. And many white women were reluctant to join with black women to subvert male dominance, deciding that what was good for their white husbands would be good for them. By the 1960s, women had been divided for decades over the issue of the Equal Rights Amendment. Homophobia further impeded the movement, as the National Organization for Women and its president, Betty Friedan, tried to keep the "lavender menace" out of feminism. Nonetheless, the women's movement made significant strides through the civil rights era.

When it came to women, the hard-boiled was stuck in the era of a giggling Carmen Sternwood. Crime fiction did as much to hold women in their place as it did to give all individuals access to individualism. It suggested to male readers that being a hero and a gentleman would not necessarily entail giving ground to women and, furthermore, that women wouldn't want them to. That promise would also have to be renegotiated in the hard-boiled crime fiction to follow in the next decade. It would become harder—but not impossible—to find women content to exclaim, "Oh, Mike!" in a breathless voice.

When Martin Luther King Jr. was assassinated in Memphis on April 4, 1968, the nation went into mourning. King's murder brought about a national outcry, and riots exploded in more than one hundred American cities. One of the national leaders who responded to King's assassination was JFK's younger brother Robert, who had managed his brother's presidential campaign, encouraged him to embrace civil rights, and served under him as attorney general. In 1968, two months after Martin Luther King was shot, while Robert Kennedy was campaigning in California for the Democratic presidential nomination, he, too, was

assassinated. Historians are divided on whether Kennedy could have won the presidency, or even the Democratic nomination, had his life not been cut short.[9] But there is no doubt that his murder, coming on the heels of King's assassination, left an enormous sense of lost possibility—the possibility of getting out of Vietnam, of bridging the nation's racial divide, of improving conditions for the poor. Though Nixon—running as the "law and order" candidate—won the 1968 election by fewer than five hundred thousand votes, he then beat George McGovern in 1972 by a large margin. That victory, however, was the beginning of the end. It was soon overshadowed by the Watergate scandal.

If we understand the hard-boiled character to stand for honesty, understatement of one's own troubles, and commitment to principle, then Nixon was one of the least hard-boiled leaders in American memory. And if hope diminished with the murders of Martin Luther King Jr. and Robert Kennedy, the revelation of Nixon's crimes and lies created subterranean lows. In the wake of Watergate, Nixon directed the White House counsel to hide the administration's involvement, refused to submit recordings, ordered the firing of the special prosecutor, and submitted erased tapes and edited transcripts. In short, he concealed his guilt as long as he could. On August 5, 1974, after months of bluster and invalidated claims of executive privilege, Nixon released the proverbial smoking gun: the incriminating tape of a July 1973 meeting that revealed he had ordered the FBI to stop investigating the Watergate burglary. Three days later, facing certain impeachment, he relented, asked Secretary of State Kissinger to join him in prayer, and resigned the presidency. Sixty-nine people were indicted as a result of Watergate, many of them top Nixon officials.

When it came to the hard-boiled principle of understanding others' troubles while understating one's own, Nixon did the opposite. In 1973, the White House distributed to members of Congress a Vietnam White Paper, containing impressive levels of

self-pity: "No President has been under more constant and unremitting harassment by men who should drop to their knees each night to thank the Almighty that they do not have to make the same decisions that Richard Nixon did."[10] In subsequent interviews, talking about American failure in Vietnam, Nixon continued to insist on seeing himself as a victim of circumstance.

Nixon's fall from grace underscored the absence of an honest leader. As it happened, the fall of the president coincided with the diminishment of the nation as a military power, as the US headed toward defeat in Vietnam. More than a million North Vietnamese and Viet Cong soldiers died in that war, as did more than two hundred thousand South Vietnamese and almost sixty thousand Americans. Up to two million Vietnamese civilians also lost their lives. Growing numbers of Americans opposed the war, and protests divided the country. At a protest at Kent State University in May of 1970, national guardsmen shot and killed four unarmed students. At a protest at Jackson State University the same month, police killed two students and injured twelve.

The very way that America exited the war, leaving South Vietnamese allies to the mercy of the North Vietnamese after promising them that no one would be left behind, generated the antithesis of national pride. At the end of World War II, American soldiers had been hailed as saviors in Europe and heroes at home. And even then, with a victory in hand and with the US position as a global military superpower well-cemented, the fact of posttraumatic stress had to be addressed. In the case of Vietnam, America's perception as a world power became both weak and cynical—devoid of moral authority and military might.

The vast disillusionment around American authority coincided with a strong resurgence in hard-boiled literature and television. In 1973, Robert Parker published *The Godwulf Manuscript*. His detective would appear in thirty-eight more novels before the author's death in 2010. Television also got into the act, with a

veritable squad room full of eponymous detectives crowding the screen in the first half of the decade.

As it had been in previous decades, the job of the 1970s hard-boiled was to enter whatever situation America found itself in at the time and to respond to its needs: to be on the right side of justice but not to be a countercultural hippie, drug user, or Woodstock-goer; to remember when America was more formal and well-mannered but not to want to return there; to support women's desire to be treated with respect but also to be paternalistic and dismissive when it suited him; to support civil rights but nonetheless operate with the historic entitlements of the white man. What is more, because maverick unconventionality remained at a premium, it was important to maintain some ironic distance from the numerous character clichés of the late 1960s and early 1970s: the laid-back hippie, the establishment reactionary, etc. This was a tall order, and in some ways an impossible one. But in 1973, Robert Parker took up the challenge.

...

The 1970s detective would not be an American pacifist ready to burn his draft card down on Main Street, nor would he be a Lieutenant Calley, murdering civilians and singing his own battle hymn. Detectives of this era attempted at once to recreate and to atone for a manliness of the past in order to situate themselves in the strange new present. Parker's introduction of Spenser became the main event in 1970s hard-boiled literature. Parker had a PhD in English and wrote his dissertation at Boston University on Chandler, Hammett, and Ross Macdonald. He later took the hard-boiled step of denouncing his own academic endeavor, noting that he had written the dissertation in two weeks and that that was "about what it's worth."[11] He did, however, say—in more than one interview—that he had started out wanting to recreate Philip Marlowe and took from Chandler the idea of an English Renais-

sance name. The name he chose for his own detective was that of a poet who chronicled the heroic acts of medieval knights, even if these were rather thin on the ground in the American 1970s.

Spenser was raised by his father and brothers after his mother died in childbirth. He is a former boxer, Massachusetts state trooper, and serviceman in the Korean War, making him at least forty years old in the first of Parker's novels. His "former" identities borrow from previous American grandeur and nod to its fadedness. Spenser has a sardonic nostalgia, but rather than being a self-aggrandizing or bitter has-been, he thrives in the cultural weeds of the early 1970s. He is kind to others, ready to protect the weak, and is indestructible. Spenser is also clever and poetic, fond of quoting Wallace Stevens. He is even a gourmet cook, though he notes that if he were a woman, no one would call him a gourmet; they would just call him a housewife. One critic remarked that Parker had essentially created a hard-boiled superhero, noting Spenser's bulletproof build and moral toughness.[12] But despite some improbably impressive fighting skills, he also deals with the human concerns of how to be a responsible individual, a male adult, and an instrument of justice in a time of widespread disillusion.

The Godwulf Manuscript is set at a university, complete with left-wing students, drugs on campus, and a cast of pompous establishment characters. Rendering the generational chasm that had developed in the 1960s, it makes clear that the 1970s hardboiled would operate in the middle of modern culture wars. But the social landscape of the 1970s was a challenge for the sort of individualism that Philip Marlowe demonstrated. For one thing, being moral in the 1970s meant being socially conscious. It meant being aware of the problems of others, not just of individuals but of groups. But being socially conscious sometimes meant spouting the well-worn lines of existing social justice movements, which diluted maverick individualism. How was the hard-boiled

to have an ethics of his own that eschewed conventional wisdom and at the same time stand on the right side of history?

When asked in an interview about the crucial ingredients of a good crime novel, Parker said that "the most important ingredient in any novel is Character, Character and Character."[13] Raymond Chandler had described the ideal hero in 1945: "He must be, to use a rather weathered phrase, a man of honor—by instinct, by inevitability, without thought of it, and certainly without saying it. He must be the best man in his world and a good enough man for any world." Being a man of honor in the aftermath of the 1960s meant living by the principles of social justice movements of the period without seeming even to be aware that the movements existed. It also meant supporting other characters who operated in the same way. And it meant supporting—not as group members but as individuals—the people whose liberties the civil rights and women's movements would make possible. Yet it also meant striding around with the same entitlements that white men had long enjoyed.

In *Godwulf*, a student member of the anticapitalist committee tells Spenser not to laugh at the group, saying that they are "perfectly serious and perfectly right." Spenser answers that so is everyone else he knows. In a world that revolves around ideologies and declarations of righteousness, Spenser is glad to meet people who don't take themselves too seriously. The cast of supporting characters is populated by friends of different genders and colors who operate on principle without saying so, who are more about the walk than the talk. This is part of the hard-boiled principle of understatement; other people's pain is to be taken seriously, but one's own is not. But it is also a signal that the hard-boiled is beginning to change his parameters.

One of the more sympathetic characters in *Godwulf* is Iris Milford, a worker at the school newspaper who, when Spenser asks her if she's ever taken LSD, responds that she is "fat, black,

widowed, pushing thirty, and got four kids," adding that she "don't need no additional problems."[14] But that is all she says about her own situation; the rest of her role in the novel is as detector and informant with strong observational skills. Spenser, too, spends time noticing people, particularly those who could be invisible to the rest of the world. For instance, when he sees a Puerto Rican kid mopping the floor of a coffee shop at 6:40 a.m., he remarks that the kid must have gotten up very early to come in and mop the floor, and wondered how late he would stay that night.

A good deal of what passes for hard-boiled authority is noticing what is missing. The detective sees that the world is not what it should be, or what it once was, but he is clear-eyed enough to doubt that the panacea ever existed. As it happened, the 1970s were a time of considerable nostalgia—for a more exalted American identity, for a simpler time, for more economic prosperity, for politicians who operate on some sense of principle. The 1950s are the decade most cherished in 1970s nostalgia, but so, too— ironically—are the 1930s. As William Stott put it, the 1930s were an era of "national bankruptcy but civic peace." The problem was that a good deal of the "civic peace" that people mourned was what countless others had fought to escape. Just as the 2016 resurrection of Reagan's 1980 "Make America Great Again" was a transparent call to reassert white male dominance, much wistfulness for the 1950s and 1930s was reactionary. Reruns of 1950s sitcoms were popular in the 1970s (as were sitcoms set in the 1950s), and although these recalled "more stable and simpler times," they also showed most women as placid housewives and featured almost no characters who were not white. Spenser seems to get this. When he is tired of the chaos at the university, he muses that he wants to get in his car and drive north: "In my mind I could see the route . . . where there's a kind of mellowness and a memory of another time and another America. Probably never was another America though." Another time, he encounters "a miasma

of profanity and smoke and sweatiness under heavy winter coats" and wonders, "Ah, where are the white bucks of yesteryear?"[15]

He has no actual fondness for reactionary well-to-do college students, of course. This is a way to mock the unwashed hippies of the present day *and* the super-clean 1950s model students that populated sitcom reruns. In other words, it's a way to distance himself from the present day and from nostalgia itself. The fact was that none of the past decades would come back. If you missed the days when white men owned the world's rights and responsibilities, then you were fated to be a punchline in a Robert Parker novel, not to be a hard-boiled detective. If you missed being part of a community, you could create one and be of service to those around you. As national franchises eclipsed small businesses, Americans became nostalgic for local attachments. It might have been convenient to buy your aspirin at Walgreen's, have your hair cut at Fantastic Sam's, and get your jeans at the Gap no matter where in the country you were, but it was ultimately a generic experience. Having a private detective around made the world seem small again. And what is more, it made law enforcement seem homespun.

One important element of 1950s and 1930s life that was missing in the 1970s was a solid model of adulthood. In the earlier days of the hard-boiled, Chandler had echoed Roosevelt, who had famously stated that "the test of our progress is not whether we add more to the abundance of those who have much; it is whether we provide enough for those who have too little."[16] But the political and paternal model of the 1970s is Richard Nixon, who serves as a model less for heroic service than for rather spectacular weaseliness.

In *Godwulf*, the investigation ends up on the English professor Hayden, whom Iris describes as "one of those little pale guys with long, limp blond hair that looks like he hasn't started to shave yet, but he's like thirty-nine." The early 1970s, it would seem, are full of pale white guys not sure how to be an adult. Lying on television

is not the way to do it, but neither is paying lip service to social justice. As Professor Hayden is being questioned—and solemnly declaring that he will die without incriminating himself—Spenser muses that in a minute he'd start addressing Spenser as "my fellow Americans."[17] But Hayden is no JFK. The man who fancies that he holds the keys to the kingdom, who trades on social justice but pursues individual glory, is a particular 1970s brand of abomination. Cornered by Spenser at the end of the novel, Professor Hayden cowers in the bathtub, having wet himself.

The early 1970s were a heady time for civil rights and feminism. Spenser dives right in. Or rather, he dives in and stays in the boat at the same time. When it comes to women and people of color, he alternates between woke compassion and white self-satisfaction. In *Promised Land* (1976), he reprimands a character who calls Hawk a "nigger" and, at the end of the novel, warns Hawk that police are coming, preventing his arrest. But Spenser's respect for Hawk ends up making Spenser, not Hawk, seem more complex and human. He anticipates numerous American stories that describe interracial friendships but still manage to be all about the white person. And Hawk remains comparatively unidimensional.[18] When it comes to balancing civil rights with white entitlement, Spenser tends to have his cake and eat it too.

When it came to the relationship between blacks and whites, it was easy to see how paternalism was code for control and condescension. It would have been socially unacceptable—for a self-proclaimed honorable man in Boston in 1973—to lament the advances of the civil rights movement. The hard-boiled way to deal with civil rights was to act like it was a given, even when you simultaneously treated people of color as inscrutable accessories. But the women's movement was another story.

...

Robert Parker sent Spenser into the middle of some fraught conversations about feminism. Not only did plots center on bad

mothers (*God Save the Child* [1974]), prostitutes made good (*Mortal Stakes* [1975]), and murderous feminists (*Promised Land*), but Spenser was in a long-term relationship with a divorced school psychologist, Susan Silverman, with whom he did a lot of communicating. Early on in *Promised Land*, a man hires Spenser to find his wife. Spenser comments that runaway wives have read two issues of *Ms.* magazine and seen Marlo Thomas on television and decided they can't go on. Susan takes him to task for his contemptuous air and proposes she knows better than he does what the woman might be going through. She accuses Spenser of assuming the missing wife ran away for "a feminist reason," and Spenser admits that he should not have made that assumption.

Betty Friedan's 1964 *The Feminine Mystique* is often cited as the start of the women's movement because it broke the silence surrounding women's supposed contentment with their place in the world. Despite the existence of the National Organization for Women, however, women did not—and do not—band together as a "network" as other disadvantaged groups did. Many of women's battles took place in private conversations—with a husband she needed to tell to do his share of the household chores or with a boss she needed to ask several times for a raise (if he would even consider it). Men had to learn that the rights and responsibilities of American women occupied the same air as theirs. Real women talked as much as men, thought as much as men, and wanted as much as men.[19] For a man to decide unilaterally what women wanted and needed was as untenable as the "separate but equal" laws of the pre–civil rights era. Feminism could conceivably, however, create a challenge for a hard-boiled man, whose contact with women was usually about outsmarting a villain, saving a victim, or finding an admirer.

Robert Parker introduced Susan Silverman in the second Spenser novel, and a lot of her conversations with Spenser focused on each person's need for freedom and desire for a reliable

companion. Because Parker wrote dozens of Spenser novels, there were a lot of these conversations, and because Susan was a psychologist, these conversations tended to sound like those from 1970s encounter groups. Each person listened to the other, and each person's emotions were validated in warm and witty repartee. Readers, though, as evidenced in letters to the author and in blog posts that continued long after Parker's death, did not necessarily want to see these conversations. They flat out didn't want to see Susan. Spenser could coexist with Hawk, a laconic soldier of fortune, but many Parker fans called Susan "insufferable" and "unbearable" and wished she would vanish so that Spenser could take care of business, get the upper hand, thwart conspiracies, and bust heads.

The fact that Spenser is willing to have his conversations with Susan is a testament to the fact that the hard-boiled lives in the real world, complete with emotional attachments and changing social mores. Parker's insistence on putting the relationship front and center may have been an echo of his own marriage. But the fact that Parker readers disapproved, sometimes vehemently, of Susan also suggests that the hard-boiled was a refuge for male traditionalism, a place where men could maintain their economic, political, and social dominance. It wasn't easy for a hard-boiled detective to be a wholehearted friend of the women's movement. To a large extent, the history of the American hard-boiled detective is the history of obstacles, both subtle and not-so-subtle, to the American women's movement.

The fact that men lived in intimate relationships with women did not necessarily make them embrace the women's movement. In every novel, Spenser mocks some incarnation of the liberated woman. Sometimes it is the free spirit who ignores her children and wants to cultivate her artistic temperament. Sometimes it is the woman who talks about herself, drinks too much, and flirts inappropriately at parties. Sometimes it is the women who are

physically unattractive. But it is always something. In many ways, there was no arena for women to just *be*, no action or opinion or image that did not provoke a vigorous male reaction. Sometimes the reaction was admiring, sometimes contemptuous, but it was always there, and it was always loud. It took up more space than the female action that inspired it. Moreover, women's claim to the same rights and responsibilities as men tended to get presented as aggressive rather than as instinctive or natural. A man advocating for the right to liberty, freedom, and equal opportunity seemed heroic and inspiring. But a woman in pursuit of the same principles came across as strident and self-absorbed. As Susan herself says when discussing the woman in *Promised Land* who had left her husband: "You assumed a feminist reason."[20] If you were a feminist, you were overly focused on your own experience. You were selfish, not an individualist—a complainer, an encounter group gone wrong. And that was something that the free-spirited male detective could criticize you for.

Second-wave feminism raised serious social justice issues, but popular culture images of women showed them insisting on looking good and having fun. Consider the iconic ad for 1973 Charlie perfume ("kinda young, kinda now, kinda free, kinda wow!"). Shelley Hack, clad in an elegant pantsuit, pulls up in an expensive car and heads into a restaurant to meet her date. (In that same year, in stark contrast, Stephen King's first novel, *Carrie*, draws a murderous picture of a young woman who doesn't get what she wants.) Television and print advertisements presented women as practical but sublime, hardworking but ethereal. It was an incoherent and impossible compendium of qualities. By the mid-1970s, nearly half of America's women were working outside the home, but "Wondra lotion [would take] the day's work right out of your hands." Commercials for White Owl cigars showed women draped on the shoulders of their husbands, smiling as the men blew smoke in their faces. An ad for Beautymist pantyhose showed

Joe Namath wearing stockings, laughing, and saying that he didn't wear pantyhose but that if Beautymist could make his legs look good, imagine what they could do for yours! He is rewarded with an adoring kiss from a female model, who presumably would continue wearing pantyhose even though they were undoubtedly just as uncomfortable for her as they were for Joe Namath, who would never think of putting them on again.

You had only to look at the ads and television shows of the period to know that the 1950s conventions were still alive and well—and relentless for women in America. And you could also see that the joke was on women—that women were expected to take care of their appearance rather than their own best interests and to laugh at the time spent doing so. Popular culture's insistence on showcasing fun-loving women was no accident. From the start, humorlessness was held against the women's movement in ways that it never had been against the civil rights movement.

When Spenser first meets the professor's wife in *Godwulf*, he describes her as a "big, hatchet-faced woman" wearing "Gloria Steinem glasses." Mrs. Hayden is clad in brown corduroy pants, leather sandals, and a gray sweatshirt, articles of clothing that no previous hard-boiled author would even have acknowledged as existing. This woman body-blocks a hitman and dies protecting her cheating husband, but what sticks with the reader is that she is "as lean and as hard as a canoe paddle, and nearly as sexy" (an echo of Raymond Chandler). A woman who isn't good-looking is an easy mark, not just for men who mistreat them but for writers who saw women as ridiculous. Spenser introduces Susan Silverman by saying that she wasn't beautiful but that "there was a tangibility about her, a physical reality, that made the secretary with the lime-green bosom seem insubstantial."[21] As the novels continue, he does admire her looks, as well as those of other women. Spenser's entire conduct is a testament to male ambivalence about women. On the one hand, he could accept a woman as complete

and three-dimensional as he was. On the other hand, he populated his hard-boiled landscape with countless women who were humorless, unattractive, or vacuous. These cardboard cutouts—and their ripeness for one-line ridicule—were as important to Spenser's power as his muscles and his gun.

Back in the 1950s, Mickey Spillane's Mike Hammer was enough a man of his time to complain about the Commies he hated with a vitriol that placed him squarely in the postwar period. Spenser also notices what is going on in politics, mentioning, for instance, that he never thought that Nixon would be president and commenting on Hoover's treatment of radicals.[22] But Spenser was also the first detective to notice and comment on popular culture as a phenomenon—to talk about books and movies and television shows and to recognize that these media created a common American vernacular. He was a cultural critic as well as a detective, able to mock the 1970s as they were happening.

In *Mortal Stakes*, Spenser poses as a writer to investigate a pitcher's possible collusion in fixing games. The team's owner asks him to think up a title for his fictitious book, so as to support his cover, and Spenser's responses amount to a comical tour through late 1960s and early 1970s popular literature. "*The Sensuous Baseball?*" he proposes, playing on those quintessentially 1970s volumes *The Sensuous Woman* (1969) and *The Sensuous Man* (1971). He also proposes *Valley of the Bat Boys*, riffing on *Valley of the Dolls*, and *The Balls of Summer*, a takeoff on *The Boys of Summer* (1972). When he finally settles on *The Summer Season*, his client looks relieved.[23]

One way we know Spenser operates in the present is that every novel has a television running in the background—at his house, at other people's houses, in bars, in his motel room. Sometimes these TVs are a vague noise, and other times specific shows (*Hollywood Squares*, a Mets game, a talk show) are playing. The early 1970s were big years for American television, as well as for a gradual

increase in diversity of actor/character representation. Americans of all colors and sexes began to find an audience. Marlo Thomas, whom Spenser blames for housewives running off to find satisfaction, starred in *That Girl* from 1966 to 1971. *Maude*, which ran from 1972 to 1978, starred Bea Arthur as an outspoken Democrat married to her fourth husband. The *Mary Tyler Moore Show* ran from 1970 to 1977 and spawned a spinoff, *Rhoda* (1974–78). *Sanford and Son*, NBC's response to *All in the Family*, aired from 1972 to 1977. *Good Times*, the first all-black family television sit-com, came to CBS in 1974 and aired until 1979. It was followed by *The Jeffersons*, which aired for ten years.

In *Promised Land*, Spenser offers help to the police department about "possible criminal activity in your jurisdiction." The policeman makes fun of his cop-language and says he should stop watching those TV crime shows, that he sounds like Perry Mason.[24] This was timely, since *The New Perry Mason* had started to air in 1973. But to be fair, if you watched prime-time television in the early 1970s—and most Americans did—it would be hard *not* to watch a crime drama.

So when the cop mocks Spenser about watching crime shows, he does so in the golden age of television detectives. Early 1970s television saw more than a dozen eponymous detectives come and go, some of them holdovers from the late 1960s and many newly released. In 1972–73, you could see *The Rookies* on Monday, *Hawaii Five-o* on Tuesday, *Adam-12* on Wednesday, and *Ironside* on Thursday. Saturday gave you *The Streets of San Francisco*. On Sunday you could watch the NBC Sunday Mystery Movie, which consisted of *Columbo*, *McCloud*, or *McMillan and Wife*. Starting in 1973–74 you had *The New Perry Mason* on Sundays, followed by *Mannix* and *Barnaby Jones*. Wednesdays offered *Cannon*, followed by *Kojak*, both holding down places in the season's top ten. The NBC Sunday mystery movie offered *Banacek*, *Tenafly*, and *The Snoop Sisters*.[25] The 1974–75 lineup put *Kojak* and *Mannix* together

on Sundays. Every evening offered a dose of crime shows: Wednesdays had *Cannon* and *Baretta*, and Thursdays put *Harry O* on the heels of *The Streets of San Francisco*. On Friday, you could enjoy *The Rockford Files* and then choose between *Police Woman*, *Baretta* (twice in a week!), and *Kolchak: The Night Stalker*. Television made it seem as though countless American heroes drove fast cars, were easy on the eyes and smooth with the ladies, and stood ready to protect you from whatever sleaziness the decade had to offer.

If we understand fictional detectives to be wishful American self-portraits, then the sheer multitude of these characters was telling. Just like the classic hard-boiled detectives of the 1930s and 1940s, television detectives navigated American identity and individualism. They also dealt with how to be principled in the time of civil rights, how to be a man's man in the era of the women's movement, and how to represent justice when the entire concept had Americans shaking their heads. It didn't matter how bewildered you were in the face of criminal violence and changing cultural mores; the important thing was to remain standing. Every detective did things a little differently, and the shakiness of that hold was its own lesson. But at the end of the day, just like in the earlier decades of the twentieth century, the detectives of the 1970s would tell Americans what was possible. What's more, they would even blur—and arguably eliminate—the line between reality and fiction. The 1970s television detectives came to the screen around the time of Nixon's deceptions, and their easy banter and familiar faces presented characters that audiences could trust. These were characters that audiences liked and wanted to return to week after week. They ended up providing models of frankness and strength that impacted—be it consciously or unconsciously— what Americans would look for in their future political leaders.

Some of the popularity of crime dramas can be put down to the popularity of television. The remaining portion can be attributed

to public anxiety about urban crime. The 1970s saw American cities in social and economic decline, as urban populations decreased and people moved to the suburbs. Still, it is probably not a coincidence that the golden age of television detectives arrived as America underwent a momentous crisis in moral and national authority. Using sight and sound, television literally brought the characters home to viewers. Because TV detectives were played by real people and were embodied in actual faces, you could look into their eyes and see them anguished about a case. They seemed real. This encouraged a sense of viewer connection. In many ways, it was the same kind of connection audiences had with politicians on TV. What is more, detectives spoke about principles, justice, and holding others accountable, and they operated in the same philosophical arena, not to mention in the same medium, as national leaders.

A politician talking on television in the 1970s was not the same thing as Roosevelt giving a "fireside chat." There was a level of performance and fabrication that had not existed in the years before television and teleprompters. (In 1954, Eisenhower was the first president to address the nation from a teleprompter.) Despite the fact that television was the home of pretense, it somehow ended up front and center in the nation's search for an honest man. This is where the hard-boiled detective came in. Nixon brought a level of disbelief to politics but also to the very concept of practiced public address. If you declared you were going to act in the public interest and tell the people the truth, you were probably lying. If you said you weren't a crook, you probably were. But if you lived in a trailer by the beach, subsisted from paycheck to paycheck, and got beat up on a regular basis while trying to help people in trouble, you were closer to being the kind of down-to-earth character viewers could believe in.

Most television detectives had nothing to do with politics, except when a plotline brought them in contact with some corrupt

congressman or candidate. The problem was that the very real-
ness of the characters—not just the fact that they were believable
as characters but that they were being voiced and played by actual
human beings—distorted the line between fiction and reality. This
distortion would prove problematic in the realm of politics. Audi-
ences responded to the openness of TV characters or, rather, to
their performance of openness. It made for some very popular
prime-time television. But it also meant that if a calculating actor
were ever to run for political office, should he turn on an act of
honesty, toughness, and caring, audiences would be primed to
embrace him.

Some TV detectives worked for police departments and others
were lone operators, but soon the independent detectives outnum-
bered those who wore a badge. Among the independents, some
ran their game in New York, some in San Francisco, others in Bos-
ton or Chicago. Some of the most popular mean streets were in
Southern California, which was home to two of the best TV de-
tectives of the decade, namely James Rockford (*The Rockford Files*)
and Harry Orwell (*Harry O*). David Thorburn called these detec-
tives the primary examples of complex characters in character-
driven stories, and while recent years have provided some strong
competition, his assessment is still tenable.[26] There is something
historically important going on with these kind and wounded
middle-aged men. In the midst of an economic and moral crisis,
with the United States seemingly on vacation from its role as
exemplary world superpower, they are modern-day versions of
Hammett's Continental Op.

Like the Continental Op, both Rockford and Harry Orwell
come to the scene with visible mileage on them. David Janssen
was forty-two years old when he started playing the titular char-
acter in *Harry O*, having played law-abiding citizens in *Richard
Diamond, Private Detective* (1957–60), *The Fugitive* (1963–67), and

O'Hara, U.S. Treasury (1971–72). James Garner was forty-six years old when Stephen Cannell and Roy Huggins cast him in *The Rockford Files*. Garner had played Bret Maverick in the Old West series *Maverick* (also created by Huggins), as well as the titular sheriff in the short-lived drama *Nichols*, which took place in 1914 Arizona. *The Rockford Files* and *Harry O* took these veterans of television justice, these men almost past their prime, and set them in the unsparing glare of contemporary California sunshine.

As the Op had said about his own investigative process, thinking was a dizzy business, "a matter of catching as many of those foggy glimpses as you can and fitting them together the best you can." Rockford and Harry both operated on foggy glimpses. Garner's face alternated between baffled, pained, and amused, while Janssen could seem lost in solitude. Rockford had served time in prison for a crime he didn't commit; he didn't carry a gun, seemed nervous around weapons, and often got beat up. Harry Orwell, low-key and thoughtful, was retired and on disability from the San Diego Police Department. He lived on the beach, repairing his boat, *The Answer*. One critic called Harry O a "quiet, wistful creation."[27] Both of them—like the Op—were accustomed to constant physical discomfort—Rockford because he was so often being punched in the face, Harry O because he had a bullet lodged in his spine.

There is a good amount of clumsiness and vulnerability on the part of both detectives: Harry's car is always broken down, and Rockford's checks bounce at the market. Yet both men bring a solid sense of ethics to the small screen. When a potential client asks Rockford to find her fiancé—the same fiancé that her father had already hired Rockford to look into—he tells her that he's got a little problem of professional ethics he has to clear up first. When she then asks what kind of ethics a private detective has to have, his answer is something Race Williams might have come up with:

Actor David Janssen (*left*) was a forty-two-year-old veteran of *Richard Diamond, Private Detective*, *The Fugitive*, and *O'Hara, U.S. Treasury* when he was cast as the titular character in *Harry O* in 1974. James Garner (*right*) won a best dramatic actor Emmy for his role in *The Rockford Files* in 1977. David Chase, who would later create *The Sopranos* for HBO, started writing for *Rockford* in that year. Photograph of David Janssen courtesy of Alamy Stock Photo

"My own kind, has to do with shaving and looking into mirrors, a lot of other trite stuff you've probably heard before. Let me see if I can work it out."[28]

Harry does not talk about his ethics but about knowing who he is and what he wants. In one episode, a woman (played by Linda Evans) asks him what he needs, and he responds, "Not much more than I have. A few friends, a little room, time to find out what I want and what I am." Linda Evans says that too much room makes her anxious, that she doesn't have friends, and that what she does when she starts to suffocate is "drink, turn on, find a man." She asks Harry if he is interested, and he responds that he doesn't make love unless he's in love: "It's got to be a hell of a lot more for me than just therapy to keep from screaming." Later, he goes to her to apologize and admits that he needs some strings, at which point the characters embrace and the camera cuts to the aftermath of a love scene in which—for some reason—both he and Linda Evans are still wearing button-down shirts.[29]

Both Harry O and Rockford shared various qualities with the actual men who played them. James Garner loved to drive as much as Rockford did. He owned American International racers in the 1960s. Garner drove a Pontiac Trans Am but made sure his character had a Firebird, which he called "more of a blue-collar car."[30] As a series executive, he inspired competence in those who worked with him. As Garner put it, "I like to let people do what they do. I think you get better work that way. They know that they won't have somebody looking over their shoulder all the time."[31] Garner grew up in Depression-era Oklahoma, raised by an abusive alcoholic father. He won two Purple Hearts in Korea. As for Janssen, he was a voracious reader, much like Harry, who would quote Shakespeare during investigations. Unfortunately, other points of intersection between Harry O and David Janssen were more ominous. As Harry runs up the stairs in the opening credits of the early episodes, he pauses to breathe heavily; Janssen would die of a massive heart attack at the age of forty-eight.

At the end of Robert Parker's *Promised Land*, Susan praises Spenser for being the adult in the room and calls him "the ultimate man, the ultimate adult in some ways, the great powerful protecting father." In much the same way, Harry and Rockford stood for father figures of some sort.[32] But whereas Spenser paid his bills on time and remained the strongest man in the room, Rockford and Harry O seemed rather marginal, in the geographic and the professional sense. Both operated out of run-down homes (in Rockford's case a trailer) on the beach in California—any farther west and they'd be in the ocean. In their own ways, both characters are living improvised lives. Neither of them can transcend the day-to-day troubles of existence, but neither seems to want to. They simply show up, they tell the truth, and are kind to those who need help, which lets them be the sort of subtle beacon that the Continental Op was back in the day. As Thorburn put it, using a vocabulary not in use in the 1930s, they were "adult drop-outs"

of a sort. But they also served to show that when it came to the 1970s hard-boiled, detectives were content to live in a small world.

The universe in which Harry and Rockford operate is a local one. Neither man is looking to make an impact on—or a statement about—corruption in the world at large. Southern California in these TV programs was worlds away from the well-dressed gangsters and cool bungalows of Raymond Chandler's LA. Even country-club snootiness had something provincial about it. The villains, the police, even criminal masterminds and the mob seem more or less homespun.[33] There are no "Commies" menacing the nation and its people. Again, this is a way to revive a lost sense of community. But it also underscores the absence of international stakes, the abandonment of worldliness. Gone were the General Sternwoods and the family lore cultivated in Europe. By the 1970s, the glamour of Hollywood stars was replaced with tabloid journalism, and *crepe de chine* had given way to wide lapels and corduroy. Emphasis on the local was no coincidence. In their easygoing and unpretentious way, detectives of the 1970s stood for an America tired of being a global example.

Harry O was canceled in 1976, when Fred Silverman moved from CBS to ABC, canceling the shows with which he wasn't involved. That was also the year that David Chase—who would later create *The Sopranos* for HBO—started writing and producing *Rockford*. Garner won the Best Dramatic Actor Emmy for *The Rockford Files* 1976-77. Also in 1976, the presidential campaign was under way, setting the unelected incumbent Gerald Ford against Jimmy Carter. If Nixon was Tricky Dick, and Reagan would be the Gipper (or the Teflon president), Jimmy Carter was just Jimmy. Carter presented himself as an outsider. Even though he came from a world of corporate Democrats, campaign ads talked about the twelve-hour days that Carter put in on his peanut farm. Carter was to politics what Harry O was to the hard-boiled. In his inaugural address, Carter quoted his high school

teacher as he declared the need to "adjust to changing times and still hold to unchanging principles." He talked about American strength resting not on the size of an arsenal but on the "nobility of ideas." Carter wore emotional vulnerability on his sleeve, in part to cultivate a down-to-earth persona and in part because he was genuinely open and honest. He was fond of country music, was friends with Hunter S. Thompson, and was interested in Bob Dylan. When he discussed his Baptist faith, he repeated that Baptists believe in complete autonomy, in "absolute and total separation of church and state," and that no person should be proud. As of May 2019, he was still teaching Sunday School at the Maranatha Baptist Church in Plains, Georgia.[34]

Carter's 1976 interview in *Playboy*—for which he wore a chambray button-down shirt identical to Harry Orwell's—addressed his regrets for political stances not taken and antiwar statements not made. He declared he would never intervene for the purpose of overthrowing a foreign government. At the end of the interview, he also added that he had "looked on a lot of women with lust" and had "committed adultery in my heart many times."[35] This admission might have been acceptable for Spenser, who would have managed to make it sound ironic and clever, but in the wake of that interview, Carter's double-digit lead disappeared. Luckily, his opponent, Ford, stumbled just as badly when he claimed that there was no Soviet domination of Eastern Europe, a head-scratcher that provoked media criticism. Carter won the presidency with 297 electoral votes.

In a September 23, 1976, editorial, the *New York Times* cited the *Playboy* interview as indicating that public figures are "increasingly reluctant to post 'no trespassing' signs at the legitimate boundaries of their private lives and intimate feelings." And then, "Acquiescence in the electorate's right to pierce the curtain of privacy will in the end lead either to more dissembling or to an accelerating affront to the dignity of elected officials." What jumps

out in Carter's oversharing moment was his interest in introspection: the same "quiet wistfulness" that Harry O had shown. As Carter put it, "Once you stop searching and think you've got it made—at that point, you lose your religion. Constant reassessment, searching in one's heart—it gives me a feeling of confidence."[36] He was transparent about hesitation in a way that no other candidate had been. The public's ability to trust a man concentrated on himself and his own conduct, earning public trust with hard work, came in part from the television detectives that had dominated prime time through the early part of the decade. For Carter, good works and "searching in one's heart" were rooted in religion, but they indicated the same sort of dedication to accountability as Williams's secular "my ethics are my own," as Rockford's "My own kind, has to do with shaving and looking into mirrors," and as Harry O's "time to figure out what I want and what I am."

Carter had a homespun humility that the detectives of the 1970s had already made all-American. The problem was, though, that television actors were not peanut farmers or politicians. They were actors, creating characters, and their humility was matched by good looks and confidence. Rockford could express frustration and get knocked around, but he would still come out on top because he was a consummate performer. And to state the obvious: he emerged victorious because episodes were written that way. Carter, however, was a real person contending with the real world. For example, politics remained fraught with racial animus. In response to the 1954 *Brown v. Board of Education* ruling, southern whites created White Citizens' Councils to maintain segregation in the South. Carter was the only white male in Plains, Georgia, who refused to join the councils, despite heavy pressure to do so. And upon winning a Georgia State Senate seat in 1962, he worked to dismantle voter suppression laws. After losing a 1966 congressional race, however, Carter campaigned in the 1970

gubernatorial race by arguing against busing and seeking the endorsement of segregationists. It was a cynical move, and it resulted in the *Atlanta Constitution* calling him an "ignorant, racist, backward, ultra-conservative, red-necked South Georgia peanut farmer."[37] Even so, he won with 49 percent of the vote. Then, to the surprise of many, his inaugural address called for an end to segregation, and once in office, he increased the number of African Americans in the state government by 25 percent.

Carter had no interest in being an "imperial" president. On inauguration day, he stepped out of the limousine and walked to the White House, to the dismay of the Secret Service. He did not like backroom dealing, which earned him enemies in Congress. His main victories—much like those of the television detectives—were local or domestic. He pushed Congress to create a "superfund" to clean up toxic waste sites. He created the Department of Energy, regulated strip mining, and blocked development of plutonium reactor technology. He reduced American dependence on foreign oil and even installed solar panels on the White House in 1979 (Reagan promptly removed them in 1981). He also made a show of turning down the White House thermostat and putting on a sweater. But Carter's good works did not manage to make him an appealing president, and he came across to many reporters as either impersonal or incompetent.

As Arthur Schlesinger wrote, an effective president must meet two requirements: to point the republic in one direction or another, and to explain why that direction is right for the nation.[38] Without such an explanation, the electorate cannot know whether the president has a vision, and it may assume he hasn't any. Television added other elements to this calculation. For one, the president had to cast himself as both a principal character and a reliable narrator. For another, audiences had come to expect that problems be solved swiftly. Robert Kennedy said in a 1966 speech in South Africa, "The road toward equality of freedom is not easy,

and great cost and danger march alongside us." Martin Luther King Jr. had noted that the arc of the moral universe was long, and it certainly did seem to be taking its time. Television, however, provided a vision of justice done in short order and done repeatedly. Carter did not thrive in the televised world. Rather than proclaiming a broad vision for the United States, he called on Americans to improve their own attitudes toward nation and government. To an audience that wanted problems dispatched in an hour, Carter announced that he could not promise a quick way out of the nation's problems, that "the only way out is an all-out effort." In an age that wanted presidents to be camera-ready and in control of the narrative, Carter seemed hesitant. There was little exhilaration in the suggestion that Americans rebuild their own confidence "little by little."[39]

As General George Patton had said, Americans love a winner. *The Rockford Files* had been reminded of this lesson during its 1975-76 season, when seven of the first nine shows had a vulnerable Rockford being duped or swindled. Frank Price, the head of television at Universal Studios, met with Garner and told him, "You can't play Rockford for a chump every week. Rockford has got to be a sophisticated guy. He is *smarter* than everyone else, not dumber."[40] So Rockford had to be smarter, and tougher, and he had to show it in under an hour. Audiences didn't want quiet wistfulness, at least not for the entire episode. They wanted a show of strength, and the same principle operated in the political realm. Americans didn't want Mr. Rogers in a cardigan in the White House. They wanted a media-savvy character who would "kill their enemies for them."

In November of 1979, Islamic militants took sixty-six Americans hostage, demanding that the shah return from the United States to stand trial. Carter's various attempts to negotiate came to nothing, and the news media maintained a merciless count of the days the hostages had been held prisoner. Carter finally ap-

proved a secret rescue mission (Operation Eagle Claw) that failed when a desert sandstorm caused three helicopters to malfunction. One of them crashed, killing eight soldiers, and the operation was terminated. Finally, near the end of his term, the administration was able to reach an agreement for the release of the hostages, and they were freed after 444 days in captivity. Carter's troubles ending the crisis wounded his reputation and hampered his ability to campaign for reelection. Into the breach came his opponent, former California governor and actor Ronald Reagan. Here was a man able to articulate a vision for the country. He had learned the lesson that Frank Price wanted to teach James Garner. Carter was honest and principled, but his humility came across on television as weak and vacillating. Reagan was neither honest nor principled, but he was a master of charm. And though numerous Americans sensed he could not actually be trusted, he won the presidency in a landslide. A 1980 cartoon showed Reagan crowing to his wife, "Nancy, I got the part!"

In the 1930s, the Continental Op and Roosevelt shared the characteristics of honesty and generosity. In 1980, what Reagan shared with television detectives was the fact of acting, and the sublimation of human character to television personality was complete. To put it in TV terms, Carter had lost the show, his part recast with a more charismatic actor. As Robert Denton writes in *The Primetime Presidency*:

> If we think of some very successful television stars, Fred MacMurray, Bob Newhart, James Garner to name only a few, we see that they are really "smaller than life." Their reactions tend to diminish the various events or situations in which they find themselves. Intense emotions are manageable. Their qualities are soothing, attractive, and everyday. Ronald Reagan is simply a television personality. His manner of communication fits the requirements of television as a medium—not necessarily those of governing or ruling a nation.[41]

While Carter had the endearing introspectiveness and frankness of a Harry O, he didn't have the good looks or charm. And he certainly didn't have the easy assurance of James Garner.[42] Television had caused an enormous change in what the public expected from public figures. It was not enough to have good ideas. It was not even enough to communicate in an earnest way with the public. You had to emulate the persona of television but also its pace and stimulation. Schlesinger wrote that politics is ultimately an educational process. And part of that educational process is modeling a certain durability. It wasn't about having an indestructible body like Spenser, and it wasn't about toughness of mind and character like Williams and the Op. Rather, it was about maintaining an indestructible persona. Reagan was called the Teflon president because no accusations stuck to him, but he was also coated with an air of televised unreality. America wanted a strong leading man, and it got one in its fortieth president.

Reagan understood that to be a winner, you had to have enemies. You needed someone to beat.[43] Reagan wanted to beat, among other things, the advances of the civil rights movement. This enmity was important because it came with a series of precast adversaries. During the 1976 campaign, Reagan railed against "welfare queens" who gamed the system and collected checks. In the same year, addressing a nearly all-white crowd in New Hampshire, he asked audiences to envision standing in line to buy a hamburger while a "strapping young buck" purchased T-bone steak with food stamps. His 1980 campaign endorsement of "states' rights" at the Neshoba County Fair in Mississippi— where three civil rights workers had been murdered in 1964— brought applause from an all-white crowd.

In October of 1982, riding on American resentment of the undeserving poor, Reagan announced his administration's War on Drugs. At the time of that announcement, less than 2 percent of Americans considered drugs to be the nation's most important

problem.[44] But the drug war came with a camera-ready enemy, namely the "new privileged class in America, a class of repeat offenders and career criminals who think they have a right to victimize their fellow citizens with virtual impunity." One week after he declared the war on drugs, Reagan said in a radio address discussing Health and Human Services that the administration was doing everything it could to "root out cheaters." The message was clear: those on public assistance were suspicious characters, likely to be cheating the government and, incidentally, spreading the scourge of drugs. Crack cocaine entered the inner cities in 1985, several years after the declaration of the war on drugs, and its destruction was catastrophic. In fact, the crack epidemic was in large part a result of the drug war, since residents of the inner cities, undereducated and without employment opportunities, had already been cast as criminals, undeserving of empathic treatment and intervention. In essence, the war on drugs created the very enemies it assaulted.

Declaring a war on drugs created a perverse sort of hard-boiled fiction. As one journalist put it, "Ronald Reagan divided the world into good guys and bad guys." The bad guys were most often racial minorities, but Reagan also railed against the Soviet Union, which he named the "evil empire." The president's anticommunism recalled Mickey Spillane, who wrote his Mike Hammer fiction as Reagan spoke to the House Un-American Activities Committee (HUAC) and started to turn his back on liberalism. Rather than television "ripped from the headlines," Reagan brought politics ripped from prime time. As an actor, Reagan had appeared in such shows as *Zane Grey Theater* (James Garner had also acted in this program), *Law and Order* (1953), and *Death Valley Days* (David Janssen was another alumnus). It is well known that the fortieth president was fond of westerns and Cold War spy thrillers. He was also a fan of TV's *Murder, She Wrote*. When he talked about young bucks and cheaters, he used the same vocabulary that

appeared in these stories. In essence, he retooled the gun battles of the Old West for a post-1960s backlash against civil rights and the poor. In 1985, promising to veto a tax hike, he quoted Clint Eastwood's *Dirty Harry*: "I have only one thing to say to the tax increasers. Go ahead, make my day." (Eastwood himself reprised that line, to roars of applause, at the 2012 Republican National Convention.)[45] After the release of hostages in Lebanon in 1985, Reagan said that he had seen *Rambo* the previous night and would know what to do the next time.

Reagan was enormously popular. In the 1920s, the editors of *Black Mask* anticipated that readers were impatient for a fight—if not to be in one, then at least to see one. Reagan brought the same goods to Americans. This is not to say that he was some sort of modern hard-boiled detective. He was more a canny hard-boiled author with a stable of villains, setting out a series of ominous adversaries and coolly outlining plans for knocking them down. Reagan wasn't necessarily going to kill your enemies for you, but he could at least continue to remind you that they were out there waiting to be killed, and this was enough for his audience. He was also calculating enough to understand that you didn't have to be an actual good guy so long as you constantly pointed out bad guys. In a sense, he became popular because he got his audience accustomed to thinking about enemies and focused on crisis. It was the same strategy that hard-boiled editors had used to sell pulp fiction in the 1920s.[46]

Reagan actually recalled the era of the Continental Op when he talked about economic policy and public enemies. In a November of 1982 speech, he said that he "remembered what it's like to be 21 and to feel your future has been mortgaged by the generation before you. That's a terrible tragedy we must never allow to happen again." When Reagan was twenty-one, the year was 1932, and the nation was in the middle of the Great Depression.[47] In his recollections, he was casting "tax and spend" economics as a

modern reincarnation of the unconstrained speculation and vast income inequality that had brought on the Great Depression. It was a senseless and specious comparison, but what Reagan lacked in reason, he made up for in gravitas. Fulminating against welfare cheats since the 1976 Republican primary, Reagan had built up the idea that shadowy public enemies were draining American resources. Americans receiving public assistance were essentially being cast in the role of the Beast. And it shouldn't be forgotten that even his "evil empire" speech—addressed as it was to the National Association of Evangelicals—started out as a criticism of teenagers' access to birth control. Without actually helping Americans, he talked as though he had trudged through the Great Depression like the Continental Op.

American politics was reduced to a series of dramatic episodes. Americans who felt disempowered wanted to see a cool customer bust the heads of their enemies. Even Americans who were not disempowered were glad to hear that there were enemies out there who could be vanquished. A crucial part of being a winner was standing on the body of the loser. The undeserving poor and teenage girls in search of birth control were easy to manage; they didn't put up much of a fight. In one episode after another, President Reagan played the role, abstract but intelligible, of the steady American tough guy.

In the 1920s, Warren Susman talked about the growing cultural interest in personality. Television altered that calculation even further. Personality was not just about how you acted with other people but who you were in the stories you told as well as who you were against. It was about what role you played on television. General Patton's famous statement about Americans loving a winner could also be interpreted as Americans loving a telegenic bully. When Carter encouraged Americans to improve their own attitudes, he was in essence proposing that there was no one for listeners to blame but themselves. Not wanting to blame themselves,

they blamed him and elected Reagan. Reagan was more than willing to blame anyone and everyone other than himself and his base. The division between stories and reality had in a sense collapsed. The hard-boiled detective had been co-opted, his 1920s and 1930s principles and his 1970s vulnerabilities compromised in the service of hostility and the fiction of lurking enemies.

During the Reagan and Bush years, the physical image of the tough guy proved durable, despite the increasingly diverse makeup of Americans. Dedicated fans of hard-boiled detective fiction will recognize this diversity represented in the pages of the novels they consume. Female crime authors and authors of color—with lead characters to match—began to publish in larger numbers. Marcia Muller created Sharon McCone in 1977, Sara Paretsky debuted V.I. Warshawski in 1982, and Sue Grafton introduced Kinsey Millhone that same year. Walter Mosley created the LA detective Easy Rawlins, a descendant of Chester Himes's Grave Digger Jones and Coffin Ed Johnson, in 1990. Barbara Neely brought Blanche White to the page in 1992, and a year later, Gary Phillips published his first Ivan Monk novel. Laura Lippman began the Tess Monaghan series in 1997. Some of these characters translated to the screen, with Kathleen Turner playing Warshawski in 1991 and Denzel Washington playing Rawlins in 1995. But in the national imagination, images of Rambo (1982) and the Terminator (1984) evoked popular ideas of toughness more than Warshawski or Rawlins did. Detectives reached mainstream popularity when they resembled the demographic of those running the country. And physically speaking, that remained predominantly and aggressively white and male—an image that would take years to evolve.

- - - - - - - - - - - - - - - - - - - -

A Lone Wolf

The rise of hard-boiled characters usually accompanies a historical moment when national morale needs a boost. The individual detective does what the public wishes it could do. During Reagan's presidency, though, individualism itself lowered national morale. Excesses of the 1980s—exemplified in *Wall Street*'s Gordon Gekko and Tom Wolfe's *The Bonfire of the Vanities*—had given individualism a bad name, showing it to be more glitz and performance than substance. In the 1990s, television turned to reinforcement of an institutional—rather than individual—model of justice. Robert Parker had said that the most important element of a story was "character, character, and character." The main premise of crime television in the 1990s was "system, system, and system." The maverick had seemingly gone the way of the leisure suit.

The 1980s gave audiences *Magnum PI* (1980–88), *Cagney and Lacey* (1981–88), *Knight Rider* (1982–86), *TJ Hooker* (1982–86), *Remington Steele* (1982–87), *Simon & Simon* (1981–89), *Spenser for Hire* (1985–88), and *The Equalizer* (1985–89), among others. Some of these (*Simon & Simon*, *The Equalizer*) came close to the Rockford model of hard-boiled toughness, whereas others—*Miami Vice*

comes to mind—did not. One standout of this decade—foreshadowing the 1990s turn to come—was *Hill Street Blues*, which ran on NBC from 1981 to 1987. *Hill Street Blues* focused on a police station in an unnamed American city and won eight Emmy awards in its first season. The series was created by Steven Bochco, who would later develop *L.A. Law* and *NYPD Blue*.

Crime television that ruled the airwaves during the 1990s followed the lead of *Hill Street Blues* and read as a correction to star power. This was not because, as in the 1960s, the 1990s were a time of widespread collective activism; it was more that the 1990s had seen the 1980s and the underside of individuals acting of their own accord. The nation was ready for something else. Networks embraced *Law and Order* (1990–2010), *Law and Order: Special Victims Unit* (1999–present), *Law and Order: Criminal Intent* (2001–11), *NYPD Blue* (1993–2005), *CSI* (2000–present), *Criminal Minds* (2005–present), *Homicide* (1993–99), *NCIS* (2003–present), *Third Watch* (1999–2005), and *JAG* (1995–2005). *The Practice* edged out the individual detective, and an ethic of "We the People" replaced *I, the Jury*.

The police procedural—"a story in which the mystery is solved by regular police detectives, usually working in teams and using ordinary police routines"[1]—had been a staple of American television and fiction for decades. From the iconic *Dragnet* to *Highway Patrol*, *Adam 12*, *Hawaii Five-o*, and *Police Story*, among others, the genre had been a mainstay of American television since 1951. In the 1990s and 2000s, though, institution-focused television shows emerged en masse as a counterpoint to 1980s individualism.

In books, hard-boiled literary characters stayed the course of ironic detachment, remaining disillusioned and down-at-the-heels. These included Michael Connelly's Harry Bosch, Sara Paretsky's V.I. Warshawski, Walter Mosley's Easy Rawlins, and George Pelecanos's Derek Strange. But television had become the

coin of the realm. It was there that the problems of individuals versus institutions would play out. In a sense, this was a matter of economics. In Mickey Spillane's heyday, paperbacks sold for a quarter apiece, and it was easy to have a novel character be wildly popular.[2] But in the twenty-first century, limitations of time and money turned readers into viewers. What is more, it made sense for tensions among fictional characters to happen on television because television as a medium was in large part responsible for the rise of bankable personalities—of celebrities and people as commodities. In other words, television had nurtured the sort of showiness that had stained individualism in the first place—had contributed to the spectacular excesses that its 1990s crime programming then moved to correct.

...

NBC's *Law and Order* ran for twenty years. Every episode began with a baritone voice-over intoning, "In the criminal justice system, the people are represented by two separate but equally important groups: the police who investigate crime and the district attorneys who prosecute the offenders. These are their stories." The real story this series told, though, was about the steadiness and devotion to procedure of police and prosecutors. In the first episode (1990), detectives are shouting at each other in the office, the lieutenant mentions that he is recovering from a drinking problem, and the district attorney reminisces about his alcoholic father. In later episodes, even later that same season, those revelations are silenced. The original series almost never shows homes, cars, friends, families, pets, or paychecks; if the characters have personal lives at all, they happen offscreen.

Law and Order was about the force of institutions, but it also admitted their limitations. For every episode that incarcerated a criminal, another let one out on a technicality. At times, it seemed like injustice was a force of its own and that social institutions were unable to repair it. But ultimately, the structure of the episodes

did not allow the viewer much room for reflection or invite social criticism. Action moved fast, events and places came with labels, and when the credits rolled, the story was over. Tensions rise and fall over the course of individual episodes, but each episode is a contained unit; the tightly packaged formula was the show's principal selling point. Dick Wolf, producer of the series, likened it to Campbell's soup and explained that "people feel comfortable going to something they know about. It attracts you because you know what you're getting." Detectives and prosecutors could bear witness and could provide a much-needed empathic response for audiences, but all were focused on containment within even the most frustrating institutional boundaries. The series characters, from the detectives, to the DA, to the psychologists evaluating the accused, even to the witnesses finding the body, became masters of the calm, understanding gaze. But following the September 11, 2001, terrorist attacks, this empathic calm turned into active frustration.[3]

After 2000, roads diverged in the wood of crime series. Networks continued to produce series that vaunted institutions. Acronym series proliferated, including the forensics drama *CSI* and the police procedural *NCIS*. Next to *Law and Order: SVU*, *NCIS* is the longest running prime-time television drama. Other police procedurals included *Bones*, *Criminal Minds*, *The Shield*, *The Closer*, *White Collar*, and *Law and Order: Criminal Intent*. Added to this mix were some private detective shows—such as *Veronica Mars* (2004–7) and *Monk* (2002–9)—that underscored human fallibility. But cable shows increasingly pushed the limits of the small screen, creating a haven for future edgy crime dramas. During the 1980s and 1990s, HBO had ventured outside the parameters of network TV with shows like *Maximum Security* (1984) and the prison drama *Oz* (1997–2003).[4] In 1999, it introduced *The Sopranos*, created by David Chase, who had written and produced *The Rockford Files*. *The Sopranos*, about a troubled mob boss and his

family, ran until 2007 and made cable the destination for innovative independent television.

In 1997, David Simon published *The Corner*, which followed the lives of drug addicts and dealers in 1990s Baltimore.[5] That book became an HBO miniseries in 2000, winning the year's Primetime Emmy Award for Outstanding Miniseries. In 2002, HBO introduced *The Wire*, which built on *The Corner* and featured some of its cast members. Arguably the finest television production of the new decade, *The Wire* ran on HBO from 2002 to 2008. It focused neither on a solitary title character nor on a vaunted institution but rather on the individual, whether policeman or civilian, as a social being. The series' characters contended with glacial bureaucracies, corrupt individuals, entrenched social injustice, homeland security, the wars in Iraq and Afghanistan, an idiosyncratic president, and a continued war on drugs.

The Wire's creator, David Simon, said that the series "is making an argument about what institutions—bureaucracies, criminal enterprises, the cultures of addiction, raw capitalism even—do to individuals." Each of its five seasons underscores the ambitions, failures, and corruptions of particular social groups and institutions. These include the police department, government, courts, public education, and media, as well as more informal systems such as drug organizations, families, and a sprawling population of dealers, consumers, henchmen, bystanders, and casualties. It was a police procedural in one sense, in that it literally showed police following procedures, but the police also followed their own conscience. Criminals followed their own procedures, some of which were more morally sound than those of the police brass. Simon called the series a "novel for television" and described it as a "Greek tragedy done in a modernist urban way, with the city as the main character."[6]

As the series shows, people who are stepped on by bureaucracies turn around and step on others, or sabotage themselves.[7] Race

Williams was enthusiastic in stating that his ethics were his own, but *The Wire* was in many ways too jaded to wave such a banner. Its vision of an ethics of one's own was more limited, more tired, more conscious of what could go wrong. People lacked the time, the money, and the bandwidth to sustain their ethics, much less to make a living from it. Those who did have the resources had no interest; the series is clear that cash and prizes come from eschewing ethics, not embracing them. But *The Wire*'s principal characters maintain a sense of accountability and initiative in a world of adversities. The show also insists that even someone who copies another person—or who declares that they are just doing what they are told—nonetheless makes the decision to do that. Everyone has to come to terms with their own actions, and no institution can absolve one of that reckoning. What made Race Williams the first hard-boiled detective, in other words, becomes shorthand for the modern condition. And *The Wire* becomes the twenty-first century's first hard-boiled crime series.

The Wire is an ensemble piece in the most fundamental sense, meaning that no individual can transcend the ensemble (the institution or the greater fabric). There is no one headliner in *The Wire*, but there are some main contenders for the role of hard-boiled principal. Publicity for the show set out Detective Jimmy McNulty (Dominic West) as the main character, but stickup man Omar Little (Michael K. Williams) was beloved by audiences. Much like Al Pacino's character in *Scarface*, Omar was the sort of outlaw featured in posters in college dorm rooms. Omar declared that he never put his gun on anyone not in the game, saying that "a man got to have a code." McNulty, however, worked for the police but put aside protocol to solve the murder cases that his bosses didn't want to pursue. His whole identity could be summed up in what his partner Bunk tells him: "There you go, giving a fuck when it ain't your turn to give a fuck."[8] When he gets forced into

retirement in the fifth season, one of his colleagues elaborates on that curious praise:

> He was the black sheep. The permanent pariah. He asked no quarter of the bosses and none was given. He learned no lessons. He acknowledged no mistakes. He was as stubborn a Mick as ever stumbled out of the Northeast parishes to take a patrolman's shield. He brooked no authority, he did what he wanted to do and he said what he wanted to say and, in the end, he gave you the clearances. He was natural police.[9]

In the first episode, McNulty announces, "I'm going to do this case, the way it should be done." It is an admirable statement, undermined because he is drunkenly peeing on a train track as he says it. Despite his apparent haplessness, he manages to set up a hidden camera to put drug dealer and murderer Avon Barksdale in prison. In the fifth season, he comes up with a way to pursue Marlo Stanfield, a mass murderer who boards up the bodies of his victims (shades of Baltimore's Edgar Allan Poe) in condemned Charm City rowhouses. His bosses don't want to focus on Marlo, so McNulty invents a sensationalist serial killer who will be seen as deserving those resources. The police department will give money to the fictitious case, and McNulty will then divert those funds into his pursuit of Marlo. He uses the corrupt police system to do what it would do in any case, which is pursue those who murder whites and ignore those who murder blacks.[10] And he boasts—in colorful terms—that no one in the police department would catch him.

Like earlier hard-boiled characters, McNulty often seems incapable of a sustained relationship. As he says to Beadie Russell: "The things that make me right for this job, maybe they're the same things that make me wrong for everything else."[11] But he can work well with others, and that's what separates him from the loners who preceded him. McNulty gets to be the upstart on his

Detective Jimmy McNulty (Dominic West) and Omar Little (Michael K. Williams) stood out as two of the most memorable characters in *The Wire*, David Simon's epic "novel for television."

team, and he does it with enthusiasm, but other team members participate in their turn. In a sense, *The Wire* does what *Hill Street Blues* started, which is look at how people can work together—not as robots in a machine and not as dueling mavericks but as individuals who encourage each other. When Greggs is shot during an undercover bust and McNulty decides the case isn't worth pursuing, Lieutenant Daniels has to shake McNulty out of his misery:

> And the shooters who dropped Kima? They're still in the wind. And whoever sent those motherfuckers into that alley, he needs to get got, too. So you can stand there, dripping with liquor-smell and self-pity if you got a mind to, but this case—it means something. . . . You do what you feel. You want to pull Avon in on half a case, go right ahead. You want to put my shit in the street, feel free. But the Eastern had a lot of stories—mine ain't the only one. . . . As long as I have days left on those dead wires, this case goes on.[12]

Daniels also stands up to Commissioner Burrell and takes the case forward when abandoning it would be easier.

No one can be valiant all the time, and everyone has moments of discouragement. The good thing about working together is that not everyone is discouraged at the same time, and each can pull the other up when needed. It might not be as spectacular as the classic hard-boiled model that has one person doing it all, but it is more realistic and much more sustainable. Audiences root for McNulty and for the entire team. And when their scheme is frustrated and crushed by the higher-ups in the police department, that frustration translates into moral condemnation of the entire corrupt system. Even though the scheme fails in the end, the fact that it ever even existed is evidence of a conscience that the system hasn't crushed. It's evidence of an ethics of one's own. Ultimately, that dynamic—the collaborative world in which no one succeeds alone but each person must stand accountable—forms the basis of the twenty-first-century hard-boiled narrative.

In *The Wire*, the police department has contradictory roles—as a corrupt force weighed down by incompetence, and as a means to do good work. And some of the police in this series are brutal, stupid, lazy, or hopelessly jaded. Most of the main characters care enough about the mission of the department to do its work whether or not their superiors back them. This is particularly important because they are able to put human faces to the increasingly guarded business of law enforcement.

With the creation of the Department of Homeland Security in the aftermath of the attacks of September 11, 2001, street-level police responding to drug crimes seemed almost homespun compared to new national security measures. From the Patriot Act to the TSA, from the liquids ban to full-body scanners, the post-9/11 world became a science fiction nightmare. In the ten years after the attacks, an estimated thirty million security cameras were installed in the US. In "The Target," the first episode of *The Wire*, which aired nine months after the attacks of September 11, an FBI agent shows McNulty live video footage of a Baltimore drug house.

McNulty looks on in admiration, but the agent explains that drug dealers are no longer a Bureau priority. "Wrong war, brother. Most of the squad's been transferred to counterterrorism. This thing's the last drug case we got pending and I gotta shut it down by the end of the month."[13] That message reverberates through the entire nation. The world has moved on to vaster and more sinister threats.

With an administration discussing multiple foreign threats to national security and preparing for the "Global War on Terror," the war on drugs became almost a remnant of an earlier world. Not that the earlier world was some panacea of justice, but it was more familiar, and it preceded trauma on an existential cultural scale. Relative to a vast and invisible national security web, police with names and faces reminded audiences of a time when threats were local rather than global, and destruction came from down the block rather than from the sky.

As various historians have noted, George W. Bush and his administration made military action the foundation of foreign policy. On the night of September 11, President Bush used the phrase "war on terrorism," describing the nation's future response. Two months later, preparations were made to invade Iraq. Weapons were diverted from Afghanistan to Iraq, even though there was no evidence of Iraqi involvement in the 9/11 attacks or complicity with al-Qaeda. In the summer of 2002, the American public heard about Saddam Hussein's stockpile of weapons of mass destruction. As James Fallows put it, "The war was already coming; the 'reason' for war just had to catch up."[14] Once military action started, it became a given. More than this, it became the American status quo.

The Wire made problems of law and order local once more. That was valuable in the early years of the Iraq War, because the sort of dissent that the characters showed to their obstinate bosses replicated the sort of dissent happening around the buildup to war in the Middle East. It wasn't that terrorism was not a serious

menace. The madness was in the method of addressing it, and the war in Iraq gave many Americans the sense that their government had gone off the rails.[15] The United States entered Iraq in March of 2003, and by the time the second season of *The Wire* aired, in June of that year, tens of millions of protestors across the globe had failed to stem the tide of war.

September 11 made the nation come together, but the administration at the helm was profoundly problematic. The American public was deeply polarized, so while Bush's approval rating rose in the wake of 9/11, his administration remained suspect to many Americans. Whereas "election" had usually meant that a majority of American voters and the electoral college had chosen a president, in Bush's case, the entire process resembled a ham-handed coup d'état. The election came down to the state of Florida, where Bush led by 327 votes out of six million. But tens of thousands of ballots were in dispute.[16] When Florida's secretary of state certified the election for Bush, it was Governor Jeb Bush—the candidate's brother—who signed the Certificate of Ascertainment on November 27, 2000. When the Florida Supreme Court nonetheless ordered a manual recount of forty-five thousand ballots, the Bush campaign filed an emergency appeal with the US Supreme Court. The Court, divided along partisan lines, decided 5-4 on December 21 to stop the recount and award the presidency to George Bush. The result was that Bush rose to the presidency not only without the popular vote (something that had not happened since 1888) but also without a clear electoral victory or mandate. On Bush's rainy inauguration day, protestors lined the parade route, and his limousine was pelted with eggs. Nine months later, the Bush administration would generate the response to September 11. The resulting combination of a deeply suspect administration and a craving for human accountability formed the backdrop of *The Wire*.

When the hard-boiled was born back in the 1920s, the law was something to be taken with a grain of salt—a fact but not a

soaring ideal. Certain laws seemed more optional than others, considering that New York City alone had more than thirty thousand speakeasies in the midst of Prohibition. Talking about liquor laws in December of 1929, drawing on the arrest of Al Capone, Hoover declared that "the lawbreaker, whoever he may be, is the enemy of society."[17] At that time, though, it was already obvious that speculators were a much greater enemy of society. In the twenty-first century, once again, even sincere respect for the law stood side by side with fairly strong skepticism about how reasonable certain laws actually were. The dubious invasion of Iraq and the increasingly intrusive rules that came from the Patriot Act expanded that skepticism into the domains of foreign policy and national security. Continued prosecutions for very low-level drug crimes also drew criticism from many Americans, as they had for decades. Neither the "Global War on Terror" nor the domestic "War on Drugs" solved the problem that they promised to solve. Both seemed a sideways response to an actual problem, an action destined to strengthen those in power rather than to improve the well-being of the American people.

In *Law and Order*, there was something admirable about submission to the institutions of the legal system, no matter how hamstrung or flawed they might be in practice. When those characters tried to game the system to capture a known criminal, their superiors would bring them up short.[18] By the time *The Wire* came around, politicians' dissimulation and the public's ironic detachment had made devotion to the system untenable. It was clear that police would have to practice some "rugged individualism" to get the law even to come close to protecting and serving the people. In the world of that series, there is an active divide between what the law is supposed to do and what it actually does, which is perpetuate enormous racial and economic inequalities. And the more politicians talk about law enforcement, the more entrenched the divide becomes.

The value of the war on drugs varied enormously, depending on where people stood on the economic ladder, what race they were, and how they felt about authority.[19] Back in the era of the Continental Op, Hoover talked about the law activating a "moral awakening" in Americans who drank without a second thought. Listeners, however, were probably unconvinced about the evils of alcohol consumption in December of 1929, when the fallout from laissez-faire capitalism was decimating the country. Seventy years later, in *The Wire*, prosecuting small drug crimes seemed a similarly losing proposition. The crack addict was a symptom of America's social ills, not their author. The war on drugs focused on incarceration rather than treatment, making addicts more helpless and excluding them more harshly from mainstream society. And the more people were excluded, the more desperate they became and the more punitive the laws were, and so it went. Because the war on drugs was accompanied by a war on the poor, the incentive to enter the drug business was enormous, despite the ruinous consequences of a felony conviction. *The Wire* illuminates that cycle and demonstrates that those who gained from the war on drugs and its failure were in many cases the same people making the laws.

It had long been said that television stories about idealistic police were fictions and that police procedurals of the 1960s through the 1980s were essentially propaganda. What set police apart in *The Wire* was their insistence on addressing the fact that cops could be part of the problem, because they were answerable to a corrupt administration. As Lieutenant Daniels puts it: "See, this is the thing everyone knows and no one says. You follow the drugs, you get a drug case. You start following the money, you don't know where you're going. That's why they don't want wiretaps or wired CIs or anything else they can't control. Because once that tape starts rolling, who the hell knows what's gonna be said."[20]

It only takes eight episodes in the first season for the money trail to lead to a Maryland state senator. Like a snake devouring its own tail, when the investigation uncovers the politician, the politician has the authority to bury the investigation. When the squad learns in the third season that Avon Barksdale was paroled from prison less than two years into a six-to-eight-year sentence, McNulty reacts with bitterness—"big joke"—and Greggs throws the computer across the room. And when the senator's driver is arrested with a bag full of cash, the police department ends up having to return it.

Most of the principals in *The Wire* are in their mid-thirties, having come of age around the time when Carter lost to Reagan and the feel-good 1970s turned into the "greed is good" 1980s.[21] And some things that generation did very well was watch a lot of television and become amateur cultural critics. They were raised on television: *Knight Rider* and *TJ Hooker* and *Remington Steele* and *Spenser for Hire*. As young adults they had *Law and Order*, *Homicide*, and *NYPD Blue*. They were familiar with the ads for Nancy Reagan's "Just Say No" antidrug campaign. They also saw political dramas playing out on television. Permeating the characters' understanding are truisms born of decades of politics turned into low culture: Politicians are duplicitous and always will be. People who have power will step on people who don't, and doing so is part of what makes having power fun. Laws, in particular those concerning drugs, do more harm than good and waste police resources. And these things will never change. Being hard-boiled in the new millennium means looking askance at the laws that make the rich richer. It also means cynicism toward the law in general, toward the government, and toward the power of the people.

• • •

Fast-forward to the first year of Barack Obama's second term as president. The nation was gradually climbing out of an economic downturn that had started in 2008, when a downward spiral in

housing prices set off the Great Recession. The financial sector had weakened, the auto industry plummeted, and the stock market lost more than half of its value. Unemployment rose to 10 percent in mid-2009 and would not recover its prerecession levels until 2015. Many homes were lost to foreclosure or remained underwater. The housing crash was concentrated in certain areas (Florida, California, Nevada), but more than half of American households saw their assets decline. Rural areas and already poor communities suffered the most. The recession also increased the nation's racial wealth disparities. As it was in 1929, loose banking rules—this time in the form of predatory lending and credit default swaps—laid the ground for an economic downturn that would worsen the country's economic inequalities. Corresponding to the economic chasm was a rise in political tribalism. As David Brooks wrote in 2017: "Today, partisanship for many people is not about which party has the better policies, as it was, say, in the days of Eisenhower and Kennedy. It's not even about which party has the better philosophy, as it was in the Reagan era. These days, partisanship is often totalistic. People often use partisan identity to fill the void left when their other attachments wither away—religious, ethnic, communal and familial."[22]

Obama's 2008 election—and 2012 reelection—in a racially divided nation worsened disconnections along racial and political lines. On the one hand, progressives saw Obama's election as a chance to breathe again after Bush's aggressive and clownish presidency. On the other hand, conservatives saw Obama's presidency as signaling an alarming left turn in social policies. The president was not a deliberately divisive character, but tribalism was intense. Pew research in 2014 showed starkly decreased ideological overlap between parties, decreased friendship with those in opposing political parties, increased partisan antipathy, and views of community that differed along partisan lines.[23] The

individual accountability felt by *The Wire* detectives had hardened into melancholic isolation.

Resentment of the opposing side is an important element of political identity, which calcified under the repetitive stress of the internet. The smartphone and its incessant connectivity represented the greatest technological advancement since television. Internet use skyrocketed between 2002 and 2018. Facebook launched in 2004, Twitter in 2006, and Instagram in 2010. The world of social media was like another dimension that most Americans inhabited, even as they also inhabited their actual communities. Just as important, the twenty-four-hour news cycle had devoured American media. With the online world constantly at hand, Americans never had to look away from the screen and never had to wonder what was going on across the globe. In many cases, though, what was going on in the world was a function of what you already thought was going on, and which news outlets you were watching.[24] There was something at once overwhelming and draining about the endless online echo chambers that increased partisan divides and aggravated resentments. Increasingly, political entrenchment replaced learning. Reading and listening involved encountering ideas that you already harbored, hearing of events that you already believed would happen, and reading bad news about politicians you already despised.

In the midst of one-sided voices, there were numerous divisive events to absorb. During President Obama's two terms, a number of landmark Supreme Court cases increased a sense of alarm for both political sides. Depending on where people stood, certain cases looked like hard evidence that the country was going in a bad direction and that ideologues—the wrong ideologues—were running it into the ground. There was the Citizens United case of 2010, which deregulated corporate political contributions. Protecting corporate expenditures under the first amendment, that decision was either a spineless concession to business interests in

the view of liberals or a long-denied first amendment protection for conservatives. When it came to social issues, *US v. Windsor* in 2013 granted federal benefits to married same-sex couples. That one was either a civil rights victory or a step on the road to Sodom, depending on who you were, where you lived, and what you believed. In 2014, *Burwell v. Hobby Lobby* granted corporations the same protections for religious beliefs as churches and individuals. If you celebrated at *US v. Windsor*, you mourned at *Burwell v. Hobby Lobby*, and vice versa. All those cases were decided 5-4, so even when you were relieved that disaster had been averted, there was always a sense that the other side was encroaching. A sense of alienation and disempowerment was common on both sides. Each side was incredulous to see that the other considered itself a beleaguered underdog, but there it was: both evinced a sense of political helplessness.[25]

What did this mean for the sort of hard-boiled detective that Americans would embrace in the numbing era of the smartphone and the twenty-four-hour news cycle? Shared American values were an illusion, as was shared American character. It made sense that ideas about American heroism would be splintered as well. In 2013, a Breitbart columnist lamented the decline of manly men in popular culture. He reminisced about Kojak, Dirty Harry, Shaft, Rockford, Baretta, McCloud, Magnum, Mike Hammer, Jake Styles, and Rambo, and then wrote: "In a liberal constitution, I believe there are two things that they are supposed to despise . . . strong male figures and country bumpkins. Both of those go completely against the liberal narrative. Strong male characters are confident, charismatic and courageous, and country shows represent the most important thing, and something that burns a liberal's retinas completely out of their heads . . . the family element."[26]

This complaint was melodramatic, but it roped the hard-boiled detective, perhaps inevitably so, into political discord. The hard-boiled hero of decades past was either a caricature or a beacon of

lost America, depending on where one stood. Of course, the decline of American society and the desire to go back to the past had been conservative talking points for decades, even before Reagan talked about making America great again and Clinton proposed we not stop thinking about tomorrow. But the noise got louder and louder during Obama's presidency. America's first black president led a profoundly racially divided country; his professorial air ran counter to deep-seated anti-intellectualism. It was not surprising that plainspoken whites would be cast as agents of a return to a lost past. When Clint Eastwood addressed an empty chair at the 2012 Republican National Convention, pretending to interview President Obama, he turned away from the chair, faced the predominantly white audience, and declared, "We own this country." The audience roared its approval. Conservatives had embraced the manly white guy for decades, as when John Wayne—icon of the right—gave Mickey Spillane a Jaguar to commend him for his anticommunism. But in the era of the echo chamber, commentators had much to say about toughness and about what made someone a "real" American hero.

Not every American was a partisan stereotype or thought in terms of partisan stereotypes. Arguably, most did not. But when conservative websites mourned the decline of tough men and progressive websites talked about toxic masculinity, any character functioning as a culture hero had to contend with those contradictions. The year 2014 was going to present a fraught environment for the hard-boiled hero. He would have to be tough but not brutal, smart but not too erudite, contemplative but not too serious, sensitive but not politically correct. What is more, he would have to be an individual, in control of his own mind. This was easier said than done in the era of social media.

A new and peculiar element of the ever-connected world was the sense of never actually being alone with one's thoughts. With the online world perpetually at hand, thoughts, about anything,

found echoes in the posts and public comments of others. Whatever thought one person had, in other words, had probably already been made public by someone else. This connectivity posed a challenge for a hard-boiled character. For the most part, they had historically been loners or at least people who thought for themselves. But what became of that solitude when the phone was vibrating all day? Even when Philip Marlowe was at his busiest, he did not have clients coming to his door every five minutes. There was down time. Modern characters had to reckon with the onslaught of virtual noise, and ringtones were not a particularly rugged or compelling sort of enemy. It would not be an easy task to create a detective who could repurpose the Continental Op for the modern era, who could captivate—or at least seem reasonably neutral to—both sides of the political spectrum and act in a heroic manner. But in 2014, HBO released its best attempt.

True Detective, written by Nic Pizzolatto, aired on HBO in January of 2014. The first season tells the story of two police detectives in rural southern Louisiana who investigate what seems to be a ritual murder. It features the swaggering, adulterous, southern traditionalist Marty Hart (Woody Harrelson) partnered with the brooding and taciturn Rustin Cohle (Matthew McConaughey). The season alternates between Hart and Cohle's 1995 investigation of the murder and the 2012 police questioning of Cohle, who by then has scraggly hair, bad skin, a mustache, a taste for bottom-shelf beer, no friends, and no badge.

Cohle is basically the embodiment of post–*Law and Order* reluctant individualism for the twenty-first century. He walks through the job with a combination of absentmindedness and grim determination. Back in the 1920s, Race Williams had been popular in part because he dealt with traumatic events without coming undone. He did it without even slowing down. So did Mike Hammer, and readers loved them, but both characters seemed rather cartoonish as a result. Rust Cohle is burdened, and he

knows it. Everyone who meets him knows it. He is a bereaved father without friends, without intimate connections, without God or master, and without furniture; he is low on personality but rich in rumination. It's as if Race Williams hit a wall, went quiet, wondered what good his own ethics really could be, but nonetheless kept trudging through the city. In *The Wire*, we saw that no one avoids being murdered, or sidelined, or fired just by doing the right thing and showing up in service to others. *True Detective* shows us that no one avoids emotional torment just by showing up. This idea is well suited to an era when national and international catastrophes came fast one upon the other and were made public almost in real time.

One of the first facts we learn about the very solitary Cohle is that he did have a family but that his daughter was killed on her tricycle by a passing car. After that, we learn, his marriage ended. In a way, this terrible loss excuses him from participation in the outside world, excuses him from political trivia, from Facebook, from all manner of virtual nonsense, and even from most human interaction. In the first episode, Cohle explains his worldview: "I think human consciousness is a tragic misstep in evolution. We became too self-aware. Nature created an aspect of nature separate from itself. We are creatures that should not exist by natural law. We are things that labor under the illusion of having a self. A secretion of sensory experience and feeling programmed with total assurance that we are each somebody, when in fact everybody's nobody."[27]

When Hart then asks him why he gets out of bed in the morning, Cohle answers, "I tell myself I bear witness. The real answer is that it's obviously my programming, and I lack the constitution for suicide." Hart shakes his head at this ("My luck, I picked today to get to know you"), but the message is clear: the time for clever hard-boiled banter has come to an end. In its place is a character dealing with the weight of the world. In a sense, the online world

has bombarded us with so many glib statements, so many pithy observations, that what audiences really wanted—even if they didn't know it—was someone who could keep to himself.

There were other reasons—other than political alienation and disenchantment—why a character putting one foot in front of the other in the midst of unimaginable sorrow corresponded with modern American circumstances. Between Columbine in April of 1999 and the airing of *True Detective* in 2014, gun violence in schools had increased to the point where reports of school shootings produced a numbing tragedy fatigue. After the December of 2012 murder of twenty first-graders and six adults at Sandy Hook Elementary School, multiple gun laws were proposed, but such important would-be legislation as the renewed assault weapons ban and universal background checks were defeated in 2013. For most Americans, these shootings were the poisonous results of a coldhearted gun lobby and craven politicians unwilling to act. For many, however, gun violence indicated a need for more guns, for tougher family structures, and for retrograde morality on a national scale. Some conservatives even harassed families of the murdered children, calling the massacre a hoax. But no matter what your opinion, the unavoidable lesson was that someone could come at you and take what you most loved. This was the environment in which Cohle operated.

When it came to earlier television detectives, photogenic good looks had been the rule. Rockford sported a warm and winning smile, Harry Orwell had the "quiet and wistful" air that made him attractive to viewers. The detectives on *The Wire* were energetic and attentive, good at repartee, socially conscious, multidimensional. Matthew McConaughey was a handsome man, but coming off an Oscar win for his role as a 1980s AIDS patient, he was not looking to seduce the camera. One critic calls him "all pinched stillness, a rubber band wrapped tight around a razor blade."[28] McConaughey said in a 2016 television interview that Cohle was

never soliciting someone to try to talk them into something. As the entire nation got more technologically connected between 1995 and 2012, Cohle had become more and more disconnected. He moves toward a more marginal place in the world, which makes his disconnection believable. But unlike someone who might choose face-to-face conversation over Snapchat, he also seems more broadly disconnected from other people. On the road of history, he walks against traffic, not toward a reactionary manliness, and not toward the warmth of human interaction, but toward a loner existence.

When Cohle is interrogated in the scenes that take place in 2012—seventeen years after the original murder—he says, "All your life, all your love, all your hate, all your memory, all your pain, it was all the same thing. It was all the same dream—a dream that you had inside a locked room. A dream about being a person." When *True Detective* debuted, being a person meant being cut out

Detective Rustin Cohle (Matthew McConaughey) is the intense, brooding, isolated protagonist on the first season of Nic Pizzolatto's *True Detective*.

in some way from what seemed to be an empowered whole. It's not an accident that the guilty parties in the show's various murders are connected to the ruling political and evangelical families in the state of Louisiana. Once again, just as it was in the 1920s, and in the 1970s, and the early 2000s, the hard-boiled individual emerged in response to public impotence and political alienation. For Democrats frustrated that even Obama's much-celebrated election did not dismantle political obstruction, for Republicans furious that an elitist president was out of touch with "real Americans," the media stoked a sense of adversity and victimhood. But being a person also meant being cut out from a sense of one's own thoughts and hopes. To some degree, this isolation had to do with technology. At the same time, it came from financial crisis and a postrecession listlessness. Despite proclamations that the economy was back on track and that recession losses were receding, you had a good chance of seeing your best efforts to save money for retirement, move toward racial and gender equality, combat political corruption, make the same living your parents did, buy a house and keep it, protect your elementary school children from automatic weapons, or see the end of a ten-year war come to nothing. If corporations were people, which they had been since 2010, then what could actual people be? In one of Cohle's 2012 questioning scenes, he states, "I know who I am. After all this time, there's a victory in that."[29] That line alone shows how far the world has come—or how far out it has gone—since the institutionally dedicated idealists of *Law and Order* debuted in 1990. Even though Cohle is determined, and for all his profound meditations on being a person, he lives in a sort of vacuum when it comes to other people.

Audiences loved *True Detective*, but critics were quick to point out that behind the good looks and the strong, silent exterior, some of Cohle's ruminations did not make a lot of sense. The *New Yorker*'s Emily Nussbaum called him a "sinewy weirdo" who

delivers "arias of philosophy, a mash-up of Nietzsche, Lovecraft, and the nihilist horror writer Thomas Ligotti." She also calls him "the outsider with painful secrets and harsh truths and nice arms" and points out that while McConaughey gives an exciting performance, "his rap is premium baloney."[30]

Once hard-boiled characters start talking about what's in their heads, like *The Wire*'s McNulty does when drunk, or Cohle does when he opens up, we see that sometimes it's a mess. There is nothing ideal about the inner workings of an actual mind. In *The Dain Curse*, the Continental Op sounded self-assured when he said that thinking was a "dizzy business." But in *True Detective*, almost one hundred years later, thinking is a full-time job. Alienation, isolation, and the burden of the mind become principal modern enemies.

In a sense, Cohle comes close to busting hard-boiled tough-guy conventions. The series is a tour de force of hermetic insulation, but the character's pain is so palpable that the toughness it creates does not seem enviable.[31] This does not ruin the character's magnetism—audiences are fond of tormented depth as spectacle—but it does show hard-boiled characters at war with themselves as much as with other people. Strong and silent becomes not so much a protection against pain but a result of it.

True Detective was HBO's most-watched show in its first year on the air. Cohle's isolation resonated with viewers. But the timing of the series (2014–19) coincided with a gradual cultural movement away from white male existential torment. That expansion had to do with increased public interest in a more diverse character base and political representation. Crime novels had moved in this direction for decades before television caught up. Sara Paretsky's V.I. Warshawski, Walter Mosley's Easy Rawlins, George Pelecanos's Derek Strange, Barbara Neely's Blanche White, Gary Phillips's Ivan Monk, Laura Lippman's Tess Monaghan, and Alex Segura's Pete Fernandez—to name only a very few—had

populated bookstores and best-seller lists for decades. These characters, unlike Cohle, are a part of their communities, pursue hobbies, and have friends. They live three-dimensional lives *and* solve crimes. But *True Detective*, with its alienated lead, was in some sense the summit of and swan song for the burdened, isolated white male principal. The third season cast Mahershala Ali in the role of the lead detective.[32] But none of the series' female characters—including Ani Bezzerides from the much-maligned second season—resonated with the public or came close to the male characters' complexities. Much as it was in the 1920s, television producers continued to foreground male characters as existential heroes. In a sense, existential pathos and exemplary universality remained the last frontiers when it came to true diversity.

- - - - - - - - - - - - - - - - - - - -

A Person of Honor

Thinking back to the Breitbart columnist who complained about weak male television characters, it is worth considering the reason for his criticism. It doesn't seem very likely that male audiences—or any audience—will flock in droves to whiny men as role models. It is more that when weak men (to use his term) outnumber tough men, the world can see that being tough is not an intrinsic part of manhood.[1] Even Cohle, the tightly wound detective, expends great effort to remain that way. And that makes plain that being a man—smart, instinctive, tough—is a matter of personality and will.

The idea of men as leaders and heroes depends in large part on the fact that popular culture hasn't questioned a man's ability to lead. No one looks at a man and worries that, because he is a man, he is unable to do one thing or another. In contrast, it is easy to look at women and wonder this. In the casting call of everyday existence, women are the victims, and men the ones who hurt or protect them. There are, of course, men who get hurt, and women who hurt others, but in the mainstream view, men are aggressors. This has made them the problem and paradoxically the solution as well.

The classic male detective, gun in hand, encouraged readers to trust him and share his perspective. Readers and audiences did not fear for his safety, because he could take care of himself. A female detective, in contrast, could at first glance look like a potential victim. Living in this world and walking the streets as a woman involves constant wariness. Women's bodies are vulnerable in a way that men's aren't. A man can get beaten up—and this happened to one hard-boiled character after another—but he returns to the job the day after that beating. The violence men perpetrate against women, however, is worse than what men do to each other. Women exist under a constant threat of violence and vulnerability from men. Everyone, men and women, knows this. This is why female hard-boiled detectives like Sara Paretsky's V.I. Warshawski and Sue Grafton's Kinsey Millhone are never quite as believable as their male counterparts, even though—as characters, as people—they are in many ways *more* believable. In book after book, they are never raped or killed, which is in itself unrealistic.

In real life, men commit traumatic violence against women every day. Misogynistic brutality is constant. For a female hard-boiled detective to be viable, she needs to be as indestructible as Hammer or Spenser. Such a female character would need the abilities of Wonder Woman in a human body.[2] Audiences want someone who can understand disillusionment and loneliness, who lives a human life on human time. They want someone who is tough but—and this is where Wonder Woman is disqualified from the category—not inherently immune to trauma. Someone who *can* get hurt or killed but who somehow, through smarts and strength, manages not to. It's a tall order. The answer to this conundrum arrived in *Jessica Jones*, which debuted in 2015 on Netflix.

The character of Jessica Jones first appeared in November of 2001 in the adult comic *Alias*, written by Brian Michael Bendis and Michael Gaydos. In 2010, executive producer Melissa Rosenberg

For a long time, the hard-boiled had been an entirely reactionary character, assuring the male reader of his natural dominance and centrality. Much of that centrality was justified by the fiction that he would take care of others, that he would be more able and inclined than another—than a woman—to leap into action and save people. From the Promise Keepers to the Quiverfull movement to countless practitioners of so-called benevolent sexism, the notion of men as guardians is ingrained in American culture. Masculine courage and leadership cements gendered social, political, and economic dominance in the popular imagination. But it is evident that many men mainly support and protect themselves, and the "manliness" lamented is, in fact, empty entitlement to privilege.

It was the same in the hard-boiled world. To protect his status, the male detective had to save someone, and that someone had to be a woman, because male readers—and many female readers—didn't want to see men in need of saving. They didn't want a man clinging and crying, "Oh, Mike!" Sometimes a detective would rescue a man whose strength had taken a hit, like when Race Williams rescued the drug-addicted Daniel in *Snarl of the Beast*. But if men regularly needed saving, then who could argue that men are the natural protectors? And if men were more predators than protectors, what would happen to the ideal of the male defender? Around the time of *Jessica Jones*'s arrival on Netflix, that ideal came up against some serious cultural roadblocks. On the rise were mass gun violence, perpetrated almost exclusively by white men, and sexual harassment and assault on college campuses and in workplaces, again frequently perpetrated by men.

The obstacles for female hard-boiled detectives—like those for other sorts of female leaders and renegades—are as much cultural and economic as physical. Countless notions that are patently untrue nonetheless pass for true when enough of the public agrees. "Men are born to lead." "Women are ruled by their emotions."

developed *AKA Jessica Jones* for 2011 at ABC, but the network rejected it. In 2013, Marvel and Disney contracted with Netflix to put *Jessica Jones* on cable. Krysten Ritter, who played a heroin addict on *Breaking Bad*, was cast in 2014. Jones is introduced as a snarky and depressive former superhero—someone who abandoned the cape and costume and started Alias Investigations. At the age of fourteen, Jones survived a car accident that killed her parents and her younger brother and put her into a months-long coma. When she woke up, she discovered she had uncommon strength. She finds this strength is useful for tossing assailants across the room, jumping up to fire escapes, and removing doors. In the second season, we learn that after her near-fatal accident, she had been brought to a genetic lab and experimented on, resulting in her powers. So, as is often true of comic book heroes, Jones's powers are indivisible from disaster. Though grounded in loss and suffering, her powers enable her to physically best her enemies and save lives, defending the people around her.

Jessica Jones brings together the qualities of previous detectives: she deals with trauma, has an indestructible nature, harbors a low-grade cynicism about human nature, moral self-doubt, a tendency to isolate, an instinct to save others, and is a heavy drinker. At the start of the series, Jones is about thirty years old. She has a bad case of PTSD, not from the accident that killed her family but because she had fallen under the mind control of a man named Kilgrave, who—by controlling her thoughts—had imprisoned her for eight months, raped her, and forced her to murder an innocent person. That act of murder jolted Jones out of Kilgrave's control, and she was able to escape. So, like earlier detectives, she has been through the worst of what people are capable of doing to one another. Because she survived Kilgrave at a time when gun violence, terrorism, and domestic violence pervade the news, her trauma stood in for that of others—men and women—who had been through similar traumatic events.

Krysten Ritter played the titular character on Netflix's *Jessica Jones*. Though the series was short-lived (2015–19), her character made mainstream the possibility of a female hard-boiled detective as found in novels for decades.

experience was incidental and his "taste for death" innate. In Jessica's case, which involved supernatural mind control rather than wartime adrenaline, the self-doubt has no reasonable basis. But doubt about one's autonomy—and uneasy resignation about the course of world events—was becoming part of the American experience.

By the time *Jessica Jones* came to the screen in November of 2015, Trump had vilified Mexican immigrants, promised to build a border wall, insulted former prisoner of war and longtime senator John McCain, called for a ban on Muslims, and espoused misogyny. The history of the United States since Trump's election has in some sense been the history of the reign of the unethical and of public surprise, dismay, and apathy in response to it. By the time the second season of *Jessica Jones* aired, the distinction between acting in one's own interest and doing gratuitous harm had become a serious American conundrum. Trump had become president by promising to support "real Americans." When it became glaringly clear (not that it was ever actually unclear) that his

principal interest was in increasing wealth for corporations and himself, alongside demonizing minorities and the poor, the people who voted for him had to defend their decision.

Even for people who were repulsed by the course of American politics and considered themselves part of the solution, the problem of accountability arose. What could one person do in the face of such widespread moral decline? One important result of a surge in internet use, and of the constant deluge of news that comes with it, is that people know about a lot more trouble than they are able to face. And they certainly know about more trouble than they can do anything about. Studies published in the 2010s found that a constant barrage of disturbing news stories leads to compassion fatigue, isolation, a sense of hopelessness, and decreased capacity for empathy.[6] The spectacle of a world populated with numerous bad people and countless more helpless people can be numbing.

In the first episode of *Jessica Jones*, when it becomes clear that Kilgrave has taken a girl prisoner and forced her to murder her own parents, Jessica books a ticket to Hong Kong to get away from him. At the last minute, though, she decides to stay and face her enemy; she ends the episode with a determined voice-over: "Knowing it's real means you got to make a decision. One, keep denying it, or two, do something about it." "Doing something about it" is an American strong suit, but it did not feel like one in 2015. The scale of the nation was so vast that a sense of community among neighbors and friends seemed disconnected from the events of the news. Even when hundreds of thousands of people marched for a cause, those multitudes did not mean any real capture of power. Social movements raised consciousness, but the injustices that sparked those movements seemed intractable. In some cases—during the series airing in 2015 and 2018—things seemed to get worse.

The sense of American decline comes, in part, from increasing media reporting of social problems that have been present all along. Part of it was that through the middle of the decade, those problems did, in fact, worsen. Consider Occupy Wall Street, which coined the term "1 percent" in 2011 and cast a harsh light on income inequalities. The "We are the 99 percent" movement blossomed, but so did the capital gains of the 1 percent—not to mention the election of a self-styled one-percenter in 2016. #BlackLivesMatter started in 2013 in response to the murder of Florida teenager Trayvon Martin by George Zimmerman. As public consciousness increased, though, so did the killings of unarmed black people. These included Michael Brown, Eric Garner, and twelve-year-old Tamir Rice, killed in 2014. The year 2015 saw the deaths of Freddie Gray, Walter Scott, and Sandra Bland, as well as the massacre of nine congregants at the Emanuel African Methodist Episcopal Church in Charleston. In 2015, the rate of police-involved deaths for young black men was five times higher than for their white counterparts.[7] In 2017. San Francisco 49ers quarterback Colin Kaepernick initiated NFL protests against police brutality; he was released from his contract and remains unsigned despite his talent. In May of 2018, the NFL announced that it would fine teams whose players refused to stand for the National Anthem. On the environmental front, in early 2016, tribal nations protested the Dakota Access Pipeline out of concern for water quality and sacred burial grounds. Two days before Donald Trump's inauguration, the Army Corps of Engineers ordered a full environmental study of the region, which Trump promptly stopped on assuming office. When it came to women's rights, in 2017, accusations against movie producer Harvey Weinstein coalesced with fury at Trump's election to fuel the #MeToo movement. That movement had started in 2006 to support women of color who had experienced sexual violence but was taken up in the aftermath of the

election to protest violence and harassment of all women and girls. There, too, though, while #MeToo made unmistakable strides, it did not preclude the continued regime of a president whose contempt for women's privacy and safety was relentless. In 2018, a Republican-controlled senate confirmed a Supreme Court justice who has moved the makeup of the Court to the right, a move that threatens a woman's right to decide whether and when to have children.

Jones lets people know what is happening, which is an important service in the era of distracting, misleading, or outright fictional news. The attention and respect that truth used to command is devoured by distraction and dysfunction, much as the attention that human contact used to command is wasted on clickbait and unprecedented government hostility toward the press. Jessica's work to vindicate the young woman accused of murdering her parents is about saving the woman's future, but it is also about correcting the record. So, too, when she assists Malcolm in escaping his addiction. When Malcolm says, "I could have died with my parents still thinking that I was all the things that he made me," he is talking about reclaiming his narrative and reputation as much as he is about surviving. When Jessica breaks Kilgrave's neck at the end of the season, she does it on a pier in front of witnesses. When Kilgrave dies, the people—whom Kilgrave had rendered into a zombie-like state—start moving, looking around, seeing their surroundings, seeing each other. The fever dream into which Kilgrave had put them—ordering them to kill each other and then ordering them into immobility—is interrupted once Jones breaks the force that had driven them to destroy themselves and others. In a sense, Jones's murdering Kilgrave is the ultimate Trump-era fantasy—that someone, some voice, some fact could break the hold that a self-destructive hate- and fear-based ideology has on the American electorate. Leaving the police station after Kilgrave's murder, Jones says in voice-over: "They

say everyone's born a hero. But if you let it, life will push you over the line until you're the villain."[8]

...

Part of what the hard-boiled detective has always done is embody what the American public wishes it could be. In a lot of ways, America is a nation of aggressive directness, of daring solutions. But it is also a nation enamored with simple answers and instant gratification. Sometimes the hard-boiled pretends those simple solutions are enough, and sometimes it is honest about their limitations. For instance, after the First World War, when the public was just beginning to understand posttraumatic stress, Race Williams was too cool to be bothered with grief. He implied that you could transcend violence with a wave of your hand. Tens of thousands of returning veterans knew it wasn't that simple, but it was nonetheless appealing to think that someone was managing it. The Trump-era hard-boiled starts to reveal some cracks in the façade of resilience. Being cool looks different when therapy is common and everyone knows about PTSD. People who suppress their feelings may be tough, but they may also be profoundly damaged.

Jessica Jones comes at the world with a version of Hoover's rugged individualism. She resists going to a support group for Kilgrave survivors ("I prefer repression"), saying she's not going to talk about her story and that someone else has always had it worse. And in the tradition of the Continental Op, her main coping mechanism is round-the-clock drinking. In *The Long Goodbye*, Marlowe explains the distinction between a hard drinker and an alcoholic: "A man who drinks too much on occasion is still the same man as he was sober. An alcoholic, a real alcoholic, is not the same man at all. You can't predict anything about him for sure except that he will be someone you never met before."[9] Jessica Jones corresponds to the benign description of someone who drinks too much on occasion, except that her occasions happen

every day. There is no change in mood, no impairment. Audiences and critics remarked that that aspect of the series was unrealistic; the fact that Jones maintains a functional existence while constantly drinking is almost as fantastic as the superpowers themselves.

Drinking whiskey and making it look comforting is a hard-boiled tradition. The Continental Op and Philip Marlowe loved alcohol, as did their authors. Jones follows their example, boosted by the fact that compared to the opioid epidemic that began ruining lives in the 2010s, alcohol seemed almost innocuous by comparison. There were more than sixty-three thousand drug-overdose deaths in the US in 2016, and death from synthetic opioids (other than methadone) doubled from 2015 to 2016.[10] A fentanyl overdose can kill a person in a few minutes. But the fact remains that alcohol is also a pernicious substance, albeit a legal one. Any actual person—especially a woman Jones's size—who drank a fifth of "Wild Fowl" a day wouldn't have Krysten Ritter's dewy skin and bright eyes. The superpowers could account for the fact that Jones remains intact, but the disconnect between what her drinking looks like on television and what heavy drinking looks like in real life is hard to miss.

In the 1920s, the great hard-boiled detective's accomplishment was surviving and maintaining an ethics of his own, even though other people were trying to kill him. In *Jessica Jones*, as in *True Detective*, the feat is surviving and maintaining ethics even though she is doing her best to kill herself. There is a moment in the first season of *Jessica Jones* when Jones and Simpson are pursuing Kilgrave, and they discuss worst-case scenarios:

> JONES. If Kilgrave gets me—
> SIMPSON. I'll take you out.
> JONES. I was gonna say dart gun me, but sure, shoot me in the head.
> SIMPSON. Same here.[11]

The characters have a dark unconcern for their own lives, but they survive nonetheless. It is a rather nihilistic vision of society, but also a weirdly optimistic vision of individual abilities.

Jones opens the first episode of the series announcing via voiceover that a big part of her job is looking for the worst in people. In the first scene, a man who's hired her to catch his wife cheating gets furious when he finds out the truth. He attacks Jessica, who tosses him into the corridor using her super strength. "People do bad shit. I just avoid getting involved with them in the first place. That works for me. Most of the time."

Melissa Rosenberg was prescient in taking Jessica Jones—conceived in 2001 after September 11—and turning her into a TV character for the internet era. Avoiding people—at least in person—was also a common American pastime in 2015, as time spent on social media increased with each passing year.[12] *Jessica Jones* has a *noir* but modern cast not because its characters are shadowy and villainous but because they are solitary. Jones sits alone on a fire escape and spies on the intimate details of people's lives, watching a plump woman eat a hamburger while exercising on a Stairmaster, then watching a lone man smelling a woman's shoe. Even as she winces at those observations, she drinks whiskey from a water bottle to quiet the flashbacks of what Kilgrave did to her. Everybody in the show is isolated in some way: the man down the hall is a heroin addict; Jones's love interest is widowed; her best friend lives in a super-secured apartment with a panic room. Her upstairs neighbors are a brother and sister living in misfit dysfunction until one of them is killed. When the sister rails at Jones, "You're all alone so you have to pick away at other people's happiness," she responds by calling her a "very perceptive asshole." Even Kilgrave is an overgrown child who has to manipulate people into spending time with him. In the era of social media and personal disconnection, watching people through their windows passes for intimacy. At least Jones is looking at actual people in real time.

When Jones says that avoiding people works for her most of the time, this could mean that avoiding people leads to loneliness or that avoiding people does not prevent bad things from happening; both are facts of modern existence. In the era of this series, the volume of violence and bad news was daunting. There were plenty of reasons to do nothing, not the least of which was that doing something did not seem to move the needle much.[13] But doing nothing—aside from the fact that it would make bad television— is not an option for the hard-boiled detective. All of them, from Race Williams on, maintain some sort of face-to-face connection with others. It is not an accident that when politicians campaign, they meet constituents and shake their hands, and that campaign ads show them meeting constituents and shaking their hands. There has to be some tactile reality, some connection.

In an interview about living in the real world in the internet era, computer scientist Jaron Lanier was asked if human brains weren't meant to handle an onslaught of incoming information. He responded:

> I think the problem with the digital era is, we get a lot of signals that are actually not real signals, like, you know, buy these shoes; go to this party; oh, you're not as hot as the other person—I don't know—just this endless stream of stuff. And so I don't think it's so much that we're being overwhelmed by genuine detail, but by pseudo-detail. And it's like we're in this behaviorist experiment where we're in this maze where instead of the world of sense and hues and shades and the subtleties of nature that are ever-changing and infinitely deep, instead, we're in this world of little buttons and lights and treat dispensers, and it's actually a curtailed, simplified world that seems complex just because having a lot of it kind of takes up our time, takes up our attention. But I actually think we are built for [a] great deal of stimulus and detail, and we're not getting it. I think that the more accurate description of modern times is that we're starved for reality.

On the series, no one is starved for reality. No one is playing Candy Crush or scrolling absently through a phone. When people want to talk to each other—and the characters do seem to want to talk to each other and see each other—they go to each other's houses. Trish comes to see Jessica in her apartment. Malcolm sits with Robyn when she mourns her brother. Jessica stays with Malcolm while he withdraws from heroin. In short, there is actual human contact, and that in itself—the face-to-face conversations that happen on the street and in doorways—keeps the characters connected to one another. And just as Spenser had done, Jones enables others to do for themselves what they had been unable to do *by* themselves. She helps Malcolm to quit drugs but leaves the choice of whether to use them or not up to him. She rescues Simpson from Kilgrave-induced suicide. She even convinces Kilgrave to save a family. She also collaborates, as in *The Wire*, with others for important missions. When she tries to kidnap Kilgrave in an early episode, Trish drives the van and Simpson shoots him with the fentanyl dart. In a sense, *Jessica Jones* moves to restore the hard-boiled detective to the sort of connectedness that predated the smartphone—and the show does this while understanding its modern precarity.

At the end of the second season, Jones talks about the importance of connection to others. She says in a voice-over at the close of the second season, "I've gone through life untethered, unconnected. I wasn't even aware that I'd chosen that." She looks at her phone, closes the computer, heads out the door, passing Malcolm, and goes to her boyfriend Oscar's apartment to have dinner with him and his son. "It took someone coming back from the dead to show me that I've been dead too. The problem is, I never really figured out how to live."[14] The camera pulls back, showing the three of them through the window, a scene of domestic camaraderie.

America in the 2010s is in a time of crisis—a constitutional crisis, a crisis of American values, of the nation's place in the world.

The crisis is one of reality, as politics and entertainment—and character and persona—are profoundly confused. In July of 2018, President Trump warned attendees at the annual convention of the Veterans of Foreign Wars to "just remember, what you're seeing and what you're reading is not what's happening," and a *New York Times* headline announced, "Trump rages against reality." For millennials, the first modern generation to have less financial success than their parents,[15] it can also be a crisis of existential and economic independence. Jones's troubles with isolation and traumatic memories function as proxies for modern groundlessness. The first season closes with Jones announcing in voice-over: "Maybe it's enough that the world thinks I'm a hero. Maybe if I work long and hard, maybe I could fool myself."[16] In an era of therapy and self-awareness, Jones is more explicit about problems of accountability and character than are previous detectives. She is also more open about her foibles than any hard-boiled character since Hammer in *One Lonely Night*. Even if one's ethics are one's own, a sense of meaningful identity and control over one's own life is no longer the given that it was in the era of Race Williams. Being a hard-boiled character means facing head-on a slew of existential, financial, and material troubles—and knowing it. From *The Wire* to *True Detective* to *Jessica Jones*, the twenty-first century hard-boiled narrative plots a course to greater vulnerability and greater determination.

...

Despite the fact that television and film animate detectives, the iconic image of the cigarette-smoking hard-boiled detective is immobile from book covers, movie posters, and television credits. Yet as the hard-boiled evolved throughout the twentieth century and into the twenty-first, characters are more open about their vulnerabilities, more expressive about the cost of being what Chandler named "a man of honor—by instinct, by inevitability,

without thought of it, and certainly without saying it." Being a person of honor is a full-time job.

Showing vulnerability is contemporary realism. It is part of being human, even if Race Williams launched the hard-boiled pretending to be impervious to fear. In 1926, he calmly recalled "the bleak walls of the orphanage where [he] learned to coldly calculate the frailties of man."[17] Almost a hundred years later, in 2018, Jessica Jones puts a hole in a wall at anger management class while sharing with the group that her family was killed. And whereas Williams was jaunty and proud of his reputation around town, crowing that neither criminals nor police were fond of him, Jones is drained by the number of troubled people who need her. Being honorable means remaining conscious of others' problems. And the simple fact of that consciousness, never mind the desire and the competence to act on it, is depleting.

Holding it all together, as both a character and a person of honor, is becoming harder and harder in the twenty-first century. It demands a level of exertion that Williams was worlds away from articulating. That exertion resonates with contemporary readers and viewers, however, because they see themselves in it. People are conscious of their own frailties and accountability. The hard-boiled detective began in the 1920s as a locus of moral authority: someone to control the narrative and yet remain critical of his own role within it. Through decades of television and as the cult of celebrity has expanded, so has the phenomenon of mastering and manipulating one's public persona. The intersection of media and politics has generated people whose principal talent is embodying a main character or creating a master narrative. That kind of mastery, though, is entirely separate from the solidity and emotion of the hard-boiled detective. The former amounts to facile strength, while the latter is small in scale and grounded in a sense of personal responsibility.

If the political scene of the mid-2010s has demonstrated anything, it is the disaster that results when blithely destructive momentum encounters the naturally truncated nature of the human attention span. The hard-boiled has always charted the question of whether the individual can stand firm in the midst of institutional and societal corruption. It has also come to chart the question of whether good can rise above inertia and weariness. Hard-boiled characters' susceptibility to fatigue and trauma is not the same as the sentimentality of romance novels or the emotional intelligence of science fiction. In the hard-boiled, there is no catharsis to be garnered from understanding others' pain, no rose-colored visions of what it means to be human.[18] Hard-boiled vulnerability amounts to a clear-eyed acknowledgment of how tough it is to maintain accountability and control. It also demonstrates—thanks to television and the unfolding of stories over weeks and months and years—how hard it is to maintain focus and emotional investment.

In the last scene of the first season of *Jessica Jones*, Jones listens to voicemail messages from various people imploring her help. Some messages are insistent, others pitiable, but all the callers are certain that she is their last option. With a combination of dismay and disgust, whether at their neediness or her own limitations, Jones deletes the messages and throws down the phone. But as the scene closes, the office phone rings and her assistant answers it, asking "How can we help?" The contemporary hard-boiled balances modest self-awareness with strength, which gives it its value for the present day.

The hard-boiled tradition has always been about one person showing up where others hesitate to tread. And if there is a silver lining to be found in the loud, violent, climate-obliterating years of the late 2010s, it's that the public is more open to diversity in its heroes. But no one person can do everything. Should one person run out of steam, as Jessica Jones does in that moment,

another person answers the call. The long history of the hard-boiled is the history of a succession of individuals who care about others and are able to act on that caring. And in its focus on showing up over years and decades, it speaks volumes about desire for competent leadership and governance. In real history, there is voluminous public need and a want of individuals prepared to respond to it. But in the hard-boiled world, someone is there. The idea of a politician who carries the public, who provides the caring response that would-be clients want from Jessica Jones, might be anathema to Hooverian individualists. But that is nonetheless where the hard-boiled comes in, presenting individuals able to withstand the outside world on their own and prepared to shore up those who can't. As Kwame Anthony Appiah wrote in an article entitled "People Don't Vote for What They Want. They Vote for Who They Are," "Successful politicians know that *I'm with you* counts for more than *I'm for you*." Hard-boiled detectives do not say they are with you, but they actually are. They create an intersection between who people want to be and who they want in their corner and make that intersection part of the American dream.

APPENDIX
Selected Authors' Fictional Works

- - - - - - - - - - - - - - - - - - - -

Carroll John Daly

Main Character	Title	Format or Publication	Date
Vee Brown	*Murder Won't Wait*	Novel	1933
Vee Brown	*The Emperor of Evil*	Novel	1937
	Mr. Strang	Novel	1936
Satan Hall	*The Mystery of the Smoking Gun*	Novel	1936
Satan Hall	*Ready to Burn*	Novel	1951
	Murder at Our House	Novel	1950
Stacey Lee	*The White Circle*	Novel	1926
Terry Mack	"Three Gun Terry"	*Black Mask*	May 15, 1923
Terry Mack	"Action! Action!"	*Black Mask*	Jan. 1, 1924
Terry Mack	*The Man in the Shadows*	Novel	1928
Race Williams	*The Snarl of the Beast*	Novel	1927
Race Williams	*The Hidden Hand*	Novel	1929
Race Williams	*The Tag Murders*	Novel	1930
Race Williams	*Tainted Murder*	Novel	1931
Race Williams	*The Third Murder*	Novel	1931
Race Williams	*The Amateur Murderer*	Novel	1933
Race Williams	*Murder from the East*	Novel	1935
Race Williams	*Better Corpses*	Novel	1940
Race Williams	"Knights of the Open Palm"	*Black Mask*	June 1923
Race Williams	"Three Thousand to the Good"	*Black Mask*	July 15, 1923
Race Williams	"The Red Peril"	*Black Mask*	June 1924
Race Williams	"Them That Lives by Their Guns"	*Black Mask*	August 1924
Race Williams	"Devil Cat"	*Black Mask*	Nov. 1924
Race Williams	"The Face behind the Mask"	*Black Mask*	Feb. 1925
Race Williams	"Conceited, Maybe"	*Black Mask*	April 1925
Race Williams	"Say It with Lead"	*Black Mask*	June 1925
Race Williams	"I'll Tell the World"	*Black Mask*	August 1925

Race Williams	"Alias Buttercup"	*Black Mask*	Oct. 1925
Race Williams	"Under Cover" (Part 1)	*Black Mask*	Dec. 1925
Race Williams	"Under Cover" (Part 2)	*Black Mask*	Jan. 1926
Race Williams	"South Sea Steel"	*Black Mask*	May 1926
Race Williams	"The False Clara Burkhart"	*Black Mask*	July 1926
Race Williams	"The Super Devil"	*Black Mask*	August 1926
Race Williams	"Half-Breed"	*Black Mask*	Nov. 1926
Race Williams	"Blind Alleys"	*Black Mask*	April 1927
Race Williams	"The Snarl of the Beast" (Part 1)	*Black Mask*	June 1927
Race Williams	"The Snarl of the Beast" (Part 2)	*Black Mask*	July 1927
Race Williams	"The Snarl of the Beast" (Part 3)	*Black Mask*	August 1927
Race Williams	"The Snarl of the Beast" (Part 4)	*Black Mask*	Sept. 1927
Race Williams	"The Egyptian Lure"	*Black Mask*	March 1928
Race Williams	"The Hidden Hand—Creeping Death"	*Black Mask*	June 1928
Race Williams	"The Hidden Hand—Wanted for Murder"	*Black Mask*	July 1928
Race Williams	"The Hidden Hand—Rough Stuff"	*Black Mask*	August 1928
Race Williams	"The Hidden Hand— The Last Chance"	*Black Mask*	Sept. 1928
Race Williams	"The Last Shot"	*Black Mask*	Oct. 1928
Race Williams	"Tags of Death"	*Black Mask*	March 1929
Race Williams	"A Pretty Bit of Shooting"	*Black Mask*	April 1929
Race Williams	"Get Race Williams"	*Black Mask*	May 1929
Race Williams	"Race Williams Never Bluffs"	*Black Mask*	June 1929
Race Williams	"The Silver Eagle"	*Black Mask*	Oct. 1929
Race Williams	"The Death Trap"	*Black Mask*	Nov. 1929
Race Williams	"Tainted Power"	*Black Mask*	June 1930
Race Williams	"Framed"	*Black Mask*	July 1930
Race Williams	"The Final Shot"	*Black Mask*	August 1930
Race Williams	"Shooting Out of Turn"	*Black Mask*	Oct. 1930
Race Williams	"Murder by Mail"	*Black Mask*	March 1931
Race Williams	"The Flame and Race Williams" (Part 1)	*Black Mask*	June 1931
Race Williams	"The Flame and Race Williams" (Part 2)	*Black Mask*	July 1931
Race Williams	"The Flame and Race Williams" (Part 3)	*Black Mask*	August 1931
Race Williams	"Death for Two"	*Black Mask*	Sept. 1931
Race Williams	"The Amateur Murder" (Part 1)	*Black Mask*	April 1932
Race Williams	"The Amateur Murder" (Part 2)	*Black Mask*	May 1932
Race Williams	"The Amateur Murder" (Part 3)	*Black Mask*	June 1932
Race Williams	"The Amateur Murder" (Part 4)	*Black Mask*	July 1932
Race Williams	"Merger with Death"	*Black Mask*	Dec. 1932

Race Williams	"The Death Drop"	*Black Mask*	May 1933
Race Williams	"If Death Is Respectable"	*Black Mask*	July 1933
Race Williams	"Murder in the Open"	*Black Mask*	Oct. 1933
Race Williams	"Six Have Died"	*Black Mask*	May 1934
Race Williams	"Flaming Death"	*Black Mask*	June 1934
Race Williams	"Murder Book"	*Black Mask*	August 1934
Race Williams	"The Eyes Have It"	*Black Mask*	Nov. 1934
Race Williams	"Some Die Hard"	*Dime Detective*	Sept. 1935
Race Williams	"Dead Hands Reaching"	*Dime Detective*	Nov. 1935
Race Williams	"Corpse & Co."	*Dime Detective*	Feb. 1936
Race Williams	"Just Another Stiff"	*Dime Detective*	April 1936
Race Williams	"City of Blood"	*Dime Detective*	Oct. 1936
Race Williams	"The Morgue Is Our Home"	*Dime Detective*	Dec. 1936
Race Williams	"Hell with the Lid Lifted"	*Dime Detective*	March 1939
Race Williams	"Race Williams' Double Date"	*Dime Detective*	August 1948
Race Williams	"Half a Corpse"	*Dime Detective*	May 1949
Race Williams	"Race Williams Cooks a Goose"	*Dime Detective*	Oct. 1949
Race Williams	"Little Miss Murder"	*Smashing Detective Stories*	June 1952
Race Williams	"This Corpse Is Free!"	*Smashing Detective Stories*	Sept. 1952
Race Williams	"Gas"	*Smashing Detective Stories*	June 1953
Race Williams	"Head over Homicide"	*Smashing Detective Stories*	May 1955
Race Williams	"Not My Corpse"	*Mammoth Book of Private Eye Stories*	June 1948
Race Williams	"The Wrong Corpse"	*Thrilling Detective*	Feb. 1949
Race Williams	"The Strange Case of Alta May"	*Thrilling Detective*	April 1950

Dashiell Hammett

| The Continental Op | "Arson Plus" | *Black Mask* | Oct. 1, 1923 |
| The Continental Op | "Crooked Souls" | *Black Mask* | Oct. 1, 1923 |

The Continental Op	"Slippery Fingers"	*Black Mask*	Oct. 15, 1923
The Continental Op	"It"	*Black Mask*	Nov. 1, 1923
The Continental Op	"Bodies Piled Up"	*Black Mask*	Dec. 1, 1923
The Continental Op	"The Tenth Clew"	*Black Mask*	Jan. 1, 1923
The Continental Op	"Night Shots"	*Black Mask*	Feb. 1, 1924
The Continental Op	"Zigzags or Treachery"	*Black Mask*	March 1, 1924
The Continental Op	"One Hour"	*Black Mask*	April 1, 1924
The Continental Op	"The House in Turk Street"	*Black Mask*	April 15, 1924
The Continental Op	"The Girl with Silver Eyes"	*Black Mask*	June 1924
The Continental Op	"Women, Politics and Murder"	*Black Mask*	Sept. 1924
The Continental Op	"The Golden Horseshoe"	*Black Mask*	Nov. 1924
The Continental Op	"Who Killed Bob Teal?"	*True Detective Stories*	Nov. 1924
The Continental Op	"Mike, Alex, or Rufus?"	*Black Mask*	Jan. 1925
The Continental Op	"The Whosis Kid"	*Black Mask*	March 1925
The Continental Op	"The Scorched Face"	*Black Mask*	May 1925
The Continental Op	"Corkscrew"	*Black Mask*	Sept. 1925
The Continental Op	"Dead Yellow Women"	*Black Mask*	Nov. 1925
The Continental Op	"The Gutting of Couffignal"	*Black Mask*	Dec. 1925
The Continental Op	"Creeping Siamese"	*Black Mask*	March 1926
The Continental Op	"The Big Knock-Over"	*Black Mask*	Feb. 1927
The Continental Op	"$106,000 Blood Money"	*Black Mask*	May 1927

The Continental Op	"The Main Death"	*Black Mask*	June 1927
The Continental Op	"The Cleansing of Poisonville"	*Red Harvest*	Nov. 1927
The Continental Op	"Crime Wanted—Male or Female"	*Red Harvest*	Dec. 1927
The Continental Op	"Dynamite"	*Red Harvest*	Jan. 1928
The Continental Op	"The 19th Murder"	*Red Harvest*	Feb. 1928
The Continental Op	"This King Business"	*Black Mask*	Jan. 1928
The Continental Op	"Black Lives"	*Black Mask*	Nov. 1928
The Continental Op	"The Hollow Temple"	*Black Mask*	Dec. 1928
The Continental Op	"Black Honeymoon"	*Black Mask*	Jan. 1929
The Continental Op	"Black Riddle"	*Black Mask*	Feb. 1929
The Continental Op	"Fly Paper"	*Black Mask*	August 1929
The Continental Op	"The Farewell Murder"	*Black Mask*	Feb. 1930
The Continental Op	"Death and Company"	*Black Mask*	Nov. 1930
Sam Spade	*The Maltese Falcon*	Novel	Feb. 14, 1930
Sam Spade	"A Man Called Spade"	*American Magazine*	July 1932
Sam Spade	"Too Many Have Lived"	*American Magazine*	Oct. 1932
Sam Spade	"They Can Only Hang You Once"	*Colliers*	Nov. 19, 1932
Sam Spade	"A Knife Will Cut for Anybody"	Published Posthumously	2013
Nick and Nora Charles	*The Thin Man*	Novel	1934
Nick and Nora Charles	*After the Thin Man*	Novel	1935
Nick and Nora Charles	*Another Thin Man*	Novel	1938
Nick and Nora Charles	*Sequel to the Thin Man*	Novel	1938

The Glass Key	Novel	1931
"The Barber and His Wife"	Short Story	1922
"The Parthian Shot"	Short Story	1922
"The Great Lovers"	Short Story	1922
"Immortality"	Short Story	1922
"The Road Home"	Short Story	1922
"The Master Mind"	Short Story	1923
"The Sardonic Star of Tom Doody"	Short Story	1923
"The Joke on Eloise Morey"	Short Story	1923
"Holiday"	Short Story	1923
"The Crusader"	Short Story	1923
"The Green Elephant"	Short Story	1923
"The Dimple"	Short Story	1923
"Laughing Masks"	Short Story	1923
"Itchy"	Short Story	1924
"Esther Entertains"	Short Story	1924
"Another Perfect Crime"	Short Story	1925
"Ber-Bulu"	Short Story	1925
"The Advertising Man Writes a Love Letter"	Short Story	1926–30
"The Second-Story Angel"	Short Story	1925
"The Man Who Killed Dan Odams"	Short Story	1923–26
"Night Shots"	Short Story	1923–27
"Afraid of a Gun"	Short Story	1923–28
"The Assistant Murderer"	Short Story	1923–29
"Nightmare Town"	Short Story	1924
"Ruffian's Wife"	Short Story	1925
"On the Way"	Short Story	1932
"Woman in the Dark"	Short Story	1933
"Night Shade"	Short Story	1933
"Albert Pastor at Home"	Short Story	1933
"Two Sharp Knives"	Short Story	1934
"His Brother's Keeper"	Short Story	1934
"Two Sharp Knives"	Short Story	1934
"This Little Pig"	Short Story	1934
"A Man Called Thin"	Short Story	1931
"An Inch and a Half of Glory"	Short Story	posthumously

Raymond Chandler

"The Unknown Love"	Poem	Dec. 19, 1908
"The Poet's Knowledge"	Poem	March 3, 1909
"The Soul's Defiance"	Poem	March 5, 1909

"The Wheel"	Poem	March 25, 1909
"Art"	Poem	April 16, 1909
"A Woman's Way"	Poem	April 22, 1909
"The Quest"	Poem	June 2, 1909
"When I Was King"	Poem	June 9, 1909
"The Hour of Chaos"	Poem	June 18, 1909
"The Bed of Roses"	Poem	June 29, 1909
"The Reformer"	Poem	July 29, 1909
"The Perfect Knight"	Poem	Sept. 30, 1909
"The Pilgrim in Mediation"	Poem	Nov. 8, 1909
"The Pioneer"	Poem	Nov. 17, 1909
"The Hermit"	Poem	Feb. 28, 1910
"The Dancer"	Poem	May 14, 1910
"The Death of the King"	Poem	July 16, 1910
"The Clay God"	Poem	Jan. 4, 1911
(Untitled)	Poem	March 18, 1911
"The Unseen Planets"	Poem	April 21, 1911
"The Tears That Sweeten Woe"	Poem	May 1, 1911
"The Fairy King"	Poem	May 3, 1911
(Untitled)	Poem	June 16, 1911
"The Genteel Artist"	Poem	August 19, 1911
"The Remarkable Hero"	Essay	Sept. 9, 1911
"The Literary Fop"	Essay	Nov. 4, 1911
"An Old House"	Poem	Nov. 15, 1911
"Realism and Fairyland"	Essay	Jan. 6, 1912
"The Tropical Romance"	Essay	Jan. 20, 1912
"Houses to Let"	Essay	Feb. 24, 1912
"The King"	Poem	March 1, 1912
"Time Shall Not Die"	Poem	April 25, 1912
"The Art of Loving and Dying"	Review	June 22, 1912
"The Rural Labourer at Home"	Review	June 22, 1912
"The Phrasemaker"	Essay	June 29, 1912
"Blackmailers Don't Shoot"	Story	Dec. 1933
"Smart-Aleck Kill"	Story	July 1934
"Finger Man"	Story	Oct. 1934
"Killer in the Rain"	Story	Jan.1935
"Nevada Gas"	Story	June 1935
"Spanish Blood"	Story	Nov. 1935
"Guns at Cyrano's"	Story	July 1936
"The Man Who Liked Dogs"	Story	March 1936
"Noon Street Nemesis"	Story	May 30, 1936
"Goldfish"	Story	June 1936

"The Curtain"	Story	Sept. 1936
"Try the Girl"	Story	Jan. 1937
"About the Article on Floral Arrangement	Letter	June 15, 1937
"A Second Letter from R C Esq"	Letter	July 1, 1937
"Mandarin's Jade"	Story	Nov. 1937
"Red Wind"	Story	Jan. 1938
"The King in Yellow"	Story	March 1938
"Bay City Blues"	Story	June 1938
"The Lady in the Lake"	Story	Jan. 1939
"Pearls Are a Nuisance"	Story	April 1939
"Trouble Is My Business"	Story	August 1939
"I'll Be Waiting"	Story	Oct. 14, 1939
"The Bronze Door"	Story	Nov. 1939
"No Crime in the Mountains"	Story	Sept. 1941
"The Simple Art of Murder"	Article	Dec. 1944
"Writers in Hollywood"	Article	Nov. 1945
"The Hollywood Bowl"	Review	Jan. 1947
"'Pros' and Cons"	Letter	May 1947
"Oscar Night in Hollywood"	Article	March 1948
"Studies in Extinction"	Review	April 1948
"10 Greatest Crimes of the Century"	Article	Oct. 1948
"The Little Sister"	Excerpt	April 1949
(Untitled)	Letter	May 1951
"Professor Bingo's Snuff"	Story	June 1951
"Ten Per Cent of Your Life"	Article	Feb. 1952
"Ruth Ellis—Should She Hang"	Letter	June 30, 1955
"A Letter from London"	Letter	Sept. 1955
"Bonded Goods"	Review	March 25, 1956
"Crosstown with Neil Morgan"	Guest Column	March 1, 1957
"Raymond Chandler Writes a Blunt Letter to the Daily Express"	Letter	June 18, 1957
"A Star Writer's Advice to Writers (and Editors)"	Letter	June 18, 1957
"Crosstown with Neil Morgan"	Guest Column	July 12, 1957
"Crosstown with Neil Morgan"	Guest Column	March 8, 1958
"The Terrible Dr No"	Story	March 30, 1958
"Playback"	Story	Oct. 1958

Mike Hammer	*Vengeance Is Mine!*	Novel	1950
Mike Hammer	*One Lonely Night*	Novel	1951
Mike Hammer	*The Big Kill*	Novel	1951
Mike Hammer	*Kiss Me, Deadly*	Novel	1952
Mike Hammer	*The Girl Hunters*	Novel	1962
Mike Hammer	*The Snake*	Novel	1964
Mike Hammer	*The Twisted Thing*	Novel	1966
Mike Hammer	*The Body Lovers*	Novel	1967
Mike Hammer	*Survival . . . Zero!*	Novel	1970
Mike Hammer	*The Killing Man*	Novel	1989
Mike Hammer	*Black Alley*	Novel	1996
Mike Hammer	"The Night I Died"	Story	1998
Mike Hammer	"The Duke Alexander"	Story	2004
Tiger Mann	*Day of the Guns*	Novel	1964
Tiger Mann	*Bloody Sunrise*	Novel	1965
Tiger Mann	*The Death Dealers*	Novel	1965
Tiger Mann	*The By-Pass Control*	Novel	1966
Morgan the Raider	*The Death Factor*	Novel	1967
	The Long Wait	Novel	1951
	The Deep	Novel	1961
	Me, Hood	Novel	1963
	Return of the Hood	Novel	1964
	The Flier	Novel	1964
	Killer Mine	Novel	1964
	Man Alone	Novel	1965
Dragon Kelly	*The Erection Set*	Novel	1972
	The Last Cop Out	Novel	1973
	The Day the Sea Rolled Back	Novel	1979
	The Ship That Never Was	Novel	1982
	Tomorrow I Die	Stories	1984
	Together We Kill	Stories	2001
Mako Hooker	*Something's Down There*	Novel	2003

Completed by or Cowritten with Max Allan Collins

Mike Hammer	*The Goliath Bone*	Novel	2008
Mike Hammer	*The Big Bang*	Novel	2010
Mike Hammer	*Kiss Her Goodbye*	Novel	2011
Mike Hammer	*Lady, Go Die!*	Novel	2012
Mike Hammer	*Complex 90*	Novel	2013
Mike Hammer	*King of the Weeds*	Novel	2014
Mike Hammer	*Kill Me, Darling*	Novel	2015
Mike Hammer	*Murder Never Knocks*	Novel	2016

	"Detective Story as an Art Form"	Article	March 1959
Philip Marlowe	"Marlowe Takes on the Syndicate"	Story	April 10, 1959
	"Crosstown with Neil Morgan"	Story	August 25, 1959
	"Raymond Chandler"	Story	Dec. 1959
	"Private Eye"	Story	Feb. 25, 1962
	"Farewell, My Hollywood"	Story	June 1976
	"English Summer"	Story	August 1976
Philip Marlowe	*The Big Sleep*	Novel	1939
Philip Marlowe	*Farewell, My Lovely*	Novel	1940
Philip Marlowe	*The High Window*	Novel	1942
Philip Marlowe	*The Lady in the Lake*	Novel	1943
Philip Marlowe	*The Little Sister*	Novel	1949
Philip Marlowe	*The Long Goodbye*	Novel	1953
Philip Marlowe	*Playback*	Novel	1958
Philip Marlowe	*Five Murderers*	Story Collection	1944
Philip Marlowe	*Five Sinister Characters*	Story Collection	1945
Philip Marlowe	*Red Wind*	Story Collection	1946
	Spanish Blood	Story Collection	1946
Philip Marlowe	*Finger Man, and Other Stories*	Story Collection	1947
Philip Marlowe	*Trouble Is My Business*	Story Collection	1950
	Pickup on Noon Street	Story Collection	1952
	Smart-Aleck Kill	Story Collection	1953
	Pearls Are a Nuisance	Story Collection	1958
	Killer in the Rain	Story Collection	1964
Philip Marlowe	*The Smell of Fear*	Story Collection	1965

Mickey Spillane

Mike Hammer	*I, the Jury*	Novel	1947
Mike Hammer	*My Gun Is Quick*	Novel	1950

Mike Hammer	*The Will to Kill*	Novel	2017
Mike Hammer	*Killing Town*	Novel	2018
Mike Hammer	"The Big Switch"	Story	2008
Mike Hammer	"I'll Die Tomorrow"	Story	2009
Mike Hammer	"A Long Time Dead"	Story	2010
Mike Hammer	"Grave Matter"	Story	2010
Mike Hammer	"Skin"	Story	2012
Mike Hammer	"So Long, Chief"	Story	2013
Mike Hammer	"It's in the Book"	Story	2014
Mike Hammer	"Fallout"	Story	2015
Mike Hammer	"A Dangerous Cat"	Story	2016
Caleb York	*The Legend of Caleb York*	Novel	2015
Caleb York	*The Big Showdown*	Novel	2016
Caleb York	*The Bloody Spur*	Novel	2018
	The Consummata	Novel	2012
	"There's a Killer Loose!"	Story	2008

Robert Parker

Spenser	*The Godwulf Manuscript*	Novel	1973
Spenser	*God Save the Child*	Novel	1974
Spenser	*Mortal Stakes*	Novel	1975
Spenser	*Promised Land*	Novel	1976
Spenser	*The Judas Goat*	Novel	1978
Spenser	*Looking for Rachel Wallace*	Novel	1980
Spenser	*Early Autumn*	Novel	1980
Spenser	*A Savage Place*	Novel	1981
Spenser	*Ceremony*	Novel	1982
Spenser	*The Widening Gyre*	Novel	1983
Spenser	*Valediction*	Novel	1984
Spenser	*A Catskill Eagle*	Novel	1985
Spenser	*Taming a Sea-Horse*	Novel	1986
Spenser	*Pale Kings and Princes*	Novel	1987
Spenser	*Crimson Joy*	Novel	1988
Spenser	*Playmates*	Novel	1989
Spenser	*Stardust*	Novel	1990
Spenser	*Pastime*	Novel	1991
Spenser	*Double Deuce*	Novel	1992
Spenser	*Paper Doll*	Novel	1993
Spenser	*Walking Shadow*	Novel	1994
Spenser	*Thin Air*	Novel	1995
Spenser	*Chance*	Novel	1996
Spenser	*Small Vices*	Novel	1997

Spenser	*Sudden Mischief*	Novel	1998
Spenser	*Hush Money*	Novel	1999
Spenser	*Hugger Mugger*	Novel	2000
Spenser	*Potshot*	Novel	2001
Spenser	*Widow's Walk*	Novel	2002
Spenser	*Back Story*	Novel	2003
Spenser	*Bad Business*	Novel	2004
Spenser	*Cold Service*	Novel	2005
Spenser	*School Days*	Novel	2005
Spenser	*Hundred-Dollar Baby*	Novel	2006
Spenser	*Now and Then*	Novel	2007
Spenser	*Rough Weather*	Novel	2008
Spenser	*Chasing the Bear*	Novel	2009
Spenser	*The Professional*	Novel	2009
Spenser	*Painted Ladies*	Novel	2010
Spenser	*Sixkill*	Novel	2011
Spenser	*Silent Night*	Novel	2013
Philip Marlowe	*Poodle Springs*	Novel	1989
Philip Marlowe	*Perchance to Dream*	Novel	1991
Jesse Stone	*Night Passage*	Novel	1997
Jesse Stone	*Trouble in Paradise*	Novel	1998
Jesse Stone	*Death in Paradise*	Novel	2001
Jesse Stone	*Stone Cold*	Novel	2003
Jesse Stone	*Sea Change*	Novel	2006
Jesse Stone	*High Profile*	Novel	2007
Jesse Stone	*Stranger In Paradise*	Novel	2008
Jesse Stone	*Night and Day*	Novel	2009
Jesse Stone	*Split Image*	Novel	2010
Sunny Randall	*Family Honor*	Novel	1999
Sunny Randall	*Perish Twice*	Novel	2000
Sunny Randall	*Shrink Rap*	Novel	2002
Sunny Randall	*Melancholy Baby*	Novel	2004
Sunny Randall	*Blue Screen*	Novel	2006
Sunny Randall	*Spare Change*	Novel	2007
Cole & Hitch	*Appaloosa*	Novel	2005
Cole & Hitch	*Resolution*	Novel	2008
Cole & Hitch	*Brimstone*	Novel	2009
Cole & Hitch	*Blue-Eyed Devil*	Novel	2010
	Wilderness	Novel	1979
	Love and Glory	Novel	1983
	All Our Yesterdays	Novel	1994
	Gunman's Rhapsody	Novel	2001

	Double Play	Novel	2004
	Edenville Owls	Novel	2007
	The Boxer and the Spy	Novel	2008
	"Surrogate"	Story	1991

Published by Other Authors

Spenser	*Cheap Shot*	Novel	2014
Spenser	*Kickback*	Novel	2015
Spenser	*Slow Burn*	Novel	2016
Spenser	*Little White Lies*	Novel	2017
Spenser	*Old Black Magic*	Novel	2018
Jesse Stone	*Killing the Blues*	Novel	2011
Jesse Stone	*Fool Me Twice*	Novel	2012
Jesse Stone	*Damned if You Do*	Novel	2013
Jesse Stone	*Blind Spot*	Novel	2014
Jesse Stone	*The Devil Wins*	Novel	2015
Jesse Stone	*Debt to Pay*	Novel	2016
Jesse Stone	*The Hangman's Sonnet*	Novel	2017
Sunny Randall	*Blood Feud*	Novel	2018
Cole & Hitch	*Ironhorse*	Novel	2013
Cole & Hitch	*Bull River*	Novel	2014
Cole & Hitch	*The Bridge*	Novel	2014
Cole & Hitch	*Blackjack*	Novel	2016
Cole & Hitch	*Revelation*	Novel	2017
Cole & Hitch	*Buckskin*	Novel	2019

NOTES

Introduction. A Silhouette

1. Cooper writes of Leatherstocking that "the eye of the hunter, or scout, or whichever he might be, was small, quick, keen, and restless . . . distrusting the sudden approach of some lurking enemy. Notwithstanding these symptoms of habitual suspicion, his countenance was not only without guile, but at the moment at which he is introduced, it was charged with an expression of sturdy honesty" (Cooper, 501). The same character announces, "I am no scholar and I care not who knows it" (Cooper, 502). Kennedy's Horse-Shoe Robinson, in turn, is "as brave a man as you ever fell in with," and the narrator writes that "the men have great dependence on what he says" (Kennedy, 112, 273). See Raine; see also Hamilton.

2. Tamony, 258; *Daily Capital Journal*, Feb. 20, 1897. In 1920, an Idaho paper described Paris Bolsheviks with knives in their teeth as a "hardboiled looking mob." *Idaho Republican*, May 3, 1920, 1.

3. Williamson and Williamson, 390; Hemingway, 42; *Coconino Sun*, Nov. 18, 1921, 4. Ege was never governor of Arizona.

4. *Washington Herald*, June 24, 1921, 16; *Ardmore (OK) Daily Ardmoreite*, June 24, 1921.

5. Daly, "The False Burton Combs," 305.

6. Daly, "Three Gun Terry," 43.

7. Hammett, "Arson Plus," 25.

8. Chandler, "The Simple Art of Murder," 59.

9. Nolan, The *"Black Mask" Boys*, 36.

10. Hammett, *Red Harvest*, 64; Roosevelt, "Inaugural Address, March 4, 1933."

11. Sean McCann writes that the refusal of the vision of racial community had to do with hard-boiled belief in American self-interest rather than in some idealistic notion of equality. McCann, 62.

12. E. Smith, *Hard-Boiled*, 206.

Chapter One. Arriving on the Scene

1. Daly, "Three Gun Terry," 43; Daly, *Snarl of the Beast*, 1; Daly, "Three Gun Terry," 43. As William Nolan writes: "Terry Mack [he could have substituted Race Williams] is the prototype for ten thousand private eyes who have gunned,

slugged, and wisecracked their way through ten thousand magazines, books, films and TV episodes. . . . The pioneer private-eye tale is remarkable in that almost every cliché that was to plague the genre from the 1920s into the 1980s is evident in 'Three Gun Terry'" (Nolan, 35).

2. Nolan, 35.

3. "The passage of the Eighteenth Amendment and enactment of the Volstead law have not tempered and moderated drinking. . . . The same difficulties experienced before the enactment of the Volstead law are experienced at present and in a more aggravated form. . . . It is true the Volstead law has dispensed with the public saloon. Instead there has come the greater evil of the 'speak-easy' places, the atmosphere of which is charged with delight for resentment of law and order." "Call the Dry Laws Futile," *New York Times*, April 11, 1926.

4. As historian W. Elliot Brownlee described, in 1929, "only one family in six owned an automobile, only one family in five owned a fixed bathtub or had electricity in its home, and only one family in ten had a telephone" (Brownlee, 411). Various historians use the term *acquisitive individualism* to describe the prevailing ethos of the 1920s; see, e.g., Montgomery, 99.

5. Daly, *Snarl*, 1.

6. Hoover, "New York City Speech, October 22, 1928."

7. Daly, *Snarl*, 156.

8. Daly, *Snarl*, 1. In 1915, the British psychiatrist Charles Myers wrote about the phenomenon of shell shock—which would later be called combat fatigue and later still posttraumatic stress disorder—and likened it to hysteria. Myers, 320.

9. A French doctor wrote in 1918 that shell shock was marked by "panting, irregular and shallow breathing; stammering, scanning, or explosive speech" and by "motor reactions [that] are slow, uncertain, feeble" (De Fursac, 37, 34). In *Snarl of the Beast*, the drug-addicted client Davison shows similar symptoms: "His breath came in uncertain gasps" (24); he walked on "uncertain feet—feet that stumbled" (45); he had "white, drawn, sunken cheeks, colorless lips—and far distant, somber, searching, roving eyes. . . . Haunted eyes followed me. . . . But our snowbird was talking; gulping it, coughing it and squeaking it out" (26).

10. In 1933, this number had decreased to fewer than three hundred thousand, but more than fifty thousand of those were from New York alone. See US Department of Commerce. President Taft had established the US Children's Bureau in 1912. The first federal agency dedicated to helping children and families, it still exists today. The first Department of Public Welfare was established at the state level in Illinois in 1917.

11. This was the case with various hard-boiled writers. Sue Grafton spoke about her enduring protagonist Kinsey Millhone in an interview on NPR's "Fresh Air": "[Kinsey] is actually my alter ego. She is the person I might have been had I not married young and had children, except she will always be braver. I am really appalled by violence and avoid it [at] all costs." See also Sutherland, 546; and Grossman and Lee. Both of his parents died of heart failure: See "Died Almost Together," *New York Times*, June 28, 1901, 5.

12. Susman, 280; *Snarl*, 2; Roland Marchand notes that ads underscored the "parable of the first impression" (208); and Erin Smith points out in *Hard-Boiled* that "social exchanges increasingly took place between strangers" (64); Susman, 280.

13. See Horowitz; Daly, "Knights," 34.

14. About the scene where Williams infiltrates a Klan meeting, finds it ridiculous, and says, "I felt as white as my robe in comparison with most of that gang," Sean McCann writes that that remark "sums up the implications of the protagonist's name. Race Williams represents the true essence of whiteness. The nature of that quality is to scoff at the Klan's fraternal bonds and to pursue an uncompromising individual liberty" (McCann, 61); Daly, "Knights," 47. Maureen Reddy writes, "Dominant consciousness in hard-boiled fiction is white consciousness" (Reddy, 9); see also Abbott; and E. Smith, *How the Other Half Read*.

15. Senator Rebecca Felton of Georgia was eighty-seven years old at her 1922 election; she served for one day. Nellie Taylor Ross was the fourteenth governor of Wyoming from 1925 to 1927. "I can't see nothing to any woman": Daly, "The Red Peril," 37.

16. Daly, *Snarl*, 2, 32; Daly, "Three Gun Terry," 46.

17. Nolan, introduction to *Nightmare Town*. These novels appeared in remarkably rapid succession. Hammett submitted *Red Harvest* to Knopf in February of 1928, and the contract was signed in April of that year. In June of 1928, he submitted *The Dain Curse*, and in June of 1929, he sent Knopf *The Maltese Falcon*. See Nolan, "Shadowing the Continental Op." This article also lists all the books into which the twenty-eight remaining Op stories have been compiled. "by far the best thing": Dashiell Hammett to Harry Block, June 16, 1929 (Hammett, *Selected Letters*, 49). *The Maltese Falcon* was made into a movie in 1931. In 1936—its rerelease blocked because of "lewd content"—Warner Bros. made a comedic version of the novel called *Satan Met a Lady*. *Red Harvest* was also made into a movie, the 1930 *Roadhouse Nights*, but that film put so much emphasis on music and vaudeville that the murders were lost among the tuxedos.

18. Hammett, *Red Harvest*, 437.

19. Two years after *Red Harvest* was published, unemployment in the United States was at almost 16 percent and by 1933 almost 25 percent. Weir, 813.

20. Chandler, "Simple Art of Murder," 58; nation's wealth: Baldwin, 187.

21. Dos Passos, 3. Dos Passos to Blanche Knopf, March 20, 1928. See also Hare; and Moore.

22. "blood-simple like the natives": Hammett, *Red Harvest*, 154; Hammett, *The Dain Curse*, 181.

23. Hoover. "Radio Address to the Nation."

24. "My cigarettes had got wet": Hammett, *The Dain Curse*, 121; Hammett, "The Tenth Clew," in *The Continental Op*, 35; Hammett, "The Golden Horse-shoe," 45.

25. "Fifty years of crook-hunting": Hammett, *The Big Knockover*, 279. The literary critic Dennis Porter writes, "The irony is in the circumstance that the

private eye began to flourish in popular literature at a time that coincided with a major crisis of American individualism as the political philosophy of industrial capitalism. In the fiction, if no longer in life, the myth of heroic individualism persists" (Porter, 176-77). This is no irony, however. Given a common understanding that individuals are fallible and need help, together with a presidential declaration that no governmental help should be forthcoming, help had to come from elsewhere; "He is a Continental operative": Hammett, *The House in Turk Street*, 99.

26. Roosevelt, "Inaugural Address, March 4, 1933."

27. These protections initially excluded agricultural and domestic workers. Farmworkers were also excluded from unemployment insurance.

28. Chandler, "Simple Art of Murder," 59; Chandler, *Farewell, My Lovely*, 203, 202, 276; Chandler, *The Long Goodbye*, 98; Chandler, *The High Window*, 479.

29. Roosevelt, "Annual Message to Congress."

30. Roosevelt had said that it was time to "speak the truth, the whole truth, frankly and boldly." Later, in *Farewell, My Lovely*, Mrs. Grayle would tell Marlowe that "there's such a thing as being just a little too frank," and he would respond, "Not in my business." Chandler, *Farewell, My Lovely*, 306.

31. McCann, 147-48.

32. As Sarah Trott points out in *War Noir*, Chandler's writing must be read in the frame of "war's traumatic impact" (1).

33. "American sense of freedom": MacShane, 6; "If their education": Chandler to Alfred Knopf, Feb. 8, 1943 (in Hiney and MacShane, 37); "Americans have no manners": Chandler to Charles Morton, Jan. 1, 1948 (in Hiney and MacShane, 83); "I like people with manners": Chandler to George Harmon Coxe, Oct. 17, 1939 (in Hiney and MacShane, 22).

34. Chandler to George Harmon Coxe, Oct. 17, 1939 (in Hiney and MacShane, 22).

35. Chandler to Blanche Knopf, Aug. 23, 1939 (in Hiney and MacShane, 20).

36. Jacques Barzun, "The Illusion of the Real," 162; Chandler, *The Long Goodbye*, 804. S. S. Van Dine's Philo Vance first appeared in *The Benson Murder Case* (1926); Van Dine's twelfth and last novel was *The Winter Murder Case* (1939).

37. "last put out by the lefties": Chandler to James Sandoe, Dec. 21, 1947 (in Hiney and MacShane, 83); "broad stained-glass panel showing a knight": Chandler, *The Big Sleep*, 3. Later in the novel, in a rather unsubtle metaphor, he moves a knight on a chessboard and remarks, "Knights had no meaning in this game. It wasn't a game for knights" (134); "I was part of the nastiness now": Chandler, *The Big Sleep*, 197.

38. In 1940, the McDonald brothers opened a drive-in restaurant in San Bernardino, California. By 1952, there were eight McDonald's in California. (Today there are more than fourteen thousand in the United States.) Dairy Queen also opened in 1940. In 1952 there were twenty-one hundred locations.

39. Chandler, *The Big Sleep*, 3. The patterned black and blue socks happened to echo the uniform necktie in school colors that Chandler wore at Dulwich, which connects him to an earlier vision of an upper-class Europe. But

despite the riches surrounding him in the Sternwood house, despite its "Old Europe" crest picturing a knight and a maiden, something is rotten there: the younger daughter has murdered the missing Regan, her sister has hidden the body, and in the greenhouse, Marlowe finds a forest of plants "with nasty meaty leaves and stalks like the newly washed fingers of dead men. They smelled as overpowering as boiling alcohol under a blanket" (7); Chandler, *The Long Goodbye*, 180; Chandler, *Farewell, My Lovely*, 229; Chandler, *The Little Sister*, 138.

40. Chandler gives the entire rich-poor contrast a moral cast. In response to a reviewer's accusation that Marlowe is an amoral character, Chandler argues that Marlowe's "moral and intellectual force is that he gets nothing but his fee, for which he will if he can protect the innocent, guard the helpless, and destroy the wicked, and the fact that he must do this while earning a meager living in a corrupt world is what makes him stand out." Chandler to James Sandoe, May 12, 1949 (in Hiney and MacShane, 115). Elsewhere, following up on his own comment that "the private eye of fiction is pure fantasy and is meant to be," Chandler explained that it was not the goodness of the detective that was fantastic but the idea that he could make money doing what he does.

41. Chandler, *The High Window*, 500.

42. Chandler to Jessica Tyndale, July 12, 1956 (in Hiney and MacShane, 222).

43. Chandler, *The Long Goodbye*, 234.

Chapter Two. A Moral Compass

1. Truman, "Message to the Congress"; Truman, "Annual Message."

2. Collins, *Mickey Spillane on Screen*, 8.

3. Johnston, "Death's Fair-Haired Boy," 95.

4. Sutherland, 544.

5. "In a post-war world apparently divided into good and evil, the United States stood alone as the champion of liberty and democracy." Crawford and Foster, 126; Snow and Drew.

6. Spillane, 3:348.

7. S. Johnson, 43-44. President Truman noted in August of 1945 that Japan had been "repaid many fold" for the bombing of Pearl Harbor.

8. Paul Tibbetts, "One Hell of a Big Bang," interview by Studs Terkel, *The Guardian*, August 6, 2002, www.theguardian.com/world/2002/aug/06/nuclear.japan.

9. Spillane, 2:6-7, 2:6, 2:6.

10. Johanna Smith writes: "While it would appear that Marlowe is now tarnished by the corruption around him, his statement actually attests to his continuing purity. That is, simply by knowing that he is 'part of the nastiness,' Marlowe in effect testifies to a moral discrimination so fine as to negate his self-condemnation." J. Smith, 596. See also Arnold.

11. Spillane, 2:260.

12. Spillane, 1:147, 1:470, 1:510.

13. Spillane, 2:8

14. Spillane, 1:7.

15. He made a distinction between war and aggressive war, the latter of which he called a "crime against peace" (Mettraux, 73).

16. Soumerai and Schulz, 282.

17. Throughout the Cold War, President Truman announced that he would avoid "selfishness" or protecting one nation at the price of others: "All free nations are exposed and all are in peril. Their only security lies in banding together. No one nation can find protection in a selfish search for a safe haven from the storm. The free nations do not have any aggressive purpose. We want only peace in the world—peace for all countries. No threat to the security of any nation is concealed in our plans and programs" ("Annual Message to the Congress on the State of the Union, January 8, 1951"). Talking about Eisenhower, Eugene Jarecki writes, "While the devastating horrors of the concentration camps underscored the need to fight for freedom, the gratuitous mass destruction of Hiroshima instilled in him an equal and opposite awareness that the fight for freedom, conducted without reason and a steady moral compass, could itself lead to atrocities" (Jarecki, n.p.). See also Holloway; "high point of international hypocrisy": quoted in Maguire, 79.

18. Orwell, 8. See also US Department of State:

> National Security Council Paper NSC-68 (entitled "United States Objectives and Programs for National Security" and frequently referred to as NSC-68) was a Top-Secret report completed by the U.S. Department of State's Policy Planning Staff on April 7, 1950. The 58-page memorandum is among the most influential documents composed by the U.S. Government during the Cold War, and was not declassified until 1975. Its authors argued that one of the most pressing threats confronting the United States was the "hostile design" of the Soviet Union. The authors concluded that the Soviet threat would soon be greatly augmented by the addition of more weapons, including nuclear weapons, to the Soviet arsenal. They argued that the best course of action was to respond in kind with a massive build-up of the U.S. military and its weaponry.

"attempted to be a disruptive influence": quoted in Brands, 86.

19. Kaufman.

20. Field, 395.

21. Advance copies of the speech put the number at 205, but in the official transcript submitted to the Congressional Record, he puts the number at 57 (Griffith, 50–51). See also Robin Shulman, "Rosenberg Sons Say Father Was Guilty, Mother Was Framed," *Washington Post*, Sept. 23, 2008; Oshinsky, 132; "That fighting Irish marine": quoted in Rovere, 57.

22. "Sometimes it's useful": quoted in Aronson, 123; Ayn Rand claimed to admire his worldview: Rand's *Atlas Shrugged* was also one of Spillane's favorite books (Sutherland, 545). See also Hendershot: "Mike Hammer's words and actions strongly encourage the reader to realize what all Americans needed to know: that the Soviets were stupid and weak, and the seductive power of

Communism could easily be exposed as fraudulent" (12); "makes Mickey Spillane look," O'Connor to Maryat Lee, May 24, 1960, in O'Connor, 398; "I had one, good, efficient, enjoyable way": Spillane, 2:173.

23. Spillane, 2:202–3; Spillane, 1:407; Spillane, 2:517 (italics in text).

24. Spillane, 3:83.

25. People earning $32,000 were taxed at 50 percent. An "Excess Profits Tax" placed a 30 percent tax on all profits in excess of 83 percent of a corporation's "normal profits." Wheeler and McDonald, 12; Vatter; May, 16.

26. See Betty Friedan's *The Feminine Mystique*, among countless other books that describe the domestic sphere as profoundly stifling for women. Elaine Tyler May describes the oppressive nature of corporate associations: "Much of the most insightful writing examined the dehumanizing situation that forced middle-class men, at least in their public roles, to be other-directed 'organization men' caught in a mass, impersonal white-collar world. The loss of autonomy was real" (May, 24). See also Whyte.

27. Whyte, 4.

28. Spillane, 3:123.

29. Spillane, 2:184; Spillane, 2:341; Spillane, 1:333.

30. Spillane, 2:153.

31. Nigel Kneale, who adapted George Orwell's *1984* for television in 1954, wrote, "That decade has sometimes been called one of paranoia, which means abnormal, sick attitudes and irrational fears. I don't think it was irrational to be fearful at that time; there was a lot to be frightened of and stories like mine were a sort of controlled paranoia, inoculation against the real horrors" (quoted in Ferrebe, 214).

32. Love, vii. As Walker and Vatter write: "Nonwhite wives have consistently been less dependent than white wives. This greater equality of minority women partly reflects, however, the relatively disadvantaged position of minority men, who are more limited in their ability to be breadwinners" (204).

33. Spillane, 1:269; Spillane, 1:359.

34. Spillane, 2:263; Spillane, 2:444; Spillane, 2:312; Spillane, 1:357. In *One Lonely Night*, she cries, "Oh, Mike! How long do we have to put up with the slime they call politics?" (Spillane, 2:70). In 1980, Cy Coleman proposed a musical based on the jazz of the 1950s. Thinking to use one of Spillane's Hammer stories, he met with the author, who offered to write a new Mike Hammer story. When he announced his involvement with the project, he said, "I like the title. Any title with punctuation is fantastic. I'm writing a typical Mike Hammer story: beautiful blondes and a great, great ending" (C. Lawson).

35. Budd et al., xv; J. Johnson, 1.

36. As Michael Kammen notes, "Most observers with a historical orientation seem to agree that the commercialization of culture accelerated rapidly after World War II" (Kammen, 58).

37. Sinatra quoted in Early, 23; Max Allan Collins, "I, the Intro," quoted in Miklitsch.

38. Spillane, 1:344.

39. "When a hillbilly sings": quoted in Williams, 107; "many things of this sort": quoted in Redd, 97.

40. Cusic, 75. "Cosmopolitan cultural critics worried that 'bad' art—such as rock music and Mickey Spillane's best selling 'Mike Hammer' detective novels—was driving anything 'good' from the cultural marketplace" (Murrin et al., 737); "I had a hundred": Spillane, 1:332–33.

41. Spillane, 2:517. In fact, the Misfits song "Death Comes Ripping" basically repeats these words.

42. Collins, introduction, viii.

Chapter Three. A Rugged Individual

1. Mottram, 98.

2. As Congress of Racial Equality (CORE) executive director James Farmer put it in 1962: "The picketing and the nationwide demonstrations are the reasons that the walls came down in the South, because people were in motion with their own bodies marching with picket signs, sitting in, boycotting, withholding their patronage" (Voth, 155).

3. Hoover, "New York City Speech." Hoover claimed that "only through ordered liberty, freedom, and equal opportunity to the individual will his initiative and enterprise spur on the march of progress. And in our insistence upon equality of opportunity has our system advanced beyond all the world."

4. Claudette Colvin had resisted moving to the back of the bus nine months before Parks (although because Colvin was an unwed teenage mother, she was not embraced as a standard-bearer for the movement). Historically black colleges and universities include Cheyney University (established 1837), Lincoln (1854), and Howard (1867); "segregation today, segregation tomorrow": quoted in Müller, 21; "unwarranted exercise of power": quoted in Maxwell, 228; "surrender all our rights": quoted in Metro, 99.

5. In 1965, for instance, less than 1 percent of the black population of Selma, Alabama, was registered to vote, while half the town's population was black. As civil rights historians describe, the murder of deacon and voting rights activist Jimmie Lee Jones by an Alabama state trooper—and the violence unleashed on the marchers to Montgomery in the wake of that murder—was cut from the same cloth as the disenfranchisement of 99 percent of Selma's black population. See Anderson; and Alexander.

6. See Philip Galanes, "Ruth Bader Ginsburg and Gloria Steinem on the Unending Fight for Women's Rights," *New York Times*, Nov. 14, 2015.

7. Bauer, 360. See Hohle on tensions between individual and group rights in the civil rights movement.

8. The vast majority of African Americans: The Nation of Islam was an exception to this rule, principally because it advocated black separatism; "Social movements aren't formed": Davis, 26. See also Elizabeth Gillespie McRae, "The Women behind White Power," *New York Times*, Feb. 2, 2018.

9. Louis Menand calls him one of the "great what-ifs of American political history" (71).

10. Larry Berman calls this "the crude surgery of the president's spin doctor" (Berman, 238). See also Garry Willis, review of Crowley's *Nixon in Winter, New York Times*, June 14, 1998.

11. Leith. The Parker-Chandler connection was renewed in 1988 when the agent representing Chandler's estate asked Parker to complete Chandler's unfinished "Poodle Springs." That novel required some dexterity in plot and style, since it has Philip Marlowe—a character Parker loved and had emulated—marry a spoiled young woman. Ed McBain wrote that at his best, Parker sounded more like Chandler than Chandler himself.

12. "a gourmet cook": Parker, *Promised Land*, 171; "a hard-boiled super-hero": J. Golsan, 159.

13. Golsan, Golsan, and Parker, 165.

14. Parker, *The Godwulf Manuscript*, 68.

15. "national bankruptcy": Stott, 83; "more stable and simpler times": Holdsworth, 118; "In my mind": Parker, *Godwulf*, 41, 122.

16. Roosevelt, "Inaugural Address, January 20, 1937."

17. Parker, *Godwulf*, 70, 190. Even the people who have not died are no longer the heroes that they were in the 1960s. The head of campus security says that Hoover "was a hell of a cop once, but his time came and went before he died" (10).

18. In *The Judas Goat*, Spenser observes: "In fact, in all the time I'd known Hawk I'd never seen him show a sign of anything. He laughed easily and he was never off balance. But whatever went on inside stayed inside. Or maybe nothing went on inside. Hawk was as impassive and hard as an obsidian carving. Maybe that was what went on inside" (90). See also Wesley Morris, "Why Do the Oscars Keep Falling for Racial Reconciliation Fantasies?" *New York Times*, Jan. 23, 2019.

19. This was the case even when men didn't want it to be, as evidenced in Ira Levin's 1972 *The Stepford Wives*.

20. Parker, *Promised Land*, 18.

21. "as lean and as hard": Parker, *Godwulf*, 149; "there was a tangibility": Parker, *God Save the Child*, 35.

22. Parker, *Mortal Stakes*, 64.

23. Parker, 26.

24. Parker, *Promised Land*, 73.

25. The detective drama *Tenafly*, featuring a black private detective, came to NBC in the 1973-74 season. The show lasted only four episodes, either because Harry Tenafly was black or because he was too stable a suburban family man. The 1971 movie *Shaft* promised a hero that was "Hotter than Bond and cooler than Bullitt."

26. Thorburn, 694; Richard Meyers, writing in 1981, called *Harry O* and *The Rockford Files* "the finest private-eye shows ever" (Meyers, 212).

27. As one TV critic puts it, comparing Rockford to Clint Eastwood film characters, while Eastwood embodies the hero, Garner embodies "the hesitater" (Gross, 42). Critics found that Rockford took modern values such as emotional intelligence and connected them smoothly to earlier hard-boiled

values like physical force, competence with a gun, deadpan demeanor, and the ability to contain one's emotions.

28. *The Rockford Files*, "This Case Is Closed," aired Oct. 18, 1974, on NBC.

29. *Harry O*, "Guardian at the Gates," aired Sept. 26, 1974, on ABC.

30. "Jim Rockford's Firebird Is the Thinking Man's Pontiac Prize," Hemmings Daily, www.hemmings.com/blog/2014/12/24/jim-rockfords -firebird-is-the-thinking-mans-pontiac-prize.

31. Robertson, 46.

32. Parker's *Promised Land*, 211. Rockford and Harry both took on an improbable number of cases centering on father-daughter relationships. This plot checks numerous 1970s boxes: it validates the generation gap, and it nods to feminism, letting women assert their adulthood but nonetheless casting the male detective as paternal and romantic leader. To mention just a few examples, the first episode of *The Rockford Files*, "Backlash of the Hunter," shows a drunken man taking the bus out to the beach, where he is murdered under the Santa Monica pier; his daughter hires Rockford to solve the crime and ends up kissing him—almost by accident—at the end of the episode. Harry—who got close to Linda Evans—is also hired to locate the father of a girl in need of a kidney donor. At the end of that episode, he is on the beach with the girl and her mother.

33. *The Rockford Files*, "Find Me if You Can," aired Nov. 1, 1974, on NBC. In 1968, Generoso Pope, founder of the *National Enquirer*, changed the magazine to make it more appealing to mainstream Americans (Cashmore, 23).

34. "adjust to changing times": Carter, "Inaugural Address"; "absolute and total separation": Carter, *Conversations*, 57.

35. Carter, *Conversations*, 58.

36. "increasingly reluctant": "Bounds of Disclosure"; "Once you stop searching": Carter, *Conversations*, 58.

37. Quoted in Carter, 35.

38. Schlesinger, 438.

39. "The road toward equality": quoted in Goduti, 216; "the arc of the moral universe": This idea, in fact, came from Theodore Parker, a Unitarian minister and abolitionist. In 1853, Parker wrote: "I do not pretend to understand the moral universe; the arc is a long one, my eye reaches but little ways; I cannot calculate the curve and complete the figure by the experience of sight; I can divine it by conscience. And from what I see I am sure it bends towards justice" (T. Parker, 48); "little by little": Carter, "Address to the Nation." In that same address, known today as "The Malaise Speech," Carter quoted a visitor to Camp David as saying, "We've got to stop crying and start sweating, stop talking and start walking, stop cursing and start praying. The strength we need will not come from the White House, but from every house in America."

40. Robertson, 122.

41. Denton, 72.

42. As it happened, *Rockford* went off the air in 1980, owing to Garner's physical problems. So did *Barnaby Jones* and *Hawaii Five-0*. Starting in that year, Reagan's election year, there was a new popular television detective in town.

This was the Ferrari-driving Magnum of *Magnum, PI,* played by heartthrob (and NRA board member) Tom Selleck. Schlesinger, 438.

43. "In the 1960s, television became the instrument of winning elections. Reagan made it the instrument of governing" (Denton, 11). In May of 1973, claiming that Watergate conspirators were "not criminals at heart," he was tone-deaf enough to call the investigation team a "lynch mob." Some have argued that Ronald Reagan was not, in fact, a racist. Whether or not this is true, he played one on television and was most convincing in the role. He had opposed the Civil Rights Act of 1964 and the Voting Rights Act of 1965, which he called "humiliating to the South." During his 1966 campaign for governor of California, he condemned the Fair Housing Act, arguing that "if an individual wants to discriminate against Negroes or others in selling or renting his house, it is his right to do so" (quoted in Schmidt, 438). Reports of the Reagan White House describe an atmosphere of vulgar and racist humor, with staffers calling Martin Luther King Jr. "Martin Lucifer Coon" (Bell, 104).

44. Alexander, 49. Sociologists Craig Reinarman and Harry Levine wrote that crack was "a godsend to the Right," as it drove mass incarceration and worsened social ills (quoted in Provine, 105). See also Regan, "Remarks Announcing Federal Initiatives Against Drug Trafficking and Organized Crime, October 14, 1982." The poverty rate for American blacks had fallen during the 1970s to a low of 30.6 percent in 1978, rising to 36 percent in 1983. In 1986, a report by the Center on Budget and Policy Priorities reported that the increase in the proportion of the black population that had fallen into poverty since 1980 was twice the proportion of whites (Ehrman and Flamm, 50).

45. "Ronald Reagan divided the world": Perlstein, 81; "evil empire": Reagan, "Remarks at the Annual Convention"; turn his back on liberalism: Reagan would later describe his mid-1946 turn from liberalism: "Light was dawning in some obscure region in my head. I was beginning to see the seamy side of liberalism. Too many of the patches on the progressive coat were of a color I didn't personally care for" (quoted in Vaughn, 132); "make my day": Reagan, "Remarks at a White House Meeting"; After the release of hostages: quoted in Jeffords, 28.

46. "So, in your discussions of the nuclear freeze proposals, I urge you to beware the temptation of pride—the temptation of blithely declaring yourselves above it all and label both sides equally at fault, to ignore the facts of history and the aggressive impulses of an evil empire, to simply call the arms race a giant misunderstanding and thereby remove yourself from the struggle between right and wrong and good and evil." Reagan, "Remarks at the Annual Convention."

47. "The severe problems which have been neglected for years and which caused unemployment to trend steadily higher—problems of runaway spending, taxing, double-digit inflation, and sky-high interest rates—are now being attacked at their roots." Reagan, "Radio Address"; Fulminating against welfare cheats: as Michelle Alexander writes, "Conservatives found that they could finally justify an all-out war on an 'enemy' that had been racially defined years before" (52).

Chapter Four. A Lone Wolf

1. Dove, 54. Literature also had its procedurals, from Ed McBain's 87th Precinct novels to Dell Shannon and Tony Hillerman.

2. *Black Mask* cost twenty cents a copy and sold—according to the blurb on its cover—1,500,000 copies a month.

3. "people feel comfortable": quoted by Neal Baer, executive producer of *Law and Order: SVU*, telephone interview by Susanna Lee, Washington DC, 2002. Another 1990s police procedural was *Homicide: Life on the Street*, based on the book *Homicide: A Year on the Killing Streets*, by *Baltimore Sun* reporter David Simon. Simon had shadowed a shift of detectives from the Baltimore police department. The series ran on NBC from 1993 to 1999 and was hailed as a "true crime classic." It produced three crossover episodes with *Law and Order*. With the advent of *Homicide*, focus turned to the residents who lived under the rule of law—with its limitations and its unevenness.

4. It had even done a *Philip Marlowe, Private Eye* that ran from 1983 to 1986.

5. DeAndre McCollough, the fifteen-year-old drug dealer whose experience inspired David Simon and Edward Burns to write *The Corner*, died in 2012 at the age of thirty-five.

6. "is making an argument": quoted in Penfold-Mounce et al., 154; "novel for television": "'The Wire': David Simon Reflects."

7. As writer Rafael Alvarez put it, the series is "making a case for the individual trying to get by in a society of harsh, indifferent institutions: bureaucracies on both sides of the law, the cultures of addiction—to power as well as dope—and raw capitalism" (Alvarez, 61).

8. *The Wire*, "The Target," season 1, episode 1, aired June 2, 2002, on HBO.

9. *The Wire*, "-30-," season 5, episode 10, aired March 9, 2008, on HBO.

10. Leigh Claire La Berge writes, "The representation of black economic violence produces one form of seriality—that is, the series' realism. Conversely, white fictitious killing, the form of seriality that emerges in season 5, offers a critique of the series' previous realism and its reception. Black serial killing is read transparently as economic: it is treated as real within the narrative frame, and it is read as realist by the viewer; white serial killing is treated as psychological within the narrative frame and therefore read as not realist by the viewer" (La Berge, 549).

"Who in this fucking unit's going to catch me? Most of the guys up here couldn't catch the clap in a Mexican whorehouse." *The Wire*, "Not for Attribution," season 5, episode 3, aired Jan. 20, 2008, on HBO.

11. *The Wire*, "Mission Accomplished," season 3, episode 12, aired Dec. 19, 2004, on HBO.

12. *The Wire*, "Cleaning Up," season 1, episode 12, aired Sept. 1, 2002, on HBO.

13. *The Wire*, "The Target," season 1, episode 1, aired June 2, 2002, on HBO.

14. Fallows.

15. See Lester.

16. Some were paper ballots incompletely punched through, and some were the notorious "butterfly" ballots designed in such a way that punching a circle

next to Al Gore's name counted as a vote for Pat Buchanan. Indeed, Pat Buchanan gained three times the votes that one would expect him to in primarily Democratic Palm Beach County. See R. Smith.

17. "Law can not [*sic*] rise above its source in good citizenship—in what right-minded men most earnestly believe and desire. If the law is upheld only by Government officials, then all law is at an end. Our laws are made by the people themselves; theirs is the right to work for their repeal; but until repeal it is an equal duty to observe them and demand their enforcement." Hoover, "Annual Message to Congress."

18. In season 9's episode "Agony," Jack McCoy and Abbie Carmichael have a representative exchange:

> MCCOY. So you throw out the Constitution.
> CARMICHAEL. Like you've never pushed the envelope.
> MCCOY. We can't have the same contempt for rules that criminals have.
> (*Law and Order*, "Agony," season 9, episode 5, aired Nov. 4, 1998, on NBC)

19. See Edsall.

20. were essentially propaganda: see Friedersdorf; "See, this is the thing": *The Wire*, "Lessons," season 1, episode 8, aired July 28, 2002, on HBO.

21. Michael K. Williams was born in 1966, Sonja Sohn in 1964, Dominic West and Wood Harris in 1969, Idris Elba in 1972. Clarke Peters is the elder statesman, born in 1952, and Wendell Pierce in 1963. It is unsurprising that McNulty, out on a date with a woman who manages political campaigns, admits that he didn't vote in the 2004 election:

> I thought about it and you know Bush seemed way over his head, I know, but he wasn't gonna win in Maryland anyhow. Besides, these guys, it doesn't matter who you got. None of them has a clue what's really going on. Where I'm working every day, the only way any of them will even find West Baltimore is if, I don't know, Air Force One crash-lands into Monroe Street on its way back to Andrews. It just never connects. Not to what I see, anyway. (*The Wire*, "Slapstick," season 3, episode 9, aired Nov. 21, 2004, on HBO)

22. Brooks.

23. See Carol Doherty's somewhat bleak report:

> The share of Republicans who have *very* unfavorable opinions of the Democratic Party has jumped from 17% to 43% in the last 20 years. Similarly, the share of Democrats with very negative opinions of the Republican Party also has more than doubled, from 16% to 38%. But these numbers tell only part of the story. Among Republicans and Democrats who have a very unfavorable impression of the other party, the vast majority say the opposing party's policies represent a *threat* to the nation's well-being.

24. Internet use skyrocketed: In the early 2000s, about half of American adults were online. In 2014, it was almost nine out of ten. Google saw five

hundred thousand searches a day in 1998, two hundred million in 2004, and 3.5 billion in 2018; which news outlets you were watching: In 2014, half of consistent conservatives turned to Fox for news on government and politics, and nine of ten conservatives trusted Fox. Consistent liberals turned to the *New York Times*, NPR, MSNBC, CNN, and PBS.

25. *US v. Windsor*: In *Hollingsworth v. Perry* (2013), the Supreme Court also invalidated California's constitutional amendment barring same-sex marriage. In 2015, the Court ruled in *Obergefell v. Hodges* that the fundamental right to marry is guaranteed to same-sex couples by both the Due Process Clause and the Equal Protection Clause. Combined with staggering income inequality, seeing corporations as people had an alienating effect on actual people. If corporations were people, then people were corporations, and where did that leave the ones who didn't have a fortune to their name? Where did that leave the ones without a social media presence?

26. "Charting the Decline of Manly Men on (and off) Screen," Breitbart News, Feb. 2, 2013, www.breitbart.com/big-hollywood/2013/02/02/hollywood -male-role-model-evolution.

27. *True Detective*, "The Long Bright Dark," season 1, episode 1, aired Jan. 12, 2014, on HBO.

28. Andy Greenwald, "'True Detective': Six Questions for the Second Half of the First Season," Grantland, Feb. 10, 2014, https://grantland.com/hollywood -prospectus/true-detective-six-questions-for-the-second-half-of-the-season. McConaughey had been primarily a star of romantic comedies and dramas; in a departure from those roles, he had won the 2014 Academy Award for Best Actor in *Dallas Buyers Club*, a devastating depiction of the HIV epidemic in 1985 Dallas, Texas.

29. "All your life": *True Detective*, "The Locked Room," season 1, episode 3, aired Jan. 26, 2014, on HBO. Pizzolatto writes, "If we're talking about hard-boiled detectives, what could be more hard-boiled than the worldview of Ligotti or Cioran? They make the grittiest of crime writers seem like dilettantes. Next to 'The Conspiracy against the Human Race,' Mickey Spillane seems about as hard-boiled as bubble gum" (quoted in Calia); "I know who I am": *True Detective*, "Seeing Things," season 1, episode 2, aired Jan. 19, 2014, on HBO.

30. Nussbaum, 78.

31. As McConaughey said in an interview, "[Cohle] was on an island. I feel sorry for you if you're living in his head, I mean, jeez, what was going on in that man's head." "Actor Matthew McConaughey Talks HBO's *True Detective*," Rich Eisen Show, June 22, 2016, YouTube video.

32. HBO's most-watched show: Andreeva; to name only a very few: Other authors include Linda Barnes, Nevada Barr, Eleanor Taylor Bland, Edna Buchanan, Janet Dawson, Janet Evanovich, Rachel Howzell Hall, Gar Anthony Haywood, Sujata Massey, Penny Mickelbury, Sandra West Prowell, Judith Smith-Levin, Valerie Wilson Wesley, and Paula Woods; The third season cast Mahershala Ali: As Sonia Saraiya puts it, "In a media landscape stacked with stories of anguished white men, Ali's casting—and Wayne's character—adds tense, necessary friction, which counterbalances the series's inclination

towards doleful nostalgia." She also writes: "In all three seasons of *True Detective*, Nic Pizzolatto's favorite characters are men badly damaged by the weight of being men" and that "the show's gaze seems unable to inhabit the interior landscape of female characters with the same close intensity it offers men."

Chapter Five. A Person of Honor

1. The series creator said that *True Detective* deconstructed archetypes of postwar masculinity (Jensen).

2. Jill Lepore writes, "Superman owes a debt to science fiction, Batman to the hard-boiled detective. Wonder Woman's debt is to the fictional feminist utopia and the struggle for women's rights" (Lepore, xiii).

3. See Taylor and Setters.

4. Some of the 2010s most salient examples are British: Catherine Cawood in *Happy Valley* (2014–) and Ellie Miller in *Broadchurch* (2013–17), both descendants of Jane Tennison in *Prime Suspect* (1991–2006).

5. *Jessica Jones*, "AKA You're a Winner!" season 1, episode 6, released Nov. 20, 2015, on Netflix.

6. See Gabbert.

7. See Swaine et al.

8. "I could have died": *Jessica Jones*, "AKA Take a Bloody Number," season 1, episode 12, released Nov. 20, 2015, on Netflix; "They say everyone's born a hero": *Jessica Jones*, "AKA Smile," season 1, episode 13, released Nov. 20, 2015, on Netflix.

9. Chandler, *The Long Goodbye*, 181.

10. Hedegaard, Warner, and Miniño. An estimated eighty-eight thousand people die from alcohol-related causes in the United States each year. In fact, from 1999 to 2016, deaths from cirrhosis rose 65 percent, and deaths from liver cancer doubled; the greatest increase was among people twenty-five to thirty-four, a demographic that would include Jessica Jones.

11. *Jessica Jones*, "AKA The Sandwich Saved Me," season 1, episode 5, released Nov. 20, 2015, on Netflix.

12. A 2015 study from Common Sense Media found that teens spent nine hours a day consuming media. See "Landmark Report."

13. As sociologist Zeynep Tufekci puts it in her 2017 book about protest in the era of social media, *Twitter and Tear Gas*, large-scale protests mean the start of something, not the finish. It means a "bursting onto the scene on a large scale without corresponding network internalities" (Tufekci, 82).

14. *Jessica Jones*, "AKA Playland," season 2, episode 13, released March 8, 2018, on Netflix.

15. See Leatherby. In part because this series is set in the Marvel universe rather than in the entirely real world in which young people without corporate jobs share modest apartments with three roommates, residents are living on modest incomes. (The Hell's Kitchen where Jessica lives is actually shot on West 101st Street.) None of these people—including Jessica—would be able to

pay $2,000 to $3,000 a month for a one-bedroom, which is what her apartment would command in the real New York City (Sola).

16. *Jessica Jones*, "AKA Smile," season 1, episode 13, released Nov. 20, 2015, on Netflix.

17. Daly, *The Snarl of the Beast*, 156.

18. In some science fiction, a robot gains competence in matters human, becoming familiar with love and pain. In *The Fifth Element* (1997), Leeloo cries at reports of war and destruction. In *Star Trek Generations* (1994), Data gains an emotion chip and an increased sense of humanity. In *Bicentennial Man* (1999), Andrew becomes human enough to fall in love but also to die. Being human provides emotional richness, and this is presented as a good thing. Various critics have noticed similarities between the hard-boiled detective and the science fiction protagonist.

BIBLIOGRAPHY

Abbott, Megan E. *The Street Was Mine: White Masculinity in Hardboiled Fiction and Film Noir*. New York: Palgrave Macmillan, 2002.

Alexander, Michelle. *The New Jim Crow: Mass Incarceration in the Age of Colorblindness*. New York: New Press, 2012.

Alvarez, Rafael. *The Wire: Truth Be Told*. New York: Simon and Schuster, 2004.

Anderson, Carol. *White Rage: The Unspoken Truth of Our Racial Divide*. New York: Bloomsbury, 2016.

Andreeva, Nellie. "'True Detective' Now Most Watched HBO Freshman Series Ever." *Deadline*, April 15, 2014. deadline.com/2014/04/true-detective-now-most-watched-hbo-freshman-series-ever-715055.

Appiah, Kwame Anthony. "People Don't Vote for What They Want. They Vote for Who They Are." *Washington Post*, August 30, 2018.

Arnold, Gordon B. *Projecting the End of the American Dream: Hollywood's Visions of US Decline*. Santa Barbara, CA: ABC-CLIO, 2013.

Aronson, Marc. *Master of Deceit: J. Edgar Hoover and America in the Age of Lies*. Somerville, MA: Candlewick, 2012.

Babington, Anthony. *Shell Shock: A History of Changing Attitudes to War Neurosis*. London: Leo Cooper, 1997.

Baldwin, Peter. *The Narcissism of Minor Differences: How America and Europe Are Alike*. New York: Oxford University Press, 2009.

Barzun, Jacques. "The Illusion of the Real." In *The World of Raymond Chandler*, edited by Miriam Gross, 159–63. New York: A and W, 1978.

Bauer, Laura, ed. *Hollywood Heroines: The Most Influential Women in Film History*. Santa Barbara, CA: ABC-CLIO, 2018.

Bell, Terrel Howard. *The Thirteenth Man: A Reagan Cabinet Memoir*. New York: Free Press, 1988.

Berman, Larry. *No Peace, No Honor: Nixon, Kissinger, and Betrayal in Vietnam*. New York: Simon and Schuster, 2001.

"Bounds of Disclosure." Editorial. *New York Times*, Sep. 23, 1976.

Brands, Henry William. *Reagan: The Life*. New York: Anchor, 2016.

Brooks, David. "When Politics Becomes Your Idol." *New York Times*, Oct. 30, 2017.

Brownlee, W. Elliot. *Dynamics of Ascent: A History of the American Economy*. Belmont, CA: Dorsey, 1988.

Budd, Mike, Steve Craig, and Clay Steinman. *Consuming Environments: Television and Commercial Culture*. New Brunswick, NJ: Rutgers University Press, 1999.

Calia, Michael. "Writer Nic Pizzolatto on Thomas Ligotti and the Weird Secrets of 'True Detective.'" *Wall Street Journal*, Feb. 2, 2014. http://blogs.wsj.com /speakeasy/2014/02/02/writer-nic-pizzolatto-on-thomas-ligotti-and-the -weird-secrets-of-true-detective.

Carter, Jimmy. "Address to the Nation on Energy and National Goals: 'The Malaise Speech.'" July 15, 1979. American Presidency Project. www .presidency.ucsb.edu/documents/address-the-nation-energy-and-national -goals-the-malaise-speech.

———. *Conversations with Carter*. Boulder, CO: Lynne Rienner, 1998.

———. "Inaugural Address, January 20, 1977." American Presidency Project. www.presidency.ucsb.edu/documents/inaugural-address-0.

Cashmore, Ellis. *Celebrity Culture*. New York: Routledge, 2014.

Chandler, Raymond *The Big Sleep; Farewell, My Lovely; The High Window*. New York: Alfred A. Knopf, 2002.

———. *The Little Sister*. New York: Random House, 1988.

———. *The Long Goodbye*. New York: Random House, 1988.

———. "The Simple Art of Murder." *Atlantic Monthly*, Dec. 1944, 53–59.

"Charting the Decline of Manly Men on (and off) Screen." *Breitbart*, Feb. 2, 2013. www.breitbart.com/big-hollywood/2013/02/02/hollywood-male-role -model-evolution.

Collins, Max Allan. Introduction to *The Mike Hammer Collection*. Vol. 1, vii–xii. New York: Penguin, 2001.

Collins, Max Allan, and James L. Traylor. *Mickey Spillane on Screen: A Complete Study of the Television and Film Adaptations*. Jefferson, NC: McFarland, 2018.

Cooper, James Fenimore. *The Leatherstocking Tales*. Vol. 1. New York: Library of America, 1985.

Crawford, Keith A., and Stuart J. Foster, eds. *War, Nation, Memory: International Perspectives on World War II in School History Textbooks*. Charlotte, NC: IAP, 2007.

Cusic, Don. *Discovering Country Music*. Santa Barbara, CA: ABC-CLIO, 2008.

Daly, Carroll John. "The False Burton Combs." In Gruesser, *A Century of Detection*, 297–317.

———"Knights of the Open Palm." *Black Mask*, June 1, 1923, 33–47.

———. "The Red Peril." In Daly, *Them That Lives by Their Guns*, 31–61.

———. *The Snarl of the Beast*. New York: HarperPerennial, 1992.

———. *Them That Lives by Their Guns*. Boston: Altus Press, 2015.

———. "Three Gun Terry." In Nolan, *The "Black Mask" Boys*, 43–72.

Davis, Flora. *Moving the Mountain: The Women's Movement in America Since 1960*. Urbana: University of Illinois Press, 1999.

De Fursac, J. R. "Traumatic and Emotional Psychoses: So-called Shell Shock." *American Journal of Insanity* 75 (1918): 19–51.

Denton, Robert E. *The Primetime Presidency of Ronald Reagan: The Era of the Television Presidency*. Santa Barbara, CA: ABC-CLIO, 1988.

Doherty, Carroll. "7 things to Know about Polarization in America." Pew Research Center, June 12, 2014. www.pewresearch.org/fact-tank/2014/06 /12/7-things-to-know-about-polarization-in-america.

Dos Passos, John. *USA*. New York: Modern Library, 1937.

Dove, George N. *The Police Procedural*. Madison: University of Wisconsin Press, 1982.

Early, Gerald. *One Nation under a Groove: Motown and American Culture*. Ann Arbor: University of Michigan Press, 2004.

Edsall, Thomas B. "The Contract with Authoritarianism." *New York Times*, April 5, 2018. www.nytimes.com/2018/04/05/opinion/trump -authoritarianism-republicans-contract.html.

Ehrman, John, and Michael W. Flamm. *Debating the Reagan Presidency*. Lanham, MD: Rowman and Littlefield, 2009.

Fallows, James. "The Right and Wrong Questions about the Iraq War." *The Atlantic*, May 19, 2015. www.theatlantic.com/politics/archive/2015/05/the -right-and-wrong-questions-about-the-iraq-war/393497.

Ferrebe, Alice. *Literature of the 1950s: Good, Brave Causes*. Edinburgh: Edinburgh University Press, 2012.

Field, Sherry L., ed. *Explorations in Curriculum History*. Charlotte, NC: IAP, 2005.

Fletcher, Anthony. *Life, Death, and Growing Up on the Western Front*. New Haven, CT: Yale University Press, 2013.

Friedan, Betty. *The Feminine Mystique*. New York: Norton, 2010.

Friedersdorf, Conor. "The Dragnet Effect: How TV Has Obscured Police Brutality." *The Atlantic*, June 12, 2015. www.theatlantic.com/entertainment /archive/2015/06/the-brutal-facts-that-sergeant-joe-friday-ignored/395591.

Gabbert, Elisa. "Is Compassion Fatigue Inevitable in an Age of 24-Hour News?" *The Guardian*, August 2, 2018. www.theguardian.com/news/2018/aug/02 /is-compassion-fatigue-inevitable-in-an-age-of-24-hour-news.

Galanes, Philip. "Ruth Bader Ginsburg and Gloria Steinem on the Unending Fight for Women's Rights." *New York Times*, Nov. 14, 2015.

Goduti, Philip A., Jr. *RFK and MLK: Visions of Hope, 1963-1968*. Jefferson, NC: McFarland, 2017.

Golsan, James. "A Note on Parker's Spenser: Hard-Boiled Detective Turned Super Hero." *South Central Review* 27, no. 1/2 (2010): 159-62.

Golsan, Richard J., James Golsan, and Robert Parker. "Interview with Robert Parker." *South Central Review* 27, no. 1/2 (2010): 163-66.

Griffith, Robert. *The Politics of Fear: Joseph R. McCarthy and the Senate*. Amherst: University of Massachusetts Press, 1987.

Gross, Robert F. "Driving in Circles: *The Rockford Files*." In *Considering David Chase: Essays on "The Rockford Files," "Northern Exposure" and "The Sopranos,"* edited by Thomas Fahy, 29-45. Jefferson, NC: McFarland, 2014.

Grossman, Richard R., and Stephen A. Lee. "May Issue versus Shall Issue: Explaining the Pattern of Concealed-Carry Handgun Laws, 1960-2001." *Contemporary Economic Policy* 26, no. 2 (2008): 198-206.

Gruesser, John, ed. *A Century of Detection: Twenty Great Mystery Stories, 1841-1940*. Jefferson, NC: McFarland, 2010.

Hamilton, Cynthia S. *Western and Hard-Boiled Detective Fiction in America: From High Noon to Midnight*. New York: Macmillan, 1987.

Hammett, Dashiell. "Arson Plus." *Black Mask*, Oct. 1, 1923, 25-36.

——. *The Big Knockover.* New York: Random House, 1962.
——. *The Continental Op.* Edited by Steven Marcus. New York: Random House, 1989.
——. *The Dain Curse.* New York: Vintage Books, 1989.
——. "The Golden Horseshoe." In *The Continental Op*, 43–90.
——. "The House in Turk Street." In *The Continental Op*, 91–120.
——. *The Maltese Falcon, The Thin Man, Red Harvest.* New York: Everyman's Library, 2002.
——. *Red Harvest.* New York: Vintage, 1992.
——. *Selected Letters of Dashiell Hammett.* Edited by Richard Layman and Julie M. Rivett. Berkeley, CA: Counterpoint, 2001.
——. "The Tenth Clew." In *The Continental Op*, 1–42.
Hare, William. *Pulp Fiction to Film Noir: The Great Depression and the Development of a Genre.* Jefferson, NC: McFarland, 2012.
Hedegaard, Holly, Margaret Warner, and Arialdi M. Miniño. "Drug Overdose Deaths in the United States, 1999–2016." CDC, NCHS Data Brief No. 294, Dec. 2017. www.cdc.gov/nchs/products/databriefs/db294.htm.
Hemingway, Ernest. *The Sun Also Rises.* New York: Simon and Schuster, 2002.
Hendershot, Cyndy. *Anti-communism and Popular Culture in Mid-century America.* Jefferson, NC: McFarland, 2002.
Hiney, Tom, and Frank MacShane, eds. *The Raymond Chandler Papers: Selected Letters and Nonfiction, 1909–1959.* New York: Atlantic Monthly Press, 2000.
Hohle, Randolph. *Black Citizenship and Authenticity in the Civil Rights Movement.* New York: Routledge, 2013.
Holdsworth, Amy. *Television, Memory and Nostalgia.* New York: Springer, 2011.
Holloway, David. *Stalin and the Bomb: The Soviet Union and Atomic Energy, 1939–1956.* New Haven, CT: Yale University Press, 1994.
Hoover, Herbert. "Annual Message to Congress on the State of the Union, December 03, 1929." American Presidency Project. www.presidency.ucsb.edu/documents/annual-message-congress-the-state-the-union-0.
——"New York City Speech, October 22, 1928." wwnorton.com/college/history/archive/resources/documents/ch27_04.htm.
——"Radio Address to the Nation on Unemployment Relief, October 18, 1931." American Presidency Project. www.presidency.ucsb.edu/documents/radio-address-the-nation-unemployment-relief.
Horowitz, David A., ed. *Inside the Klavern: The Secret History of a Ku Klux Klan of the 1920s.* Carbondale: Southern Illinois University Press, 1999.
Hosch, William L., and Mark Hall. "Google Inc.: American Company." *Encyclopædia Britannica.* www.britannica.com/topic/Google-Inc.
Jarecki, Eugene. *The American Way of War: Guided Missiles, Misguided Men, and a Republic in Peril.* New York: Simon and Schuster, 2008.
Jeffords, Susan. *Hard Bodies: Hollywood Masculinity in the Reagan Era.* New Brunswick, NJ: Rutgers University Press, 1994.
Jensen, Jeff. "'True Detective' creator Nic Pizzolatto on Carcosa, Hideous Men, and the Season 1 Endgame." *Entertainment Weekly*, Feb. 27, 2014. http://ew.com/article/2014/02/27/true-detective-nic-pizzolatto-season-1.

Johnson, Jeffrey K. *Super-History: Comic Book Superheroes and American Society, 1938 to the Present.* Jefferson, NC: McFarland, 2012.

Johnson, Sheila K. *The Japanese through American Eyes.* Stanford, CA: Stanford University Press, 1991.

Johnston, Richard. "Death's Fair-Haired Boy." *Life*, June 23, 1952, 79–95.

Jones, Sophie. "Women and 'The Wire.'" *Pop Matters*, August 24, 2008.

Kammen, Michael. *American Culture, American Tastes: Social Change and the 20th Century.* New York: Alfred A. Knopf, 2012.

Kaufman, Zachary D. *United States Law and Policy on Transitional Justice: Principles, Politics, and Pragmatics.* New York: Oxford University Press, 2016.

Kennedy, John Pendleton. *Horse-Shoe Robinson.* Philadelphia: Carey, Lea and Blanchard, 1835.

La Berge, Leigh Claire. "Capitalist Realism and Serial Form: The Fifth Season of *The Wire.*" *Criticism* 52, no. 3 (2010): 547–67.

"Landmark Report: U.S. Teens Use an Average of Nine Hours of Media Per Day, Tweens Use Six Hours." Common Sense Media, Nov. 3, 2015. www .commonsensemedia.org/about-us/news/press-releases/landmark-report -us-teens-use-an-average-of-nine-hours-of-media-per-day.

Lanier, Jaron. "Jaron Lanier: How Can We Repair the Mistakes of the Digital Era?" Interview by Guy Raz. *TED Radio Hour*, NPR, May 25, 2018. www.npr .org/templates/transcript/transcript.php?storyId=614079247.

Lawson, Carol. "Broadway; Spillane's Hammer Will Solve His Next Case in a Musical." *New York Times*, Nov. 14, 1980.

Lawson, Ellen NicKenzie. *Smugglers, Bootleggers, and Scofflaws: Prohibition and New York City.* New York: State University of New York Press, 2013.

Leatherby, Lauren. "Five Charts Show Why Millennials Are Worse Off Than Their Parents." *Financial Times*, August 29, 2017. www.ft.com/content /e5246526-8c2c-11e7-a352-e46f43c5825d.

Leith, Sam. "Robert B Parker: Hard-Boiled, Old School and Y'know, a Bit Sloppy." *The Telegraph*, Feb. 23, 2008, www.telegraph.co.uk/culture/books /3671370/Robert-B-Parker-Hard-boiled-old-school-and-yknow-a-bit-sloppy .html.

Lepore, Jill. *The Secret History of Wonder Woman.* New York: Vintage, 2015.

Lester, Paul Martin. *On Floods and Photo Ops: How Herbert Hoover and George W. Bush Exploited Catastrophes.* Jackson: University Press of Mississippi, 2010.

Love, Barbara, ed. *Feminists Who Changed America, 1963–1975.* Urbana: University of Illinois Press, 2006.

Maclean, Nancy. *Behind the Mask of Chivalry: The Making of the Second Ku Klux Klan.* New York: Oxford University Press, 1995.

MacShane, Frank. *The Life of Raymond Chandler.* London: Cape, 1976.

Madden, David. *Tough Guy Writers of the Thirties.* Carbondale: Southern Illinois University Press, 1968.

Maguire, Peter. *Law and War: International Law & American History.* Rev. ed. New York: Columbia University Press, 2010.

Marchand, Roland. *Advertising the American Dream: Making Way for Modernity, 1920–1940*. Berkeley: University of California Press, 1985.

Maxwell, Angie. *The Indicted South: Public Criticism, Southern Inferiority, and the Politics of Whiteness*. Chapel Hill: University of North Carolina Press, 2014.

May, Elaine Tyler. *Homeward Bound: American Families in the Cold War Era*. New York: Hachette, 2008.

McCann, Sean. *Gumshoe America: Hard-Boiled Crime Fiction and the Rise and Fall of New Deal Liberalism*. Durham, NC: Duke University Press, 2000.

McCarthy, Joseph. "Address to the League of Women Voters, Wheeling, West Virginia, February 9, 1950." Teaching American History. https://teachingamericanhistory.org/library/document/address-to-the-league-of-women-voters-wheeling-west-virginia-2.

Menand, Louis. "The Presidential Election of 1968." *New Yorker*, Jan. 8, 2018, 69–75.

Metro, Rosalie. *Teaching US History Thematically: Document-Based Lessons for the Secondary Classroom*. New York: Teachers College Press, 2017.

Mettraux, Guénaël, ed. *Perspectives on the Nuremberg Trial*. New York: Oxford University Press, 2008.

Meyers, Richard. *TV Detectives*. La Jolla, CA: AS Barnes, 1981.

Miklitsch, Robert. *The Red and the Black: American Film Noir in the 1950s*. Urbana: University of Illinois Press, 2016.

Montgomery, David. "Labor in the Industrial Era." In *A History of the American Worker*, edited by Richard Morris, 79–113. Princeton, NJ: Princeton University Press, 2014.

Moore, Lewis D. *Cracking the Hard-Boiled Detective: A Critical History from the 1920s to the Present*. Jefferson, NC: McFarland, 2006.

Morris, Wesley. "Why Do the Oscars Keep Falling for Racial Reconciliation Fantasies?" *New York Times*, Jan. 23, 2019.

Mottram, Eric. "Ross Macdonald and the Past of a Formula." In *Essays on Detective Fiction*, edited by Bernard Benstock, 97–118. New York: Springer, 1983.

Müller, Jan-Werner. *What Is Populism?* Philadelphia: University of Pennsylvania Press, 2016.

Murrin, John M., Paul E. Johnson, James M. McPherson, Alice Fahs, and Gary Gerstle. *Liberty, Equality, Power: A History of the American People*. Boston: Cengage Learning, 2011.

Myers, Charles. "A Contribution to the Study of Shell Shock: Being an Account of Three Cases of Loss of Memory, Vision, Smell, and Taste, Admitted into the Duchess of Westminster's War Hospital, Le Touquet." *The Lancet* 185, no. 4772 (1915): 316–20.

Nolan, William. *The "Black Mask" Boys: Masters in the Hard-Boiled School of Detective Fiction*. New York: Mysterious Press, 1985.

———. Introduction to *Nightmare Town*, by Dashiell Hammett, vii–xvii. New York: Alfred A. Knopf, 1999.

———. "Shadowing the Continental Op." *Armchair Detective* 8 (1975): 121–23.

Nussbaum, Emily. "Cool Story, Bro: The Shallow Deep Talk of *True Detective*." *New Yorker*, March 3, 2014.

O'Connor, Flannery. *The Habit of Being: Letters of Flannery O'Connor*. New York: Macmillan, 1988.

Orwell, George. *In Front of Your Nose, 1945–1950*. New York: Penguin, 1968.

Oshinsky, David M. *A Conspiracy So Immense: The World of Joe McCarthy*. New York: Oxford University Press on Demand, 2005.

Parker, Robert. *God Save the Child*. New York: Random House, 1974.

———. *The Godwulf Manuscript*. New York: Random House, 1973.

———. *Mortal Stakes*. New York: Random House, 1975.

———. *Promised Land*. New York: Random House, 1976.

Parker, Theodore. *The Collected Works of Theodore Parker*. Edited by Frances Power Cobbe. Vol. 2, *Sermons.—Prayers*. London: Trübner, 1879.

Penfold-Mounce, Ruth, David Beer, and Roger Burrows. "*The Wire* as Social Science-Fiction?" *Sociology* 45, no. 1 (2011): 152–67.

Perlstein, Rick. *The Invisible Bridge: The Fall of Nixon and the Rise of Reagan*. New York: Simon and Schuster, 2015.

Porter, Dennis. *The Pursuit of Crime: Art and Ideology in Detective Fiction*. New Haven, CT: Yale University Press, 1981.

Provine, Doris Marie. *Unequal under Law: Race in the War on Drugs*. Chicago: University of Chicago Press, 2008.

Raine, William MacLeod. *Famous Sheriffs and Western Outlaws: Incredible True Stories of Wild West Showdowns and Frontier Justice*. New York: Skyhorse, 2012.

Reagan, Ronald. "Radio Address to the Nation on the Congressional Agenda and the Economy, Nov. 6, 1982." American Presidency Project. www.presidency.ucsb.edu/documents/radio-address-the-nation-the-congressional-agenda-and-the-economy.

———. "Remarks at a White House Meeting with Members of the American Business Conference, March 13, 1985." American Presidency Project. www.presidency.ucsb.edu/documents/remarks-white-house-meeting-with-members-the-american-business-conference.

———. "Remarks at the Annual Convention of the National Association of Evangelicals in Orlando, Florida, March 08, 1983." American Presidency Project. www.presidency.ucsb.edu/documents/remarks-the-annual-convention-the-national-association-evangelicals-orlando-florida.

Redd, Lawrence. *Rock Is Rhythm and Blues*. East Lansing: Michigan State University Press, 1974.

Reddy, Maureen T. *Traces, Codes, and Clues: Reading Race in Crime Fiction*. New Brunswick, NJ: Rutgers University Press, 2003.

Robertson, Ed. *Thirty Years of "The Rockford Files": An Inside Look at America's Greatest Detective Series*. New York: iUniverse, 2005.

Roosevelt, Franklin Delano. "Annual Message to Congress on the State of the Union, January 6, 1941." American Presidency Project. www.presidency.ucsb.edu/documents/annual-message-congress-the-state-the-union.

———. "Fireside Chat, December 9, 1941." American Presidency Project. www.presidency.ucsb.edu/documents/fireside-chat-12.

———. "Inaugural Address, March 4, 1933." American Presidency Project. www.presidency.ucsb.edu/documents/inaugural-address-8.

———. "Inaugural Address, January 20, 1937." American Presidency Project. www.presidency.ucsb.edu/documents/inaugural-address-7.

Rovere, Richard H. *Senator Joe McCarthy*. Berkeley: University of California Press, 1996.

Saraiya, Sonia. "*True Detective* Season 3 Is Mahershala Ali's Show." *Vanity Fair*, Jan. 11, 2019. www.vanityfair.com/hollywood/2019/01/true-detective -season-3-review-mahershala-ali.

Scaggs, John. *Crime Fiction*. New York: Routledge, 2005.

Schlesinger, Arthur M. *The Imperial Presidency*. New York: Houghton Mifflin, 2004.

Schmidt, Christopher W. "Defending the Right to Discriminate: The Libertarian Challenge to the Civil Rights Movement." In *Signposts: New Directions in Southern Legal History*, edited by Sally Hadden and Patricia Minter, 417–47. Athens: University of Georgia Press, 2013.

Smith, Erin. *Hard-Boiled: Working-Class Readers and Pulp Magazines*. Philadelphia: Temple University Press, 2010.

———."How the Other Half Read: Advertising, Working-Class Readers, and Pulp Magazines." *Book History* 3 (2000): 204–30.

Smith, Johanna M. "Raymond Chandler and the Business of Literature." *Texas Studies in Literature and Language* 31, no. 4 (1989): 592–610.

Smith, Richard L. "A Statistical Assessment of Buchanan's Vote in Palm Beach County." *Statistical Science*, Nov. 1, 2002, 441–57.

Snauffer, Douglas. *Crime Television*. Santa Barbara, CA: Greenwood, 2006.

Snow, Donald M., and Dennis M. Drew. *From Lexington to Baghdad and Beyond: War and Politics in the American Experience*. New York: Routledge, 2015.

Sola, Katie. "Can Superhero Jessica Jones Afford Her Dingy Apartment? An Investigation." *Forbes*, Nov 24, 2015. www.forbes.com/sites/katiesola/2015 /11/24/jessica-jones-apartment/#407f5bca21d4.

Soumerai, Eve Nussbaum, and Carol D. Schulz. *Daily Life during the Holocaust*. Santa Barbara, CA: ABC-CLIO, 2009.

Spillane, Mickey. *The Mike Hammer Collection*. Vols. 1–3. New York: Penguin, 2001.

Stott, William. *Documentary Expression and Thirties America*. Chicago: University of Chicago Press, 1986.

Susman, Warren I. *Culture as History*. New York: Pantheon, 2012.

Sutherland, John. *Lives of the Novelists: A History of Fiction in 294 Lives*. New Haven, CT: Yale University Press, 2012.

Swaine, Jon, Oliver Laughland, Jamiles Lartey, and Ciara McCarthy. "Young Black Men Killed by US Police at Highest Rate in Year of 1,134 Deaths." *The Guardian*, Dec. 31, 2015. www.theguardian.com/us-news/2015/dec/31/the -counted-police-killings-2015-young-black-men.

Tamony, Peter. "The Origin of 'Hard-Boiled.'" *American Speech* 12, no. 4 (1937): 258–61.

Taylor, L. D., and T. Setters. "Watching Aggressive, Attractive, Female Protagonists Shapes Gender Roles for Women among Male and Female Undergraduate Viewers." *Sex Roles* 65, no. 1-2 (2011): 35–46.

Taylor, Michael, and Nigel Thrift, eds. *The Geography of Multinationals: Studies in the Spatial Development and Economic Consequences of Multinational Corporations*. New York: Routledge, 2012.

Thorburn, David. "Detective Programs." In *Museum of Broadcast Communications Encyclopedia of Television*, edited by Horace Newcomb. 690–96. New York: Routledge, 1997.

Tibbetts, Paul. "One Hell of a Big Bang." Interview by Studs Terkel. *The Guardian*, August 6, 2002. www.theguardian.com/world/2002/aug/06/nuclear.japan.

Trott, Sarah. *War Noir: Raymond Chandler and the Hard-Boiled Detective as Veteran in American Fiction*. Jackson: University Press of Mississippi, 2016.

Truman, Harry. "Annual Message to the Congress on the State of the Union, January 8, 1951." American Presidency Project. www.presidency.ucsb.edu /documents/annual-message-the-congress-the-state-the-union-19.

——"Message to the Congress on the State of the Union and on the Budget for 1947," Jan. 21, 1946. American Presidency Project. www.presidency.ucsb .edu/documents/message-the-congress-the-state-the-union-and-the -budget-for-1947.

Tufekci, Zeynep. *Twitter and Tear Gas: The Power and Fragility of Networked Protest*. New Haven, CT: Yale University Press, 2017.

US Department of Commerce, Bureau of the Census. *Children under Institutional Care, 1923: Statistics of Dependent, Neglected, and Delinquent Children in Institutions and under the Supervision of Other Agencies for the Care of Children, with a Section on Adults in Certain Types of Institutions*. Washington, DC: Government Printing Office, 1927.

US Department of State, Office of the Historian, Bureau of Public Affairs. "NSC-68, 1950." https://history.state.gov/milestones/1945-1952/NSC68.

Vatter, Harold G. *The US Economy in the 1950's: An Economic History*. New York: Norton, 1963.

Vaughn, Stephen. *Ronald Reagan in Hollywood: Movies and Politics*. Cambridge: Cambridge University Press, 1994.

Voth, Ben. *James Farmer Jr.: The Great Debater*. Lanham, MD: Lexington Books, 2017.

Walker, John F., and Harold G. Vatter. *History of US Economy since World War II*. New York: Routledge, 2015.

Weir, Robert E., ed. *Class in America*. Vol. 3, *Q–Z*. Westport, CT: Greenwood, 2007.

Wheeler, William Bruce, and Michael J. McDonald. *TVA and the Tellico Dam, 1936–1979: A Bureaucratic Crisis in Post-Industrial America*. Knoxville: University of Tennessee Press, 1986.

Whyte, William. *The Organization Man*. New York: Simon and Schuster, 1956.

Williams, Roger M. *Sing a Sad Song: The Life of Hank Williams*. Urbana: University of Illinois Press, 1981.

Williamson, C. N., and A. M. Williamson. "The Shop Girl." *Munsey's Magazine*, July 1914, 345–463.

"'The Wire': David Simon Reflects on His Modern Greek Tragedy." *Variety*, March 7, 2008. https://variety.com/2008/tv/news/the-wire-david-21043.

INDEX
